Moche Art and Iconography

UCLA LATIN AMERICAN STUDIES

Volume 33

A Book on Lore

Series editor
Johannes Wilbert

Editorial committee
Robert N. Burr
Thomas J. La Belle
Gerardo Luzuriaga
James W. Wilkie

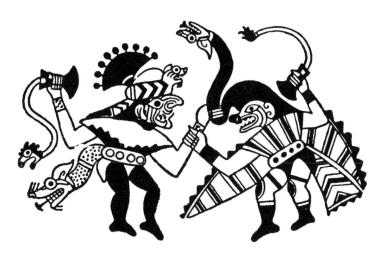

MOCHE ART AND ICONOGRAPHY

CHRISTOPHER B. DONNAN

UCLA Latin American Center Publications

University of California, Los Angeles • 1976

UCLA Latin American Center Publications
Copyright © 1976 by The Regents of the University of California
All rights reserved
Library of Congress Catalog Card Number: 75-620011
ISBN: 0-87903-033-X
Printed in the United States of America

Based on a design by Alice McGaughey

To Sharon

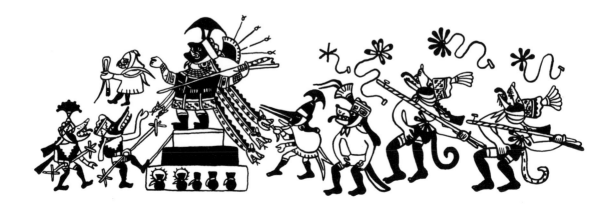

Preface

Many people have been charmed by Moche art. With my first exposure to it I found that my initial resistance was minimal, and my subsequent curiosity virtually incurable. The first exposure took place in the spring of 1964 when I had the opportunity of working with the extraordinary collection of Moche material excavated by Max Uhle in 1899. The result was a study of Moche ceramic technology, published the following year, and a craving to know more about the people who created this exquisite art style.

Since at that time there had been very little scientific excavation of Moche refuse, and most of what had been done was unpublished, little was known about the nonartistic aspects of Moche culture. Thus, I decided to select one valley on the north coast of Peru which had been occupied by the Moche people, and intensively to site survey and excavate those sites pertaining to the Moche occupation. The Santa Valley was selected, and a total of seventeen months of fieldwork there yielded much information about the material aspects of Moche culture which were not depicted in the art.

Even before the report on the Santa Valley study was completed, it became apparent that a systematic analysis of Moche iconography was the next major step in gaining a greater understanding of these ancient people. In the spring of 1968 the idea of creating an Archive of Moche Art was developed, and the first collections of Moche art were photographed. Since then, the archive has expanded to include photographic records of Moche art from almost all major museums and private collections in the United States, South America, and Europe. As the sample size in the archive increased, analysis of the iconography began—a series of graduate seminars were offered in the Department of Anthropology at the University of California, Los Angeles, using the archive to ex-

plore various facets of the art. The time-consuming task of organizing the existing sample in the archive and incorporating the constant flow of new material proceeded on a year-round schedule.

Meanwhile, three summers of fieldwork in Peru were carried out with the purpose of learning more about the nature of Moche culture through archaeological excavation. Moche-Huari murals were excavated at Batan Grande in 1969, and the following year a major excavation was conducted at the maritime settlement of Huanchaco. In 1972, the pyramids at Moche were reexcavated as part of the Chan Chan-Moche Valley Project. During each of these field seasons the interplay between our ongoing analysis of the art and the material we were excavating from Moche sites was fascinating, and proved to be very rewarding in our understanding of the iconography.

In the process of accumulating the large sample of Moche art now contained in the archive, some rather unexpected avenues of related research developed. In a private collection in Peru, for example, there was a unique Moche bowl depicting a set of figures engaged in metalworking. This prompted a series of experiments in an effort to understand the representation, and the result was a rather extensive reconstruction of certain aspects of Moche metallurgical technology. In 1971 it became apparent that early sixteenth- and seventeenth-century documents containing information about the native people who inhabited Peru at the time of the Spanish conquest also contain valuable clues to the interpretation of Moche iconography. As a result, an extensive search through all available documents of this type was carried out. During the past four years ethnographic study of folk-healing practices on the north coast of Peru has been conducted by Douglas Sharon, and as a result, several extremely significant correlations between these practices and Moche iconography have been observed.

Quite clearly, then, this study of Moche iconog-

raphy is not derived solely from an examination of art objects. It is a multifaceted approach that focuses many avenues of investigation on the interpretation of what Moche artists were trying to express.

This study has resulted from the efforts of many individuals, and I would like to take this opportunity to express my gratitude for their assistance. Perhaps my greatest debt is to the directors and curators of the public museums, as well as the private collectors who have so graciously allowed their Moche pieces to be recorded. Without their help the archive could never have become a reality.

I am also most grateful for the able assistance of Susanne Konigsberg and Diane Latham for their help in getting the archive organized in its early stages, to John Rowe, Douglas Sharon, and Donald McClelland for help with specific portions of this manuscript, to Patrick Finnerty and Donna McClelland for help with the illustrations, and to the students who have shared in the frustrations as well as the rewards of this research.

Three granting agencies have been responsible for providing the necessary funds to establish the archive and carry out the analysis. These are the American Council of Learned Societies, the Academic Senate of the University of California, and the Samuel H. Kress Foundation. To these agencies I extend my sincere appreciation. I am also grateful to the Ahmanson Foundation and the Ethnic Arts Council of Los Angeles for providing funds to support this publication.

Franklin Murphy deserves special thanks. His fondness for ancient art, and faith in our approach to understanding it, resulted in our being able to photograph European collections for the archive.

Finally, I wish to express my sincere appreciation to Donna McClelland for her tremendous devotion to this research. Her endless hours spent working with the archive have been crucial to the success of this project. They have also made her one of the leading experts on Moche iconography. Frequent "brainstorming" sessions with Donna McClelland and Alana Cordy-Collins as this report was being written were instrumental in hammering out some of the more difficult sections. Their enthusiasm and support were boundless and whatever success is achieved is to be shared with them.

Contents

I. Introduction

When most people think of ancient Peru, they think of the Inca—their impressive architecture of carefully fitted stones, magnificent roads and irrigation systems, spectacular sites such as Sacsahuaman and Macchu Pichu, and vast riches in gold and silver which were taken from them by conquering Spaniards in the sixteenth century. Many people are unaware, however, that the Inca were but the last in a series of civilizations that developed in the highland and coastal areas of Peru in the centuries before the arrival of Europeans.

This book deals with an earlier civilization—known today as Moche (or Mochica)—which flourished more than 1000 years before the beginning of the Inca empire. Although these people had no writing system, they created a vivid artistic record of their activities and the objects in their environment. This artistic record provides tantalizing clues concerning the nature of their society and their supernatural beliefs. The focus of this study is an analysis of Moche art, to determine the nature of its depiction, the scope of its themes, and the way in which it can best be understood.

The Moche people lived on the north coast of Peru. This area is one of the driest deserts in the world, with an average annual precipitation of 0.5 cm. As a result, human life is generally confined to the river valleys that derive their water resources from the runoff of the great Andean Cordillera and channel that water in a southwesterly direction, emptying it into the Pacific Ocean (see map 1).

In the summer (November to May) is is hot in this area, but the dry desert heat is mitigated by the sea breeze. This is the period of heaviest rainfall in the mountains, and the time when the greatest amount of water flows in the river valleys. The remainder of the year has a moderate temperature, with a tendency toward chilly nights and mornings. During part of the winter season (June to October) sea fogs are common, particularly along the coast, and the sky is overcast practically every morning until noon or after. Frequently these low-hanging clouds precipitate a thin, cold drizzle.

The native fauna of the river valleys includes numerous sea and land birds, lizards, frogs, foxes, and rodents. Deer are also present, although rarely seen today, and felines are said to have been seen in historic times. The cool Humboldt current sweeps northward along the coast and supports abundant sea life. Fish, shellfish, and crustaceans are available and sea lions, though seldom seen today, are still found along the coast.

Agriculture, today as in the past, is the basic subsistence activity in the valleys, and most of the area on the valley floors is presently being cultivated. The margins of cultivation on the sides of the valleys are frequently covered with scrub growth of low algarroba trees usually referred to as *monte*. In other areas, generally near the rivers where there is an abundance of water, there are dense growths of cane, cattails, and marsh grass. These areas support a wide variety of fresh water crustaceans, fish, and water fowl.

The earliest archaeological evidence of human occupation on the north coast of Peru dates prior to the end of the Pleistocene, when man was dependent on hunting and gathering for subsistence. Archaeologists have succeeded in tracing the development of culture in this area from that time through the beginning of agriculture, the development of settled village farming communities, and the introduction of ceramics, loom weaving, and metallurgy. As human population grew, larger settlements developed with increasing social stratification, specialization of labor, fully developed artistic expression, and monumental architecture.

By the first millenium B.C., a religious state had begun, with an associated art style known as Chavin. This art style has been found throughout much

of present day Peru, suggesting that this was a major period of unification, with considerable communication between widely separated geographical areas.

Chavin unification diminished during the last centuries B.C., and the various areas of Peru began to develop their own distinctive art styles. Soon the Moche style became dominant on the north coast. Although the origin of this art style is not well understood, at its greatest period of influence it was dominant in all of the valleys from Lambayeque to Nepeña, a distance of more than 250 kilometers north-south (see map 1). Moche settlements are found in nearly all parts of these valleys, from the sea to the point where the floodplain narrows as it enters the canyons leading up into the Andean mountain range. This is generally a distance of about 50 kilometers east-west. Although Moche settlements have not been found north or south of this area, nor in the adjacent mountain regions, isolated occurrences of Moche material, or Moche stylistic features, have been found beyond these boundaries, thus indicating some degree of contact with the surrounding areas.[1]

The culture of the Moche people was in many respects a continuation of Chavin culture. Moche subsistence was based primarily on agriculture and supplemented extensively by maritime resources. To a lesser degree, hunting of land mammals, birds, and snails added to the diet. Llama and alpaca were domesticated for sources of meat and wool, and llama also served as beasts of burden. The Muscovy duck and guinea pig were domesticated and used for food.

Metal casting techniques, the alloying of metals, and the widespread use of copper and silver appear to have been added by Moche craftsmen to an already highly developed gold metallurgy that was known to Chavin artists. Similarly, Moche potters added the use of molds to an extensive list of techniques for producing fine ceramic objects.

Loom weaving of cotton and wool fibers was practiced, utilizing a great variety of techniques to produce elaborate textiles.

The Moche people built temples, palaces, and platform mounds of rectangular, sun-dried mud bricks—a construction material well suited to the arid climate of the northern Peruvian coast. Their structures were frequently plastered and painted with colorful designs.

Moche graves are usually rectangular pits in which the bodies were placed in an extended position. Sometimes the pits are lined with mud bricks or stone and roofed with large cane beams. Many elaborately furnished graves have been found, and the marked differentiation in the quality and quantity of grave goods indicates a highly developed social class system and complex division of labor. These aspects of Moche society are also demonstrated in the art by the ways in which persons and activities are depicted.

Moche artistic expression is amazingly varied. Animals, plants, anthropomorphized demons or deities, and a wide range of life scenes are shown, including the hunting of animals, fishing, combat, the punishment of prisoners and criminals, sexual acts, and the pomp of rulers seated on thrones or carried in litters. Architectural details—temples, pyramids, and houses—are all depicted in Moche art, as are features of clothing and adornment. The degree of realism with which Moche art is expressed and the wide spectrum of subject matter make it one of the most appealing of all pre-Columbian art styles. The representations, both painted and modeled, are detailed and comprehensible with a tendency toward realism leading to the production of genuine portraits on some of the modeled pieces. Much of the art appears to tell a story, and to give tantalizing glimpses into the daily life, ceremonies, and mythology of the people who created it. At the same time, one has the feeling that he is looking at the work of artists who enjoyed experimenting and who had some-

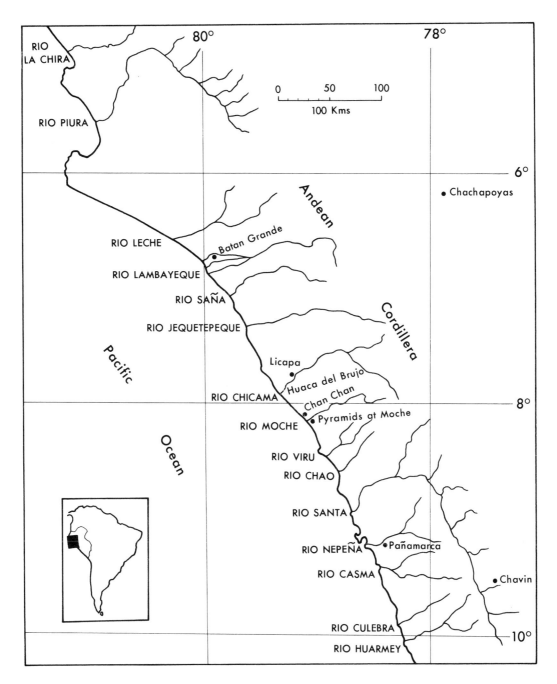

Map 1. The north coast of Peru.

3

thing they were trying to say, over and above the production of a routine piece of ornament.

Moche artists continued to create their products for more than seven centuries. During this time the style gradually changed, but clearly maintained its characteristic themes and manner of representation. Then, about A.D. 750, the Moche style began to disappear from the north coast. The circumstances under which this took place are not well understood, although it has been postulated that the end was brought about by invasion of Huari people from the southern mountain regions of Peru. Archaeological research has demonstrated that the end of the Moche kingdom is contemporary with the introduction of the Huari style on the north coast of Peru, but there is no good evidence that the two events are causally related.

During the next seven centuries, the people of the north coast continued to develop a more complex society, with strong emphasis on large urban centers. A style known as Chimu replaced the Moche style, and many of the ancient Moche sites were abandoned. Others continued to be occupied, and the Moche material was buried by refuse of these later people.

By A.D. 1470, the Chimu people had developed a large political state that dominated the entire north coast of Peru. This state, known as the Kingdom of Chimor, had its capital in the Moche Valley at Chan Chan—a city covering more than 16 square kilometers. This was the largest urban center in South America—prior to the arrival of Europeans.

The Kingdom of Chimor was conquered by the armies of the Inca Empire sometime shortly after 1470. The area maintained much the same culture as before, but was under the authority of the Inca state. In 1528 the Spanish entered Peru, and soon conquered the Inca Empire, thus placing the people of the north coast under European rule.

It is only with the arrival of Europeans that we have any written accounts of the native people who lived on the north coast of Peru. Since the earlier cultures had no writing system, their story must be reconstructed entirely on the basis of archaeological research. This involves the painstaking excavation of what remains of their palaces, temples, and tombs, as well as their domestic architecture and refuse deposits. Archaeological research in this area is particularly instructive because the arid climate has preserved perishable material such as plant remains, basketry, and textiles, which are absent from archaeological sites in most other areas of the world. The remarkably complete archaeological record thus allows for a much more thorough reconstruction of ancient culture than can usually be made.

The potential for reconstructing the culture of the Moche people is even further enhanced by the wealth of information contained in their art. Perhaps more than any other group that lacked a writing system, the Moche people left a graphic record of themselves in their artistic representations. So complex and varied are these representations that they offer a unique opportunity for gaining insights into the nature of this ancient culture.

II. The Approach

Various attempts have been made to interpret Moche art, but have met with only limited degrees of success. In 1902–1903 Arthur Baessler published his own extensive collection of Moche pottery in four beautifully illustrated volumes. His interpretation of the iconography was quite limited, however, and was based almost exclusively on ethnographic analogy. Rafael Larco (1938–1939), largely on the basis of his own extensive collection, sorted the subject matter of Moche art into groups and identified plants and birds by their scientific names. He planned to do a similar study of human depiction, but unfortunately this was never completed. Gerdt Kutscher (1950a, 1950b, 1954b, 1955) published various works on Moche iconography, which include marvelous reproductions of many important pieces. For the most part, however, these pieces are described in terms of the more obvious features of their surface adornment, or are interpreted in a largely subjective fashion. In 1970, Danièle Lavallée published an analysis of the animal representations in Moche art which is similar to Larco's treatment of this topic. It is, however, more extensive in scope and based on a somewhat larger sample. Elizabeth Benson (1972) has recently published a general account of Moche culture, which includes comments on the iconography. Minor works dealing with specific aspects of Moche iconography include detailed analyses of dress by Gosta Montell (1929) and Jorge Muelle (1936a), an analysis of musical instruments by Arturo Jiménez (1950–1951), and analyses of the bean runner motif by Rafael Larco (1942, 1943) and José Imbelloni (1942).

THEORY

Our approach to Moche iconography is distinct from any attempted before. It is based on the assumption that inherent in the art is a symbolic system that follows consistent rules of expression. In many respects, this symbolic system is similar to the symbolic system of a language. In language, the speaker can modify what he is saying about an object (noun) by selecting a set of modifiers (adjectives and adverbs) and inserting them in their proper place in the message according to a set of rules (grammar).

In art, the communication is between the artist and the viewer. The artist conveys information about objects such as houses, men, or ceremonies—we might call these "artistic nouns"—by using a set of modifiers or "artistic adjectives." Thus individuals can be recognized as being rich or poor, high or low status, warriors, gods, or servants depending on the modifications the artist chooses to make in the way he depicts the individual. By using a certain combination of modifiers he can even represent a specific individual such as a god, king, or folk hero.

Similarly, the artist uses what we might call "artistic adverbs" to modify the action shown, and thus he is able to convey the speed of a given runner, the force of a mace blow or the intensity of a battle by the way he arranges the scene, and the various details he adds to the representation.

In both language and art, communication is possible only when there is full understanding of and reasonable adherence to the rules of expression. If either the speaker of a language or the artist producing his work deviates too far from the rules of expression, his message may be misunderstood.

The rules of expression are learned by individuals as they live in a given culture. Generally the learning occurs outside formal educational contexts, and takes place on a subconscious level. The average individual of Western culture will find it difficult to recall how he learned all of the rules of expression governing the representation of Santa

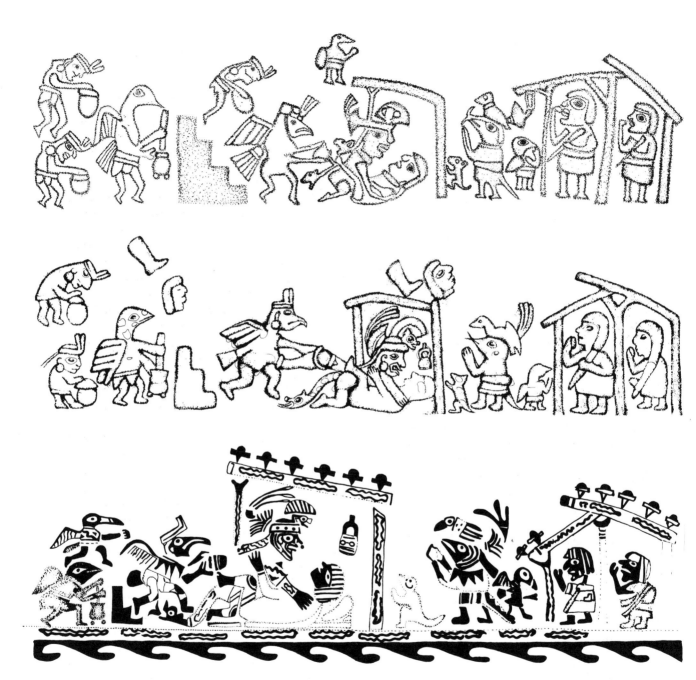

Figure 1. Three versions of a ceremony apparently involving sexual intercourse and human cannibalism.

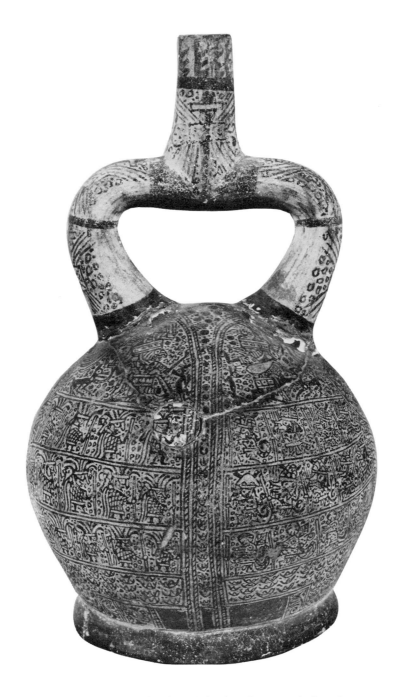

Figure 2a. Stirrup spout bottle with fineline drawing of a burial ceremony.

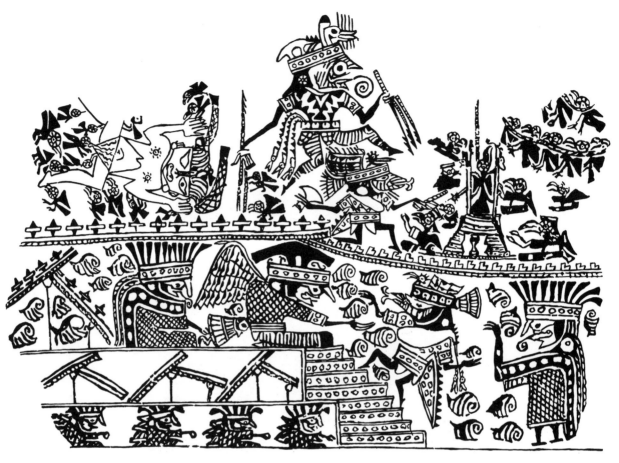

Figure 2b. Fineline drawing derived from the back side of figure 2a.

Claus. How, for example, did he learn that Santa Claus wears black boots, and a belt buckle that is square or rectangular? Yet he has internalized these rules of artistic representatioan so thoroughly that he notices immediately if the artist shows Santa Claus wearing anything but his standard clothing. If too many of the conventions are altered by the artist, the viewer becomes confused about the identification of the figure, or misinterprets the representation altogether. Thus, to have his work understood the artist must conform to the rules of expression.

Our approach seeks to interpret Moche art through noting the patterns that result from artists

working according to these rules of expression. It is the consistent correlations in details of the representations that provide the clues to the message itself. Specific individuals can be identified by noting the consistent combination of features associated with them—their physical form, distinctive clothing, and objects being held—in the same way that Santa Claus can be distinguished from all other figures in Western art. Furthermore, the meaning of a specific figure can be determined, at least in part, by noting the range of activities in which he is engaged, and the consistent setting in which he is represented. With a good sample of scenes showing Santa Claus, it would thus be

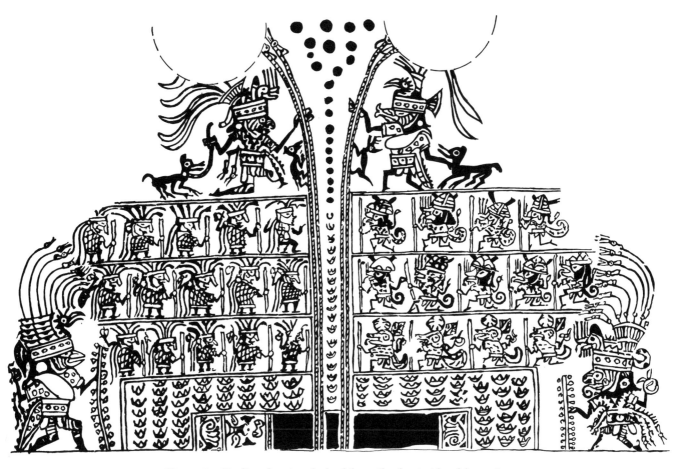

Figure 2c. Fineline drawing derived from the front side of figure 2a.

possible to determine that he is supernatural (note his mode of transportation and manner of entry into houses) and he is seasonal in importance rather than being equally important through all seasons of the year. It is also possible to note that he is somehow involved in gift giving, and his "ceremonial paraphernalia" includes stockings by the fireplace, and an evergreen tree that is brought inside the house and decorated with ornaments. All this can be determined *without* an accompanying written text because of the repetition of features with which he is represented. Obviously this type of repetition can only be observed through analysis of a large sample of the art. The larger the sample, the greater the potential for making correct observations.

There are two additional points that can be made by our analogy between Moche art and a spoken language. First, we can expect individual variation in the way in which the systems are expressed. Just as all individual speakers of a language express themselves in a unique way, so each artist has his own unique style that may experience some modification during his lifetime. Thus some pieces of the art which are clearly depicting the same scene (fig. 1) or even the same individual will have variations owing to peculiarities of individual style—variations that are not necessarily significant in

terms of the message being communicated. Distinguishing between stylistic peculiarities and variations that represent distinct messages is often difficult. Nevertheless, an awareness of both possibilities is crucial in working with the art.

The final point that might be made by our analogy between Moche art and a spoken language is that although the kinds of information that can be conveyed in either system are theoretically unlimited, in practice only a certain range of topics is communicated. With language, the range of topics is generally limited by the nature of the relationship between the individuals involved, or by the function that the communication is supposed to fulfill. As our analysis of Moche art proceeded, it became apparent that the information being communicated was limited to a surprisingly small inventory of themes (see chapter 8) and that these themes seemed to be interrelated in such a way as to suggest a rather specific and limited function for the art itself (see chapter 9).

Since our basic assumption is that Moche art has a symbolic system that follows consistent rules of expression, the problem becomes one of devising a means of working with Moche art in such a way that the consistent rules are brought out, and the correlations become observable. To do this, a large sample is crucial.

METHOD

Since a large sample of Moche art was basic to our approach in understanding the iconography, means had to be devised to record and catalogue the large numbers of Moche specimens available in widely scattered collections. It was fortunate that the system devised when the research began proved to be quite satisfactory and could be maintained with only minor changes as the sample size increased.

Essentially, the system is based on photographing the individual specimens of Moche art with black-and-white print film. Since the vast majority of Moche art is monochrome or bichrome, it almost always can be adequately recorded without the use of color film. Kodak Plus X and Tri X 35mm film was consistently used, thus making it possible to photograph specimens under a wide range of lighting conditions.

Specimens were photographed from all sides. The number of photographs taken of each specimen depended on the complexity of the iconography—some simple effigy pots required only two or three photographs from various angles, whereas the more complex pieces with fineline drawing required as many as 20 or 30 photographs before they were fully recorded. For one extremely complex design (fig. 2a–c), 108 photographs were necessary to record all of the details.

Notes were taken as the specimens were photographed, recording the museum, catalogue number, height, and any details about the piece which might not be clear from the photographs alone. Any evidence of restoration was recorded in the notes.

In addition to the specimens photographed in museums and private collections, we combed through numerous books, magazines, and catalogues to find published illustrations of Moche art. Similarly, the files of auction galleries and art dealers were searched for photographs. Copies were then made of the photographs from these sources, and the location of the original illustrations was recorded in our notes.

A contact print was made of each negative. These prints were labeled according to the source of the specimen, and all photographs of a single specimen were then taped together. These were sorted into categories according to the object or scene depicted on the specimen. Categories developed as the sorting proceeded—all portrait head bottles formed one category, tule boat representations formed another, anthropomorphized monkeys still another, and so on. Photographs of specimens of a single category

were kept together on stiff pages treated with a friction backing, thus facilitating their removal and placement on other pages if necessary. The pages were then numbered by category, and organized by numerical sequence.

As our sample size increased, many of the original categories were redefined, others were added, and a few were eliminated by sorting the specimens they contained into various of the other existing categories. When the sample included approximately 2,000 specimens, it seemed that there were many unique pieces, thus giving the impression that the art had almost limitless variation in the scenes and objects represented. As the sample size approached 5,000, however, many of the seemingly unique pieces were duplicated many times, thus forming their own category, or, even more often, were found to be merely a variation of one of the already existing categories. With our present sample size of more than 7,000 specimens, we find almost no unique pieces, and the art is clearly limited to the representation of a surprisingly limited number of themes.

The Moche Archive now utilizes 90 categories into which all of the art is divided. Since some specimens have components belonging to two or more of these categories, the categories are cross-referenced so that anyone interested in finding all depictions of a certain category can begin by checking the sheets of that category, as well as each of the other categories in which additional examples might be found. Most of the basic 90 categories have been further sorted into finer sets. Thus, for example, the category of tule boats is divided into those with natural and anthropomorphized boat forms, those with supernatural figures, and those with natural figures.

Since our categories and subcategories are formed by sorting the representations according to subject matter, many of the categories consist of various representations of specific individuals or events. For example, all representations of

iguanas and lizards were originally put into the same category. As more representations were found of each, it became apparent that these could be separated into two categories, and the iguana further subdivided into natural and anthropomorphized representations. When all representations of the anthropomorphized iguana were isolated in this way, the consistency in his costume and in his role suggests that he was a specific figure in the minds of the Moche people, and had a prescribed role and meaning in their ideology. Thus the method of organizing the archive for analysis makes use of the repetitive patterns inherent in Moche art. In this way we are in a better position to understand the world view of the culture that created it.

This system of categories and subcategories has also proven to be a very efficient means of handling the large sample. In most cases, it is possible to obtain all examples of a given theme in a matter of minutes, even though we are dealing with more than 7,000 specimens and perhaps 70,000 photographs.

Since nearly all of the photographs in the archive are contact printed from 35mm negatives, the small size of the prints sometimes makes it difficult to see all of the detail on a given specimen. But it is quite easy to locate the negative for a contact print and make an enlargement from it. We have enlarged the photographs of many of the more complex representations, and these are organized in manila folders according to the categories discussed above.

One other aspect of the Moche Archive, which has proven to be of considerable value in our research, is a file of fineline drawings. Many of the most elaborate Moche fineline drawings have been published as black-and-white drawings. We have made Xerox copies of most of these from publications, and they are filed in three-ring binders according to the categories discussed above. Since we have photographs of the vessels them-

selves, we have in many instances checked the published drawings for accuracy—quite often details of the scenes are either incorrectly reproduced or entirely omitted in the published illustrations.

Because of the large number of specimens in the archive and the wide variety of features that can occur on any one vessel, it has often been suggested that some type of mechanical or computerized system be used for retrieving specimens having a given set of features, or for performing statistical correlations. During the formation of the archive, a serious study was undertaken to see whether an automated system could be developed which would benefit the research effort. For several reasons it was concluded that the development of such a system would not be a wise expenditure of the limited human and monetary resources available to the program. Conversion from a manual to an automated system is only warranted if the labor of converting to the automated system promises to be less than the labor saved by its use. In addition to the effort of developing the system for the archive, at least one man-year would be required for the coding of all the specimens in the present sample. It is doubtful that this investment of labor would be recovered during the use of the system.

Another problem concerns coding. To assure consistency in coding the features on each vessel, it would be necessary to prepare a catalogue with all significant variations of each feature (headdress, face designs, clothing, body positions, etc.). Otherwise it is inevitable that a given feature appearing on different vessels would be coded inconsistently, which would reduce the effectiveness of searches for that feature. Such a catalogue would be nearly impossible to create at the present time, since we are not fully aware of what constitute the *significant* variables of the art. Even after years of research, we are still learning the ways in which Moche artists encoded information through subtle artistic modifications. Until the significant variables are more fully understood, a truly effective catalogue cannot be developed.

Early in the study it was determined that whatever system was used in working with the archive, it should retrieve pictures of the vessels and not just a list of numbers. Otherwise much time and effort would be expended going back to the archive to locate the pictures. Relatively few retrieval systems have this capability. Except for the manual pin-sort card system, those that do are expensive and not readily available. Our repeated manual searches of the archive have produced an invaluable familiarity with the material. Many inadvertent but valuable discoveries have been made during these searches. This familiarity with the material, together with the manner in which the archive is organized, permit very rapid manual searches.

Statistical analyses of the archive are of questionable validity because of the nature of the sample. Nearly all of the specimens in the sample were obtained by the illicit looting of graves, and thus they have little or no provenience data. Moreover, since they were obtained for the purpose of being sold on the art market, the sample has an inordinate number of elaborate pieces that were preserved by the looters as opposed to the more plain forms that are often discarded or destroyed during the looting process. Also, as will be explained below, the archive does not include all specimens of Moche art which exist in collections today. Thus the relative frequencies of representations in the archive are not an accurate reflection of what was originally produced by Moche artists. Since there are very little reliable provenience data for the vast majority of the specimens, statistical analysis by location is virtually impossible.

A few words should be said at this point about the sample size now incorporated in the Moche Archive. In the process of photographing the various collections, published illustrations, and photographic collections, only specimens with

iconography were recorded. Other specimens, such as cooking pots, plain jars, or undecorated objects of metal, wood, or stone were not recorded. Moreover, since there is much repetition in Moche art, particularly in simple representations such as frogs and ducks, once a good sample of these forms was included in the archive, duplicates were not recorded. Thus there are only about 30 samples of modeled ducks in the archive, although probably more than 300 examples were seen in various collections. Since the archive now contains at least one example of nearly every Moche vessel form and decoration, it is not uncommon to get access to a new collection of Moche material and find that only perhaps one specimen in 25 is in any way new and thus warrants being recorded and added to the sample.

Therefore, although the archive now contains more than 7,000 specimens, it actually includes an example of each form and design represented in more than 100,000 Moche specimens in the collections from which it was derived. It is difficult to estimate the percentage of all Moche iconography which this represents. Given the infrequency with which we are now finding forms and designs not already represented in the archive, however, it seems likely that we are approaching a complete inventory of the Moche iconography that is available in the world's collections at the present time. This sample, then, is ideal for the type of analysis discussed at the beginning of this chapter. Nevertheless, additions to the sample are still being searched for, and, when found, are often cause for much excitement. In the years ahead they will bring about modifications in the interpretations we now have of Moche iconography.

III. Moche Art

Although Moche art is widely known and admired, most people are unaware of the full range of its expression, or have not examined enough of it to understand the rules that govern its form. Like all art styles, Moche art is governed by a rather rigid set of rules. An examination of these rules is prerequisite to understanding the iconography.

MEDIA

Perhaps it is best to begin with the media in which Moche iconography is expressed. Certainly the most common medium, and most well known, is ceramic. Well over 90% of the Moche art that

has survived is in this medium, and almost everything that is depicted in any other medium is also shown in ceramic form.[2]

A specific set of techniques was used in ceramic manufacture (see Donnan 1965). Direct modeling, coiling, stamping, and mold making (using two-piece press molds) were used either singly or in combination to build up the objects. They were then slip painted with either red, white, or a combination of red and white slip—multicolored slip designs are almost never found. Firing generally occurred in an oxidizing atmosphere, resulting in a reddish brown or beige paste color. Some of the pieces were deliberately fired in a reducing atmosphere, however, giving the vessel an overall grey to black appearance. Many ceramic objects exhibit a postfire application of organic black pigment that had been painted and subsequently scorched onto

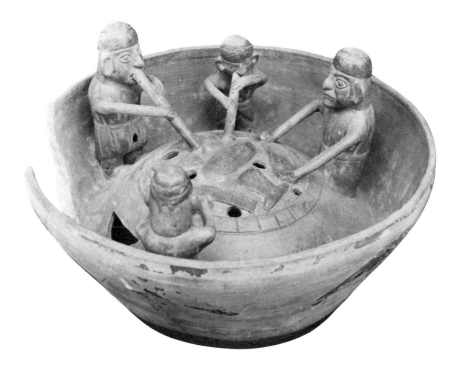

Figure 3. Ceramic bowl depicting metal smelting.

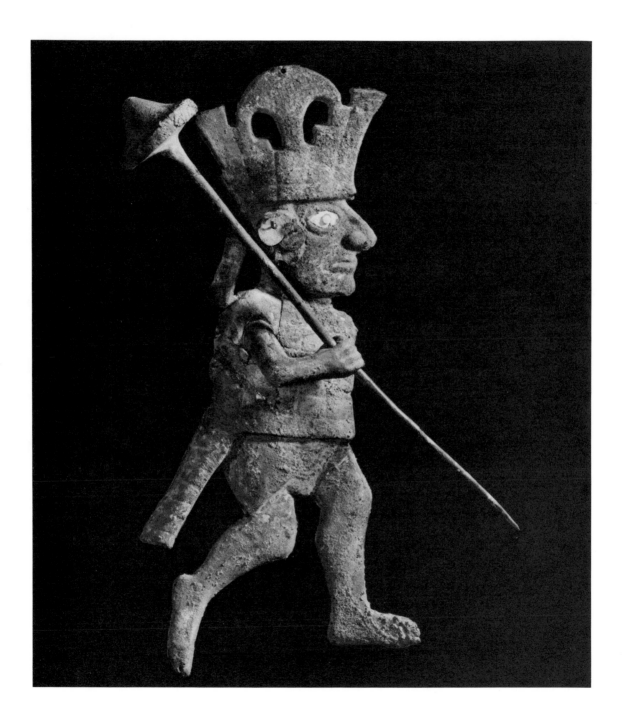

Figure 4. Walking warrior made of hammered sheet metal.

the surface to provide details such as face paint, mustaches, and designs on clothing (color plate 1). Note, however, that this pigment is fugitive—it wears off with persistent handling, and is particularly easy to remove from ceramic objects that have been buried for long periods in moist soil. Undoubtedly many specimens have lost their organic black pigment as a result of careless scrubbing by modern collectors. Thus, many objects that now reveal little or no trace of organic black pigment must have originally been much more ornate.

After ceramics, metal is the most common medium in which Moche art is expressed. Gold, silver, and copper metal were used, as well as alloys of these three in various combinations. A gold-copper alloy, consisting of about one part copper to four parts gold appears to have been most popular, and objects of it were frequently gilded by a depletion technique to give the surface a high concentration of gold. Bronze, the alloy of tin and copper, was not used by Moche craftsmen.

Metalworking was done with a simple furnace (fig. 3) in which the forced draft of air was provided by blowtubes (see Donnan 1973a). Artistic representations were created primarily in sheet metal, which was worked by hammering and annealing, repoussé, cutting, crimping, and incising (fig. 4). Often two or more of these techniques were used in combination. There are a few metal objects made with a lost wax casting technique, and in some instances the casting was done around a friable core. Cast objects are quite rare in the sample of Moche metal, but those that do exist reflect a high degree of skill, and complete mastery of casting techniques (fig. 5).

Textiles comprise another major medium for artistic expression. Unfortunately, our sample of Moche textiles is limited owing to a lack of preservation, but those that do survive demonstrate a fully developed textile art in which complex and detailed iconography is often expressed (Ubbelohde-Doering 1967:70–74). The primary weaving technique for artistic expression is tapestry, with

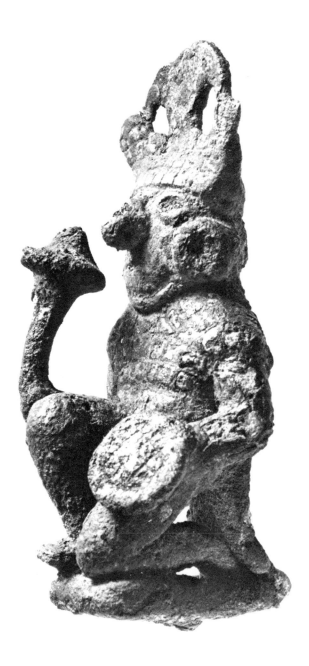

Figure 5. Kneeling warrior of cast metal (height 5.7 cm).

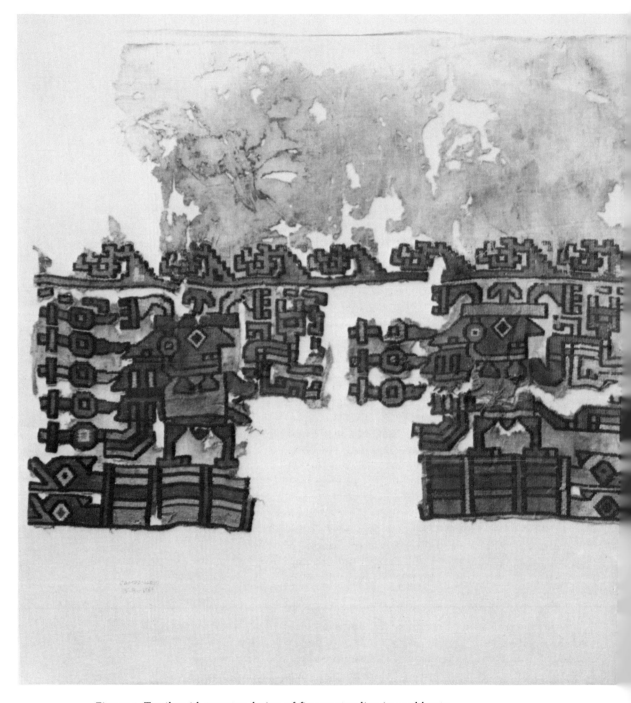

Figure 6. Textile with tapestry design of figures standing in reed boats.

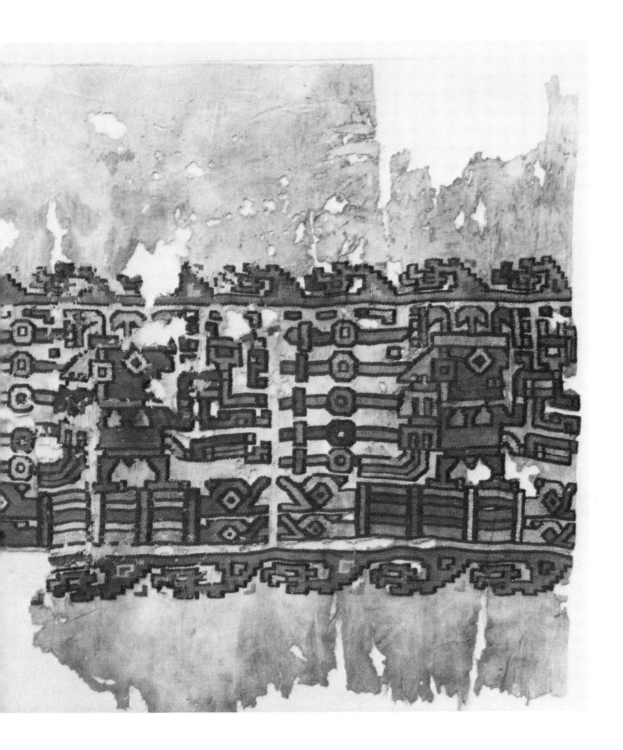

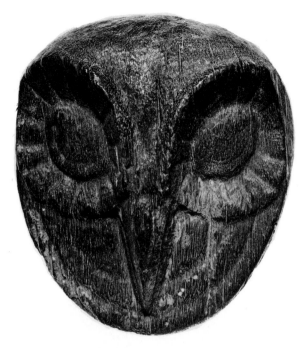

Figure 7. Owl head of carved wood (height 13.5 cm).

rendered in low relief and painted with mineral pigment. Examples of these are to be seen at the sites of Lipaca and Huaca del Brujo in the Chicama Valley.

Moche iconography is also expressed, to a lesser degree, in the carving of bone, stone, and wood (fig. 7 and color plate 3). Considerable skill is reflected in the treatment of each of these media. They are generally worked in the full round, with details added by incision and inlay.

Inlay is widely used in expressing artistic detail in Moche art. Small pieces of stone, shell, and metal are carefully shaped, and subsequently cemented into place with a vegetable resin. In addition to inlaying bone, stone, and wooden objects, metal, ceramic, and shell objects are frequently elaborated in this way (color plates 3 and 6b).

Moche craftsmen pyroengraved gourds with complex designs. Excavation of refuse from Moche habitation sites yields numerous fragments of gourd containers, thus demonstrating that they were widely used in daily life. Bowls, cups, and low plates are the most common forms (Donnan 1973b:105–107). In some instances these vessels have simple geometric designs, or complex designs such as that shown in figure 8.

Another medium of artistic expression that has been recovered, though rarely, is tattooing the human body. The best example of tattooing was reported by Ubbelohde-Doering from an elaborate Moche tomb he excavated at Pacatnamú (Ubbelohde-Doering 1967:30, 76, 77). The forearms of the individual had been tattooed with a design consisting of a procession of lizards and anthropomorphized animal figures. Other evidence for tattoo (or scarification) comes from the art itself, where human forearms and faces often are decorated with detailed designs (fig. 9).

In addition to the media mentioned above, for which there are varying degrees of evidence in the archaeological record, there are two media that might have been used by Moche artists. These are body paint (primarily on the face) and featherwork.

cotton warps and multicolored wool wefts (fig. 6). Embroidery of wool thread on a cotton fabric is also found, and may have been a popular technique for creating designs. Depictions of designs on clothing worn by some ceramic figures suggest that tie-dyeing and the attachment of metal discs may have also been a prevalent means of elaborating Moche textiles.

Murals elaborating the walls of Moche structures have been reported from many areas of the north coast. The majority of these, and certainly the most significant in terms of iconographic detail, are those rendered in incised line and polychrome pigment on plastered surfaces (color plates 2a and 2b). The most important of these are the murals at Pañamarca (Schaedel 1951; Bonavia 1959), Moche (Kroeber 1930), and Batan Grande (Donnan 1972). Other murals that may have been made by Moche craftsmen are geometric and zoomorphic forms

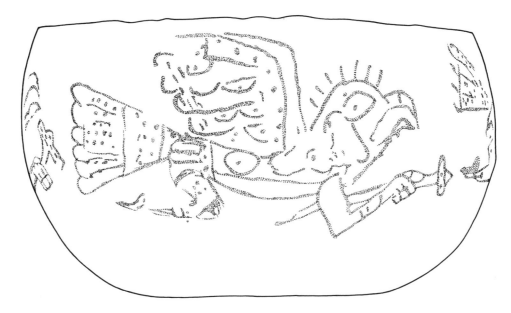

Figure 8. Pyroengraved gourd with design of bird warriors.

From the art it is apparent that many of the figures wore body paint. Excavation of Moche graves often reveals the presence of red mineral pigment adjacent to parts of the body. Unfortunately, however, this is not sufficiently preserved for recognition of the designs on the body. In some instances these designs may have been sufficiently complex to be important to the study of Moche iconography. The same is true with featherwork, which was quite possibly elaborate, but for which almost nothing remains.

Within the various media of Moche art, depiction can be carried out in one or a combination of three artistic forms: two-dimensional representation, low relief sculpture, and sculpture in the full round. Each of these artistic forms has its own set of rules that govern the way in which elements are depicted. But the rules do not change from one medium to another. Thus, a two-dimen-

sional human figure shown in slip paint on the surface of a ceramic jar is almost identical to the same figure incised in sheet metal, painted in mural form on the wall of a structure, woven into a textile, or tattooed in human flesh. Similarly, a three-dimensional representation of an owl warrior cast in metal is strikingly similar to the same figure modeled in clay, or carved in wood, stone, or bone. The specific canons of art, which are followed regardless of the media being used, are what unify Moche iconography and allow us to deal with it as a unit for purposes of analysis. We now turn to an examination of these canons.

CANONS

The most obvious feature of Moche art is its high degree of naturalism. As is demonstrated in

subsequent sections, nearly all of the objects shown have a direct relationship to items that were visible in the immediate environment in which Moche artists lived and worked. Even the fantastic supernatural creatures that are depicted can be seen as composites of parts derived from objects visible in the artist's environment. Transforming these visible objects into the characteristic form they assume in Moche art involves a rather specific set of rules that were followed by artists working in all the various media.

Scale. With very few exceptions, when Moche artists depicted an object, the depiction was between 1 and 30 centimeters high, and the vast majority of the depictions are between 5 and 20 centimeters high. Thus, if the artist set out to create a three-dimensional sculpture of a bird, a standing figure, or a single human head, the final product, no matter what medium was used, would almost always be between 5 and 20 centimeters high. The same is true of figures shown in two-dimensional form or low relief. Most of the objects on which the iconography is expressed are also within this size range. Objects that are larger, such as textiles or large ceramic vessels, are decorated either by leaving a wide margin around a figure or by filling the design area with multiple figures. Either way, the figures themselves are within the 5- to 20-centimeter size range. The only exception is in polychrome murals, such as those at Pañamarca (color plate 2*b*) where the height of some figures is as much as 120 centimeters. Nevertheless, there is nothing in Moche art resembling colossal stone carving, huge sculptured ceramic urns, or life-size metal statuary. One result of this limited size range is that almost everything is shown smaller than

Figure 9. Seated figure with serpent design on his face.

life size. Another is that most of the art is easily portable—a feature that is likely to have played a significant role in the similarity of Moche art throughout the area of its distribution.

Relative size. Moche artists often depict more than one figure in a single design. When this is done, the relative size of figures, such as men and deer, or deer and dogs, generally conforms to natural scale. If something is anthropomorphized, it usually is depicted at human size. Mountains, houses, and large trees are the only objects that are reduced in size relative to the other objects shown in a single representation.

If more than one deer, seal, or other creature is shown in a design, all the animals of one kind are normally shown the same size. This is also true for human and anthropomorphized figures. There are, however, three exceptions to this norm. The first involves ceramic vessels decorated with fineline design which have a spiral composition. On these vessels the first figure at the base of the chamber is smaller than the others (fig. 10). Second, there are some instances where depth of field is indicated by small figures in the upper portion of the scene (fig. 11). The third, and perhaps most common of the exceptions, are scenes where differential size of the figures is used to indicate status. Such is the case in many of the ceremonial scenes, where the most important figure is the largest, warriors slightly smaller, people bearing food still smaller, and background figures the smallest (see fig. 104, below).

Depiction of humans or anthropomorphized creatures involves a standard enlargement of the hands and heads. Sexual organs may also be enlarged for emphasis, although normally they are

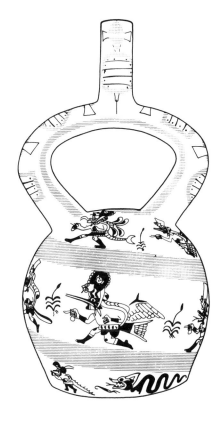

Figure 10. Stirrup spout bottle with spiraling design of running figures.

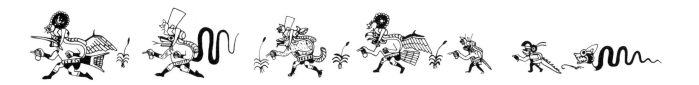

small relative to the size of the body, or are simply not indicated.

Perspective. When Moche artists chose to reproduce an object in three-dimensional sculpture they clearly made an effort to portray it as accurately as possible. Certain distortions were standard, such as the enlarging of the hands and head on most figures, but the objects shown are portrayed in natural perspective and are quite easy to identify.

Rendering an object in two-dimensional form or low relief involved greater distortion, but this distortion followed a specific set of artistic conventions. Fortunately, many subjects shown in two-dimension and low relief are also shown in three-dimensional sculpture, and thus the two can be compared to factor out the artistic conventions involved in translating a depiction from three dimensions to two.

Two-dimensional and low relief representations of human and anthropomorphized creatures are basically a combination of profile and frontal views; three-quarter and oblique views do not occur. Arms and legs are always shown in profile. Heads are almost always shown in profile, as are most representations of feet. The torso, eye, and hands are shown frontal. The representation of hands is frequently distorted, however, because the fingers are often clenched; yet fingers on both hands are shown as though bent toward the viewer. Since this is combined with the custom of showing the thumb at the top of the hand, the figures often appear to have two right or two left hands rather than one of each (fig. 11).

Objects that are thin and flat will be turned 90° so as to appear frontal, presumably to make them more immediately recognizable to the viewer. Thus headdress ornaments, nose and ear ornaments, and strap-handled bags are generally turned 90°. This practice extends to other objects as well. A star-shaped mace, for example, will have the handle shown in profile, but the mace head turned 90° to make it recognizable (see fig. 22, below).

In depicting nonhuman creatures in two dimensions and low relief, Moche artists adhered much more strictly to profile view. The eye, however, is still turned to appear in frontal view, as are the whiskers of most animals. The bill of the Muscovy duck is particularly interesting in that it is shown in top view while the head is shown in profile.

There is a set of nonhuman creatures that differ from all others in being shown from the top rather than profile—presumably to show them from the most recognizable view. These include the crab, spider, catfish, octopus, ray, and centipede. Also included is the snake, shown without ears, as opposed to the serpent, which is a snakelike creature with ears.

Four of these creatures, the crab, octopus, spider, and ray are often anthropomorphized in an unusual way. Since they do not have a clearly discernible head that is separate from their bodies, a human head may be added and thus they are sometimes shown with two faces, one on the body and the other on the additional human head (fig. 12).

Plants in two-dimensional representation are shown in profile, with one notable exception—on a flowering plant that often occurs in marsh scenes, the blossoming flower is shown top view (fig. 13).

Depth of field. In two-dimensional and low relief representations Moche artists used specific conventions for establishing depth of field. Whereas Western art usually employs overlay, shading, and diminishing size toward a fixed vanishing point to create an illusion of depth, Moche art does not utilize any of these conventions. Instead, depth of field is rendered by two techniques. The first involves depicting small figures or objects in the upper portion of a scene so that they appear to be in the distance. Very often this is either a single figure (fig. 14), a small structure that may or may not have a figure inside (figs. 14 and 15) or a series of figures in mountains (fig. 11). The second technique is to divide a scene into two or more horizontal panels, each containing a set of figures. The

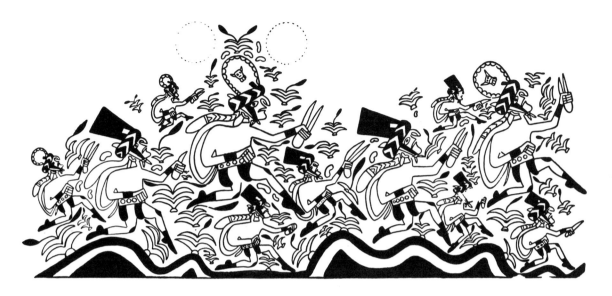

Figure 11. Running figures.

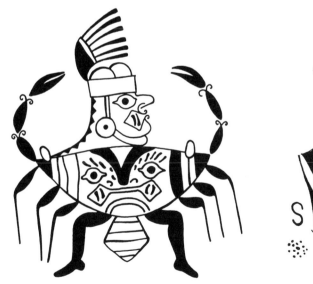

Figure 12. Anthropomorphized crab.

Figure 13. Marsh scene.

Figure 14. Stirrup spout bottle with modeled and painted depiction of sea lion hunting.

Figure 15. Arraignment of prisoners.

individual panels represent distinct two-dimensional horizontal planes at varying distances from the viewer (figs. 15, 22, and 105). In the scene shown in figure 22 (below), for example, the field of combat has been divided into two planes, each represented by one of the horizontal panels. Rather than representing the warriors in the background either smaller than or placed behind those in the foreground, they are simply brought forward and shown in a distinct horizontal panel.

Pose and action. Moche artists render specific portions of the body in certain ways to relay information about the subject. The following conventions are nearly universal in human and anthropomorphized figures:

1. Variations in the position of the feet and legs specify motion or lack of it. Thus by slightly altering the distance between the feet, figures are made to stand, walk, run, or dance. By bending the legs under the torso, a figure is made to sit, without necessitating a corresponding alteration of the rest of the body.

2. Variations in hand and arm position specify action. Thus the figure can be shown grasping, hitting, throwing, pulling, and so on, by simply changing the position of the arm and hands, again with no alteration necessarily taking place in the rest of the body.

3. Variation in the position of the torso indicates speed, falling, or death. Thus a running figure is given speed by tilting the body forward, and figures knocked off balance or falling are indicated by tilting the torso either forward or back. Death is often indicated by simply turning a figure horizontal or upside down and splaying the arms and legs.

4. Variation in head position can indicate mood. Figures with their heads turned back while the body moves forward are often in flight, and presumably in fear.

Sex differentiation. It is very difficult to define accurately the sex of figures in Moche art, and in most instances it should not be attempted. At one point in our research we began to rely on

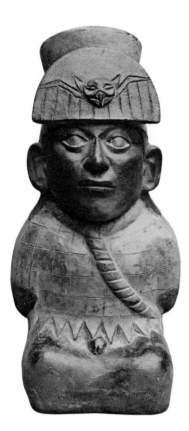 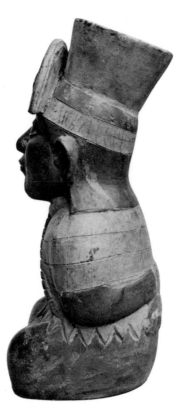

Figure 16. Jar modeled in the form of a seated prisoner (three views).

the presence of ear ornaments as the exclusive property of males, and long braided hair as the exclusive property of females. Eventually, however, as additional examples of the art were accumulated, exceptions were found to each of these conventions, thus rendering them unreliable as sex determinants in any specific case. More recently we began to consider leg paint, and particularly the knee spot, as occurring only on male figures in the sample. A possible exception to this rule, how-

ever, is the scene shown in figure 1 which depicts two individuals having intercourse inside a structure. In one variant of this scene (fig. 1c), the figure on the bottom (generally considered to be a female) is shown with leg paint in the form of a knee spot. If this figure is female, then obviously knee spots should not be used to identify males within the sample. In practice, therefore, it seems best to identify the sex of a figure only when the genitals are clearly depicted.

With regard to animals, only the deer can be identified as male or female, since male deer are shown with male genitals and antlers, whereas female deer lack both.

Status. Status of human and anthropomorphized figures is indicated by a variety of artistic conventions, most of which are probably derived from actual status indicators used in Moche society. High status may be shown by having a figure dressed in elaborate clothing, accompanied by a live feline, sitting on a raised platform, or transported in a litter that is carried on the shoulders of individuals of lower status. Also, as mentioned above, status is reflected in the relative size of figures in the same scene, with individuals of high status shown noticeably larger than others.

Low status is indicated by the absence of status indicators listed above. Relatively simple clothing is worn by low status individuals, and they are often engaged in menial tasks.

Dignity. Scenes that depict combat and treatment of prisoners suggest that there may be a set of canons indicating loss of dignity. As with the canons reflecting status, these are probably derived from practices in Moche society. Vanquished opponents often are shown with their clothing removed, ropes put around their necks, their hands tied behind their backs, blood flowing from their noses, or being held by the hair. A figure with one or a combination of these features is presumably losing dignity, although he may or may not also have lost status. Thus it is possible for a figure to maintain his high status by having elaborate clothing (fig. 16) or being carried in a litter (fig. 15) while at the same time experiencing a loss of dignity.

A corollary of these canons is that in combat, if any of the above features are happening to an individual, he is losing the conflict, and if they have occurred, he has lost. Thus, an individual having his clothing removed is losing a battle—if his clothing has been removed, he has lost.

Identification of species. With the great variety of life forms illustrated in Moche art, it is important to identify the species of a creature whenever possible. Various attempts have been made to identify species in Moche art (Larco 1938–1939; Lavallée 1970), but these did not account for all the representations of a given creature, and were not explicit about the characteristics that can be used to identify it consistently.

We have been able to identify the following species because of the consistent manner in which they are depicted. It is by no means a complete inventory, since it purposely does not include those that are unidentifiable, nor those whose representation is so variable as to preclude their identification by means of specific characteristics. The characteristics noted below can generally be relied upon to provide precise identifications, and are applicable whether a creature is shown in natural form or is anthropomorphized.

Felines consistently have ears that point forward, and a straight tongue that goes forward. They may or may not have pelage markings and whiskers, and the tail can curve either up or down. They normally have clawed feet, and are frequently anthropomorphized.

Foxes have ears that point back, and a straight tongue that goes forward. They may or may not have whiskers. The tail is almost always divided along its length into two colors. The tail goes straight back or curves up, but never curves down. Foxes do not have pelage markings and are frequently anthropomorphized.

Dogs have ears that point up, and a tail that curves up. They are almost always spotted, but the spots are larger than those of the feline. They are almost never anthropomorphized.

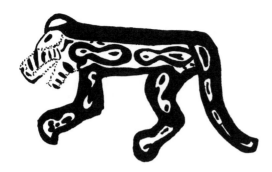

Feline

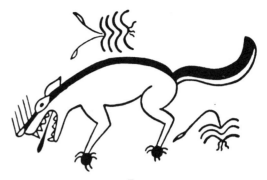

Fox

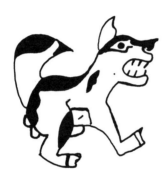

Dog

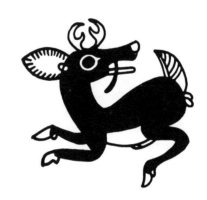

Deer

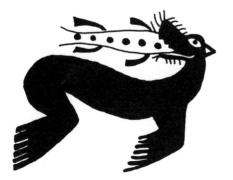
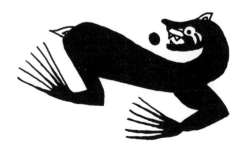

Sea lions

Deer are consistently shown with the tongue out the side of the mouth, large diamond-shaped ears (often with leaflike veins), and cloven hoofs. They have a short tail that consistently turns up. The tail is frequently elaborated with a line pattern. A male deer is shown, with both antlers and male genitals, but a female is shown with neither.

Sea lions can be recognized by their fins, and small ears that often point back or down. They almost always have a ball-like object or a fish in front of or in their mouths.

Llamas are similar to deer in having a cloven hoof, but can be distinguished by having a burden on their backs and either halters over their heads, or ropes through their ears or around their necks. They have short tails that consistently turn down. They also have pointed ears and may or may not have spots.

Monkeys are shown with a long tail of a single color which is almost invariably curved under rather than up. Their tongues project forward, and they sometimes wear earrings (they are the only animals that do so when shown in their natural form).

Iguana are almost always anthropomorphized. Their faces have a pointed muzzle and are usually lined. The upper side of their tails is almost always serrated. When anthropomorphized, they usually wear a burden bag around the waist and have a bird incorporated in their headdress.

Bonito are clearly distinguishable by having extremely large fins that are serrated on both edges and a serrated tail.

Barracuda are depicted with a thin, curving body shown from above and a head and tail shown in profile.

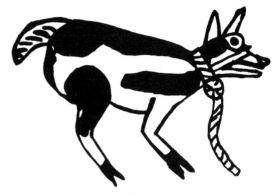

Llama

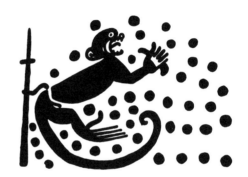

Monkey

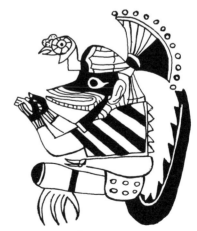

Iguana

Bonito

Barracuda

Catfish

Hummingbird

Catfish are depicted with a thin, curving body and a triangular-shaped head shown from above.

Hummingbirds can be distinguished from all other birds because of their thin split tail and a long beak that is straight or gently curved and pointed.

Muscovy ducks have their bills turned 90° so that they are shown in top view while the rest of the figure, including the head, is shown in profile.

Dragonflies have two or more long ellipsoid wings and generally have two antennae that are characteristic of insects. Each of the two antennae curls inward, as opposed to the bifurcated tongue of the lizard which curls outward.

Spiders are represented from top view with segmented bodies. The mouth is indicated as a slit that starts at the top of the head. They may or may not have small curved antennae. There are always more than five legs, although the total number varies considerably.

Crabs are represented from top view and have a combination of legs and claws that radiate from the body.

Crayfish are shown with a curved body and a fan-shaped tail. They have long, flowing antennae and may or may not be shown with claws.

Centipedes are shown from top view, with numerous legs projecting out from each side of the body. They usually have two antennae in the shape characteristic of insects; each antenna curls inward.

Lizards are shown with a long thin tail that generally curves down and a face with a pointed muzzle. The tongue is bifurcated when it is shown, with the two ends curving outward. In contrast

Muscovy duck

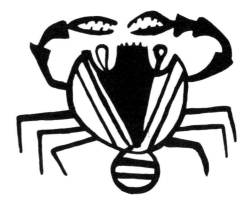

Crab

Dragonfly

Crayfish

Spider

Centipede

Lizard

Octopus

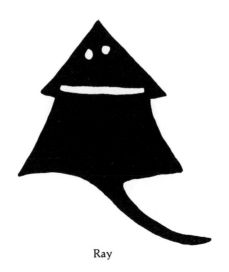

Ray

to the iguana, the lizard does not have serrations on its tail. Lizards are frequently shown in association with the seed pod of the *algarroba* tree.

Octopuses are shown from top view, with numerous curved tentacles radiating from a circular body. The tentacles sometimes have dots or bumps on the inner part of the curve to indicate the suction pads.

Rays are shown from top view, with a pointed tail projecting from the base of a triangular-shaped body.

THE MOCHE ARTIST

In the course of our analysis of a large sample of Moche ceramics, we began to recognize specimens that were so similar as to appear to be the work of a single artist. Although the instances are few, they offer some good insights into the nature of the artistic production.

There are essentially two criteria involved in recognizing the work of a single artist: (1) that the specimens reflect a high degree of *similarity* with one another, and (2) that the specimens are clearly *dissimilar* to the rest of the sample. The second criterion is crucial to the methodology, for in identifying the work of a given artist, it is not enough that certain pieces are similar to each other; they must also be distinctive within the overall style. To satisfy this second criterion, a large sample is needed, for only then can the full range of variation be appreciated.

Two specimens with identical forms are not necessarily the work of a single artist. Moche ceramic production involved the use of molds, and there is reason to believe that duplicate molds existed for creating some vessels. Thus different potters could produce vessels of identical form by either sharing one set of molds, or working independently with their own set of molds. If, however,

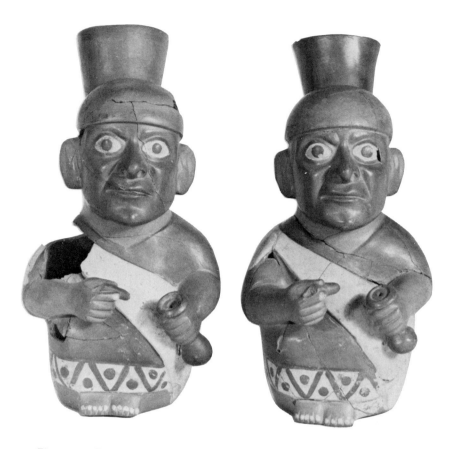

Figure 17. Two jars, each modeled in the form of a figure chewing coca leaves and holding a lime gourd and spatula. These jars were almost certainly made by the same potter.

vessels of identical form are made of the same clay and slip, burnished in the same way, and reflect a similar firing process, the likelihood that they were made by the same artist is greatly increased. If, in addition, the vessels were found in association—in the same grave, for example—there is further reason to believe that they are from the hand of the same artist. Such is the case with the pair of jars illustrated in figure 17, which were found in the same grave at the Pyramids at Moche. Many duplicates of rather simple vessels have been found in this way, suggesting that they may have been produced in great numbers. Some rather elaborately modeled specimens have also been found with duplicates. The true masterpieces of Moche art, however, including the most elaborate sculptural forms, are generally unique pieces, and it is seldom that two or more of them can be

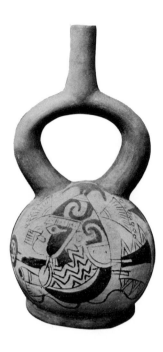

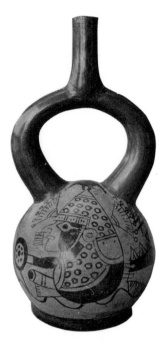

Figure 18. Stirrup spout bottle with fineline drawing of an anthropomorphized bean warrior.

Figure 19. Stirrup spout bottle with fineline drawing of an anthropomorphized bean warrior almost certainly painted by same artist as the vessel opposite.

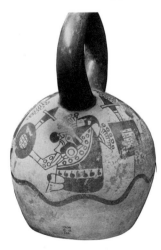

Figure 20. Stirrup spout bottle with fineline drawing of an anthropomorphized bean warrior almost certainly not painted by the artist who painted the vessels above.

identified as the work of a single artist. Moreover, it is extremely difficult to recognize the work of a given artist when the sculptural forms are not identical. For example, it is difficult to find instances of a modeled frog and modeled duck, or a standing figure and a house model, which are clearly the work of a single artist.

In contrast, fineline drawing offers a particularly good opportunity to recognize the work of a single artist. There are several instances where two or more drawings share so many characteristics that they are almost certainly from the hand of a single painter. A rather simple example of this is illustrated in figures 18, 19, and 20. Although all three vessels have similar designs painted on the chambers of stirrup spout bottles, the first two (figs. 18 and 19) are clearly painted by the same artist, while the third (fig. 20) is the work of someone else. The criteria that best reflect this are the shape of the chin, nose, mouth, and upper leg, the degree of bend in the arm, the circles and lines on the upper leg, and the manner of representing the tassels on the helmet. The overall posture of the body, the degree of curve in its depiction, and the relative size of the head and torso are also valuable criteria. These features reflect a basic approach to the layout and execution of the painting, and tend to be related to individual mannerism rather than dependent on the requirements of the depiction. In contrast, features such as the basic form of the nose ornament, designs on the garments, and the presence or absence of the backflap are of less value in recognizing the work of a single artist, since these features often depend on the details of what is being represented rather than on the individual style of the painter.

It is interesting how similar the vessels are in the first two examples (figs. 18 and 19). The form of the chamber, the presence of the ring base, and subtle details of the shape and contour of the spout all suggest that these vessels were probably made by the same potter. It is, of course, impossible to say whether the potter and painter are the same individual, although this is quite possible. Alternatively, the potter and painter may be two individuals working together in a single shop.

Figures 21 and 22 illustrate another pair of vessels that were almost certainly painted by the same artist. Again it is the similarity in anatomical features of the figures that provides the best evidence. The forms of the eyes, nose, and hands are particularly diagnostic.

Whereas the previous pair (figs. 18 and 19) had a similar layout of the design, this pair demonstrates two distinct variations of layout—one having five large figures extending over the full height of the vessel wall, and the other with multiple figures positioned on two horizontal panels.

The two chamber forms are also quite different. One has a ring base and seated figure modeled on top of the chamber, while the other lacks both of these features. Unfortunately, the stirrup spout on figure 21 has been repaired and its original form is not known. Thus comparisons cannot be made between the two spouts to determine whether or not they may have been made by the same potter. Nevertheless, it is clear from these two specimens that individual Moche artists painted distinct forms of stirrup spout bottles, rather than painting only on a single form.

A third pair of vessels painted by a single artist is shown in figures 23 and 24. This pair is of particular interest because it demonstrates that certain artists painting stirrup spout bottles also painted completely different vessel forms, in this instance a flaring bowl. Moreover, this pair demonstrates that a single painter depicted various themes, and did not merely repeat the same type of design on all vessels.

These instances of specimens that appear to be the work of individual artists are but a few of the examples that can be identified. They suggest that the artists were highly skilled, probably full-time craftsmen who, though working within the stan-

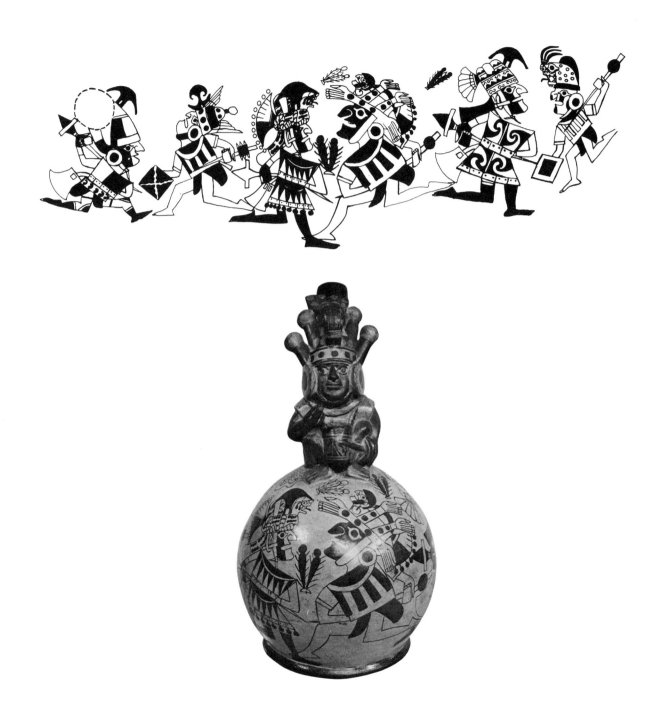

Figure 21. Stirrup spout bottle with modeled figure, and fineline drawing of combat.

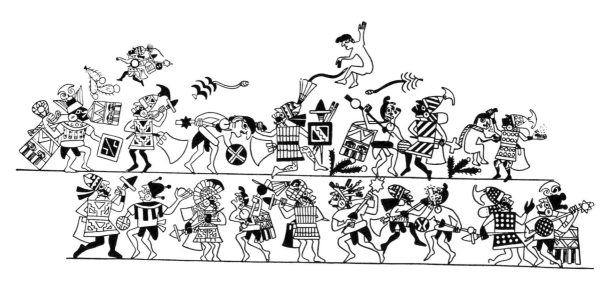

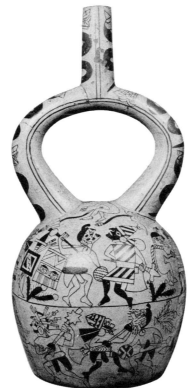

Figure 22. Stirrup spout bottle with fineline drawing of combat.

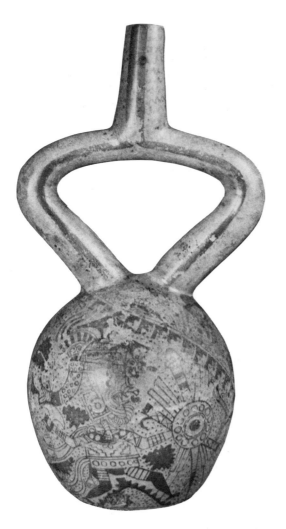

dard canons of Moche art, enjoyed some idiosyncratic variation. If the artists were affiliated with specific workshops, then these workshops almost certainly engaged in the production of a wide range of vessel forms rather than specializing in a single form. That the work of certain artists can be recognized today suggests that the Moche people also were able to identify the work of specific individuals. Perhaps they had certain artists whose work was highly revered, and who had considerable influence over their contemporaries as well as the artists of subsequent generations.

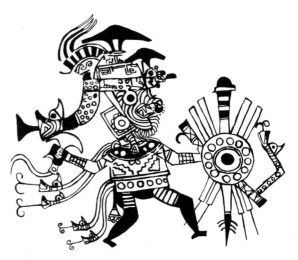

Figure 23. Stirrup spout bottle (left) with fineline drawing of a supernatural warrior (above).

40

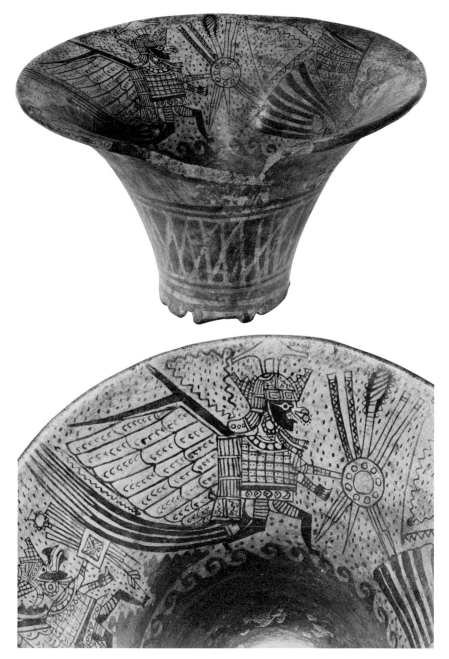

Figure 24. Flaring bowl with fineline drawing of supernatural warriors, and detail of same drawing.

41

IV. Chronology

Basic to understanding the iconography of Moche art is a clear understanding of its chronology. The absolute chronology for the Moche style is difficult to define precisely. There are very few radiocarbon dates from organic material associated with Moche artifacts, and most of these pertain to the middle part of the Moche sequence. Since there are almost no radiocarbon dates for the earliest and latest parts of the sequence, dates for the beginning and end of the sequence must be derived by noting the relative contemporaneity of the Moche style with other styles in the Andean area whose absolute chronologies are known. On this basis it would appear that the Moche style had its origin sometime after the end of the Chavin style, presumably in the last 200 years before the beginning of the Christian era. Since Huari style material was introduced in the north coast of Peru near the end of the Moche sequence, this must have occurred sometime around A.D. 650 to 750.

It is possible to subdivide the Moche style into five sequential phases. These are defined on the basis of changes in Moche ceramics. The division into five phases was first proposed by Rafael Larco in 1948. Although the evidence supporting the five-part division was never published, Larco stated that it was based on stratigraphic superposition of burials within a single cemetery, as well as analysis of the material associated in individual burials. He observed that the ceramic vessels from a single grave have certain features in common— most notably the form of the stirrup spout bottle and, in particular, the subtle changes that take place in the upper portion of the stirrup spout. Larco's seriation also suggested some changes that take place in the chamber form of stirrup spout vessels. Since he did not specify the diagnostic features of his five phases, nor provide the evidence on which his chronology was based, his scheme was not widely accepted nor used by other scholars working with Moche material. Subsequent research, however, has verified Larco's sequence and has shown the way in which objects other than stirrup spout bottles can be assigned to one or another of his five phases.

Even now, evidence on which the Moche chronology is based is quite limited. Among the best available evidence is the collection of 31 gravelots excavated by Max Uhle in 1899 from the Pyramids of Moche in the Moche Valley. In addition, there are a few gravelots excavated by Ubbelohde-Doering in the Pacasmayo Valley during the 1930s (Ubbelohde-Doering 1967), several gravelots excavated during the Virú Valley project of the 1940s (Strong and Evans 1952), seven gravelots excavated by Donnan in the Santa Valley in 1965 and 1966 (Donnan 1973b:50–52), and approximately 45 gravelots excavated by various Peruvian and American archaeologists working in the Moche Valley from 1962 until the present (Donnan and Mackey MS). These gravelots—less than 100 in number—constitute the most significant data now available for dividing the Moche style into a sequence of phases. Although these gravelots come from several valleys on the north coast of Peru, by far the greatest number are from the Moche Valley. Some valleys are represented by only a few gravelots, and there are no gravelot associations presently available from others. Therefore, although there undoubtedly were differences between the Moche pottery from one valley and that from another at any given point in time, our sample does not allow us to document such geographic differences. Moreover, since the chronological differences that we now assume to be characteristic of the five phases of the Moche style are largely based on gravelot associations from the Moche Valley alone, they may not prove to be valid for other valleys of the north coast. This is particularly likely for the earliest part of the sequence, Phases I and II, and for the end of the sequence in Phase V.

Let us now turn to an examination of those features that allow us to identify Moche ceramics by phase. Our comments here are restricted to those forms on which complex iconography appears, and do not deal with changes in simple undecorated vessel forms such as storage and cooking vessels.

STIRRUP SPOUT BOTTLE

This is the vessel form most commonly elaborated with complex iconography, and it is fortunate therefore that it is among the easiest of the vessel forms to identify by phase. The upper portion of the stirrup spout is the best means of identifying the phase of a given bottle, and this can be done according to criteria used by Larco (fig. 25). Spouts of Phase I are short and rather thick, with a pronounced lip at the rim. In Phase II the short thick form of the spout is maintained, but there is a considerable reduction in the lip. In Phase III the spout has a pronounced flaring contour. Although a few spouts maintain a slight trace of the earlier lip, it is no longer apparent in most examples. In Phase IV the spout is taller than in any of the previous phases, and is parallel sided. It is also thinned from the inside on the upper portion of the lip rather than having the square cross section that was characteristic of the previous phases. Finally, in Phase V, the spout has a height similar to that of Phases I, II, and III, but is tapered toward the top. Like the Phase IV spout, it is thinned from the inside near the lip.

In addition to the form of the stirrup spout, the chamber form can often be used to determine the phase of a given specimen. There are several chamber forms characteristic of specific phases within the sequence. These are illustrated in figures 26 through 30.

SPOUT AND HANDLE BOTTLE

Another vessel form on which complex iconography frequently occurs is the spout and handle bottle. It is characterized by a hollow chamber with a straight spout and a solid handle that is connected to the spout at one end and to the chamber at the other. Almost all spout and handle bottles are from Phase IV and have chamber forms similar to the stirrup spout bottles of this phase. They also have very tall parallel-sided spouts that are thinned from the inside. There are a few spout and handle bottles from Phases II and V. They are characterized by spout and chamber forms similar to those on the stirrup spout bottles of these phases (fig. 31).

DIPPER

This vessel form is characterized by an oblate, neckless chamber with a large, horn-shaped handle extending horizontally from one side at about the midpoint. Dippers are often referred to as "corn poppers" in the literature, but since they were not made to be used over a fire, this could not have been their function. There are no dippers presently known to be of Phases I, II or V, although dippers are fairly common in Phases III and IV. A Phase III dipper is easily recognized, since its design is normally painted on the upper portion of the chamber. In contrast, Phase IV dippers have designs painted on the lower portion of their chambers (fig. 31).

FLARING BOWL

Flaring bowls are deep open vessels with sides that flare outward from the base. All flaring bowls can be attributed to Phases III, IV, or V with the majority of examples being of Phases III and IV. It is often difficult to distinguish between the flaring bowls of one or another of these phases on the basis of shape characteristics alone. Nevertheless, through time there is a general shift in form (fig. 32). Flaring bowls of Phase III are relatively wide at the base and straight sided in the lower part with only a slight flare toward the upper portion of the rim. In Phase IV they have a some-

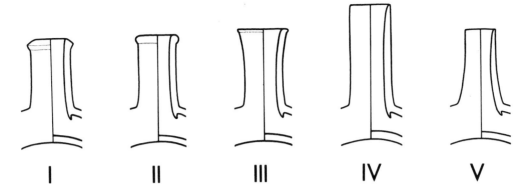

Figure 25. Characteristic spout forms for stirrup spout bottles, Phases I through V.

Figure 26. Characteristic forms of stirrup spout bottles in Phase I.

Figure 27. Characteristic forms of stirrup spout bottles in Phase II.

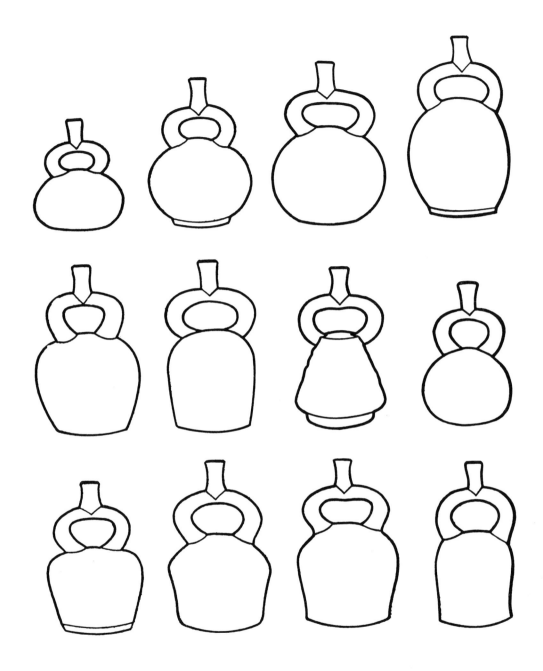

Figure 28a. Characteristic forms of stirrup spout bottles in Phase III.

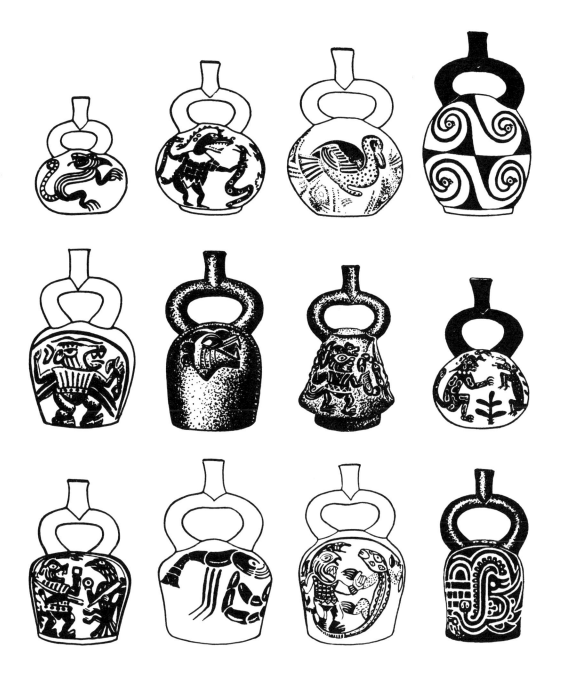

Figure 28b. Characteristic decorations of stirrup spout bottles in Phase III.

47

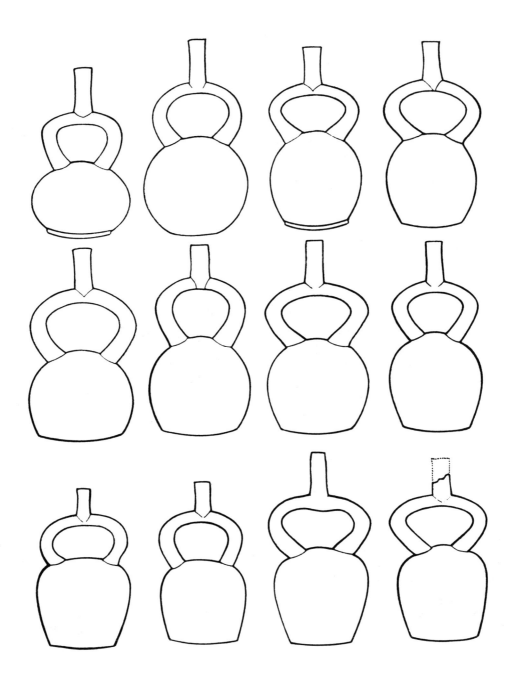

Figure 29a. Characteristic forms of stirrup spout bottles in Phase IV.

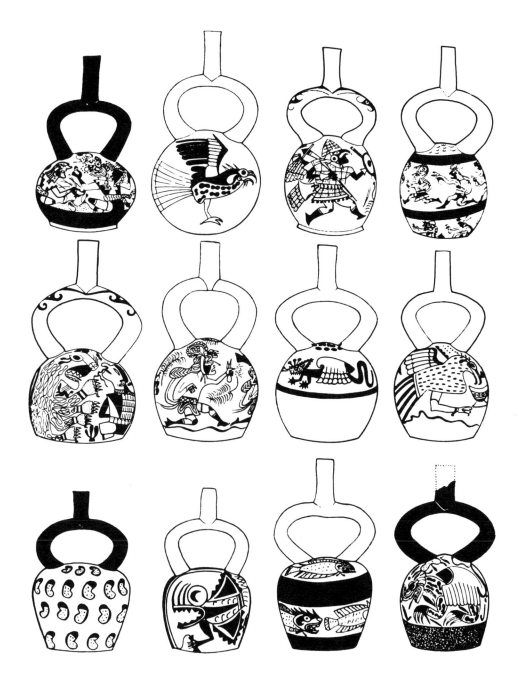

Figure 29b. Characteristic decorations of stirrup spout bottles in Phase IV.

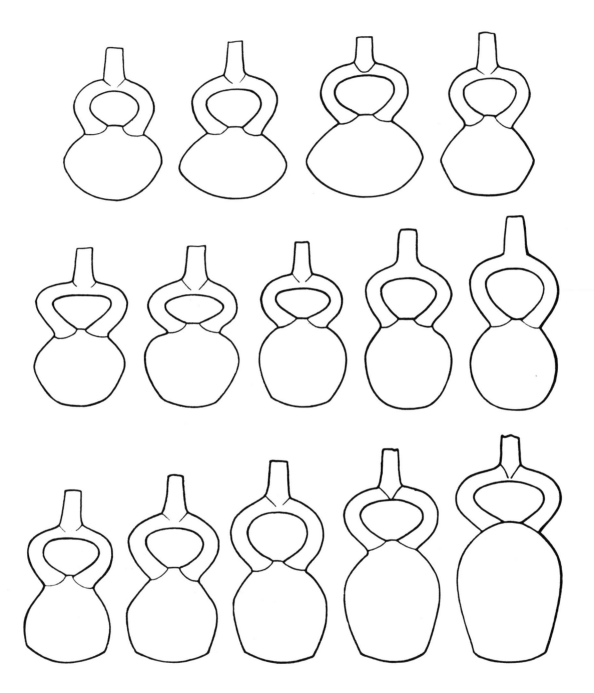

Figure 30a. Characteristic forms of stirrup spout bottles in Phase V.

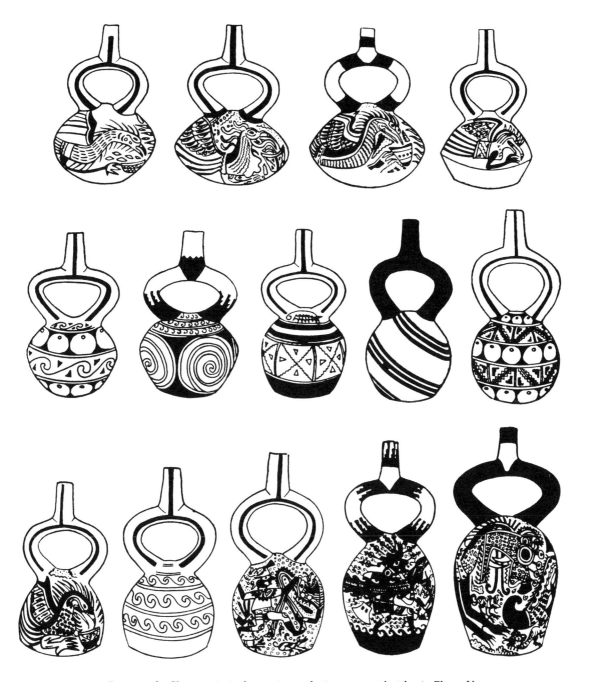

Figure 30b. Characteristic decorations of stirrup spout bottles in Phase V.

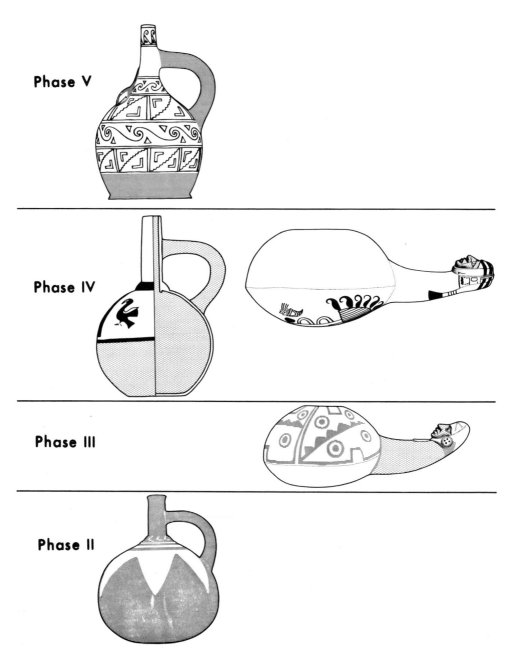

Figure 31. Characteristic forms of spout and handle bottles and dippers, Phases II through V.

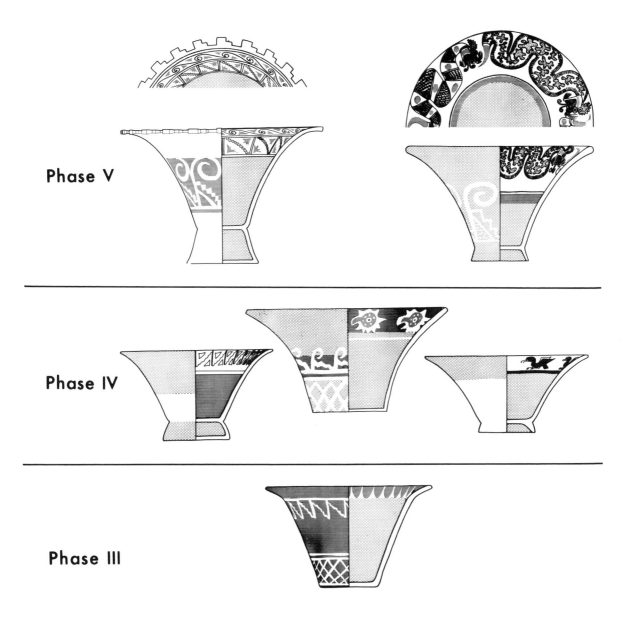

Phase V

Phase IV

Phase III

Figure 32. Characteristic forms of flaring bowls, Phases III through V.

what narrower base and greater curvature in the profile of the wall, thus resulting in a more pronounced flare at the rim. This trend continues in Phase V, when flaring bowls have a remarkably small base, an extremely pronounced flare, and a great deal of curvature in the vessel wall. The rim terminates in an almost horizontal position. On some of the flaring bowls of Phase V the entire rim has been notched in the form of small steps (fig. 32). All flaring bowls with notched rims can automatically be identified as Phase V.

Flaring bowls of Phases III, IV, and V may or may not have rattle bases. Rattle bases, however, are most common on flaring bowls of Phases IV and V. If a flaring bowl is painted with fineline drawing, the nature of this drawing can often be quite helpful in assigning the specimen to a given phase (see section on fineline drawing below).

MODELED BOWL

Other than flaring bowls, the only bowl forms that carry a significant amount of iconography are those with modeled chambers (fig. 33). These are often modeled to depict such things as human portrait heads, plants, animals, and fish. On the basis of our sample we can suggest that *all* modeled bowls are Phase IV.

JAR

Jars are closed vessels with a deep chamber and a prominent neck that extends upward from a rather large opening near the top of the chamber. There is a great variety of Moche jar forms, but only a few of these are elaborated with complex iconography. Most significant are the effigy jars, whose chambers are modeled to represent forms such as human figures, plants, and animals. Most effigy jars date from Phases II, III, and IV, but it is often difficult to identify a specific piece by phase. Perhaps the best means of determining the phase is to find a similar form modeled on a spout and handle bottle or stirrup spout bottle. Thus, an effigy jar with a chamber modeled in the form

of a seated figure can best be identified to phase by finding a similar seated figure in a stirrup spout or spout and handle bottle whose phase is diagnostic.

One of the most common forms of effigy jars depicts a human figure whose face is modeled into the neck of the jar and torso is represented by the chamber. Specimens of Phase III can generally be separated from those of Phase IV by noting the upper portion of the jar neck. In Phase III the upper portion of the jar neck is an integral part of the headdress itself (fig. 34). In Phase IV, however, the headdress is modeled separately, and a standard jar neck extends above it (fig. 35). As with flaring bowls, some jars can be dated most precisely on the basis of the fineline drawing that is added to their exterior surface (see section on fineline drawing below).

Other Moche ceramic objects, such as pedestal cups, whistles, and miniature vessels, must be given phase designations by analogy to the stylistic changes found in the vessel forms discussed above, or identified to phase because such objects are depicted in an artistic representation that can itself be identified by phase.

FINELINE DRAWING

The use of red and white slip pigment to decorate ceramics begins in Phase I, and continues through Phase V. In Phases I and II there is some attempt to use the slip to create a design in fineline. True fineline representations, however, are not fully developed until early in Phase III, when we find complex detail and multiple figure designs on single pots. The fineline drawing tradition is important throughout Phase III, and continues to develop through Phases IV and V. The corpus of scenes painted during these three phases includes many of the most complex representations found in Moche art. Thus identifying these scenes by phase is of crucial importance in our understanding of the iconography.

It is possible to identify fineline drawing from

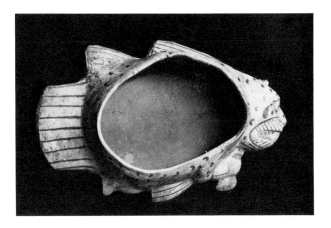

Figure 33. Modeled bowl depicting an anthropomorphized fish holding a tumi knife.

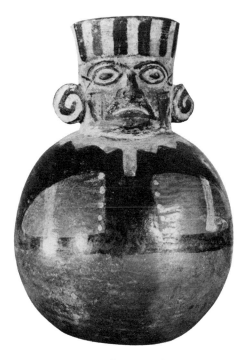

Figure 34. Effigy jar, Phase III.

Figure 35. Effigy jar, Phase IV.

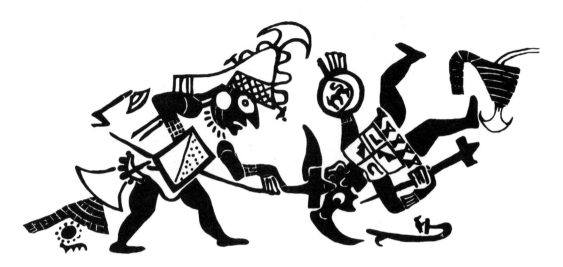

Figure 36. Phase III fineline drawing of warriors in combat.

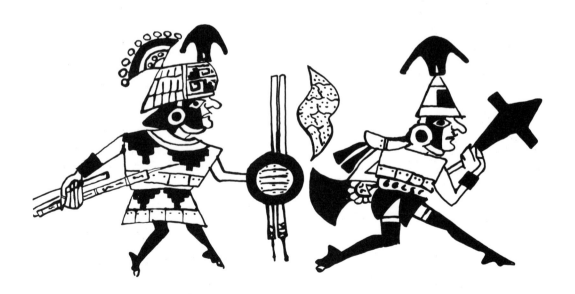

Figure 37. Phase IV fineline drawing of warriors in procession.

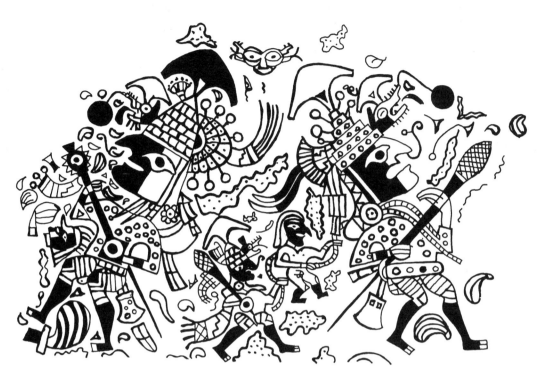

Figure 38. Phase V fineline drawing of warriors with a prisoner.

Phase III because the few figures are relatively large, they are painted with broad line, and the representation generally involves a considerable amount of solid area or silhouette (fig. 36). Open-work and fine detail within figures are not found in this phase.

In Phase IV, the technique of fineline painting improved, and this is reflected in the degree to which the artists could control extremely narrow lines. This allowed for more detail and choice in the use of silhouette and open area. It also made it possible to draw figures that were considerably smaller than those of Phase III. Thus more figures were often represented in the same amount of space, and there was more complexity in the action

and movement being depicted (fig. 37).

Phase V artists were able to control extremely narrow lines, and they used this ability to increase the detail and complexity of their drawings. There is very little silhouette or solid area in the representations. Rather, figures are shown in outline, with considerable detail in facial features, ornament, clothing, and implements. The increased control of fineline also allowed artists of Phase V to represent many more individual figures (and hence complex activities) on a single vessel. In addition, the entire background was often filled with small dots or filler elements, thus causing the figures to be somewhat obscured by the detail surrounding them (fig. 38).

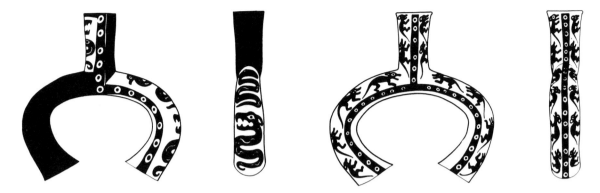

Figure 39a. Stirrup spout designs characteristic of Phase III.

The characteristics of the fineline drawing of Phases III, IV, and V are consistent regardless of vessel form. Thus, Phase III figures painted on chambers of stirrup spout bottles are very similar to Phase III figures on the interior rims of flaring bowls, or on the exterior surfaces of Phase III jars.

Some stirrup spout bottles have fineline drawing on their spouts as well as chambers. This occurs on a few specimens in Phase III, and is particularly common in Phases IV and V. Certain spout designs occur only in one phase, and thus can be used as an aid in determining the phase of a given specimen (fig. 39).

There are two other features of fineline drawing which, because of their unique occurrence in Phase III, give a precise means of identifying the phase of those pieces on which they occur. Both were used to provide detail to portions of the design rendered in solid silhouette fashion. With the first technique, the vessel was painted with an overall white slip, the fineline drawing was then applied with red slip, and the pot was fired. After firing, incision was made with a sharp pointed instrument that scratched through the red slip to reveal the white slip underneath (fig. 40). Details such as ornaments, fingers, or lines in the face were provided by this slip-cutting technique. With the second technique, details were added by over-painting. The artist began by painting the entire exterior surface with an overall white slip. The design was then painted with red slip, and later elaborated by overpainting with white slip (fig. 41).

PORTRAITURE

Although Moche art is characterized by an amazing degree of realism, the extent to which it replicates natural form varies from phase to phase. Thus the degree of realism can be used in some instances as a phase indicator. This is particularly true with portraiture, that is, the modeling of a human face in such a way as to suggest that it is the representation of a specific individual. Portraiture does not occur in Moche art until late in Phase III. Even at that time, however, the representation of naturalistic human faces maintains a stylized quality. It is in Phase IV that we find the full development of portraiture. It is to this phase that we can assign all of the famous portrait head bottles and portrait head bowls (color plate 7a). The production of portrait vessels apparently did not continue into Phase V.

SURFACE COLOR

In many instances it is possible to identify Phase V specimens on the basis of their unusual surface color. This color, which does not occur in the other phases, has the following characteristics: the

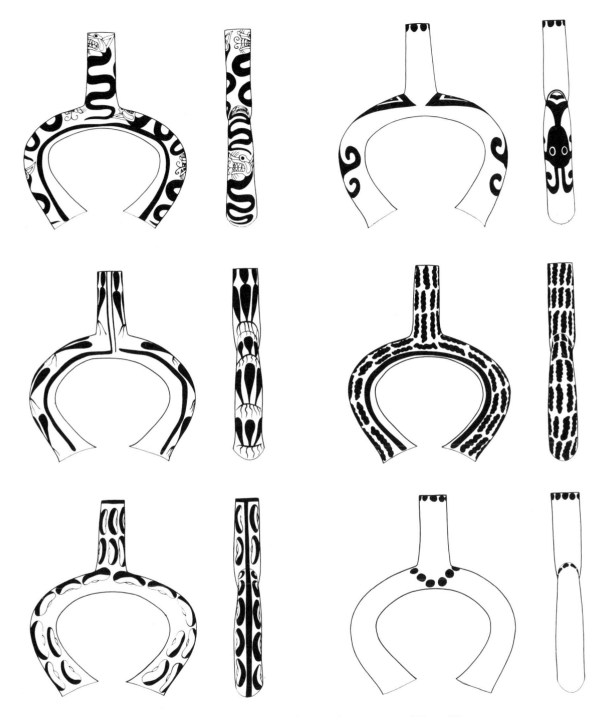

Figure 39b. Stirrup spout designs characteristic of Phase IV.

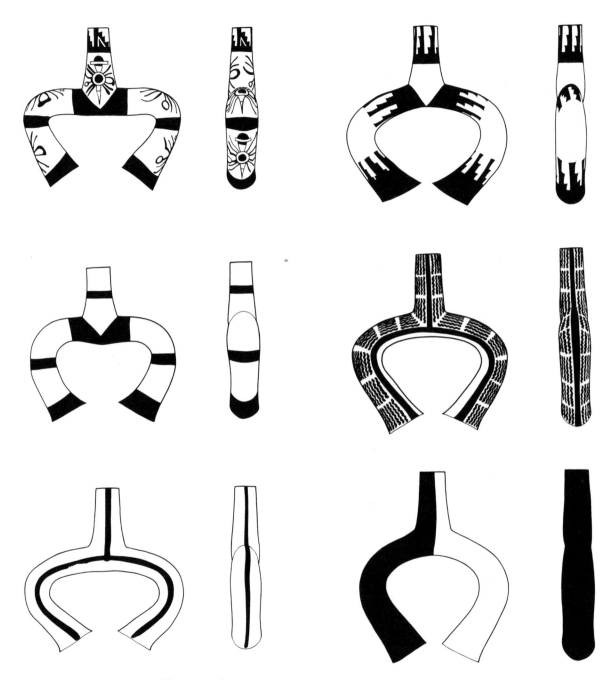

Figure 39c. Stirrup spout designs characteristic of Phase V.

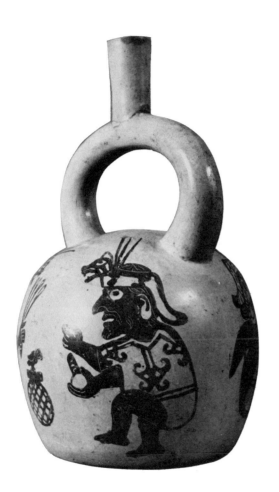

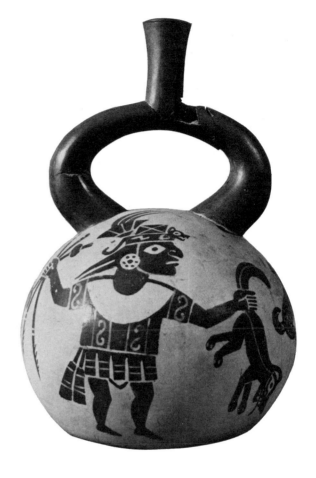

Figure 40. Phase III stirrup spout bottle with fineline drawing. Details have been added by cutting through the dark slip to reveal the light slip underneath.

Figure 41. Phase III stirrup spout bottle with fineline drawing. Details have been added by painting over dark slip with a second application of light slip.

Figure 42. Seated figure with a coiled hairstyle that is unique to Phase V.

suggesting that a higher temperature may also have been involved.

COILED HAIRSTYLE

Another feature unique to Phase V is a distinct hairstyle found on modeled representations of male figures. The hair on the sides and back of the head is combed straight down and is about chin length. The hair on top of the head appears to be shorter, and cut in such a way that a coil pattern is formed (fig. 42). This hairstyle is so unique to Phase V that all vessels on which it is found can confidently be assigned to this phase.

POLYCHROME SLIP PAINTING

There are several vessels that have Moche designs painted in polychrome slip paint. Most of these are double spout and bridge bottles (color plate 4a), although some have stirrup spouts similar to those of Phase V (color plate 4b). Since double spout and bridge bottles, as well as polychrome slip painting, are features of the Huari style. these vessels are believed to belong to the last part of Phase V, when Huari influence was present on the north coast of Peru.

As Moche art evolves from Phase I through Phase V, the developing techniques of fineline drawing and multiple figure modeling allowed for more and more complexity in representation. The resulting increase in detail in the late representations gives the impression of increasing elaboration of objects (such as costumes, ornaments, and implements), although in reality they may not have changed significantly from earlier phases. Similarly, although the mythology, religious practices, and ceremonies appear more complex in the late phases, this is probably because the artistic developments made it possible to *depict* more complex scenes, and not because of any actual increase in the complexity of Moche ideology or behavior.

light-colored slip, which is cream or slightly buff-colored in other phases, is grey in Phase V, and the dark slip or paste, which is normally brown or maroon, is black in Phase V. The grey and black color scheme is found not only on vessels with fineline drawing, but is also prevalent on modeled pieces. It probably results from a new technique of firing ceramics—a technique that involved greater reduction of the clay during the firing process. Often the surface is slightly crazed on these vessels,

V. Archaeological Record

Beginning with Max Uhle's excavations at the Pyramids of Moche in 1899, and continuing with all subsequent excavations of Moche material, archaeological evidence has been extremely useful in gauging the degree of realism in Moche iconography. For the most part the material uncovered in Moche sites has demonstrated that nearly everything shown in the art is an accurate, though sometimes stylized, rendering of the objects that these people had available in their immediate environment. In this section we review the nature of the archaeological record, indicating the material that remains from the Moche occupation of the north coast, the way this material can help us to interpret the art, and some of the discrepancies between the archaeological record and Moche iconography which still pose questions for future research.

FAUNA AND FLORA

Nearly all items of fauna and flora that are represented in Moche art are native to the immediate environment of the north coast, and can be found in the archaeological sites of the Moche people. Excavation of Moche habitation refuse yields remains of corn, beans, squash, peanuts, manioc, and pacae. Similarly, guinea pig, llama, and bird bones, and maritime resources such as fish, shellfish, crab, and sea lion are commonly found, thus indicating their use as food. Shells of land snails are found but are not common. It is curious that there are artistic depictions of deer and fox being hunted, and yet the bones of these animals have not been identified in the refuse. One vessel in our sample (fig. 43) shows a deer being butchered and eaten, thus attesting to its use as

food. This, however, may have occurred only on ritual occasions, and the remains disposed of in a special way. Foxes do not appear to have been used as a food resource. Although there are no known depictions of avocado, guava, and sweet potatoes in Moche art, remains of these plant foods are frequently found in the refuse.

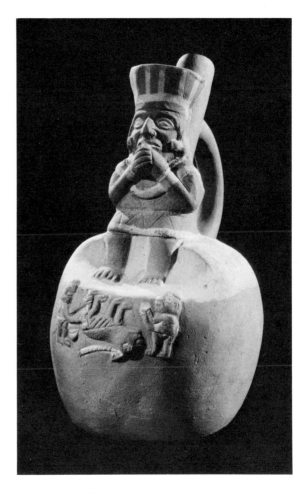

Figure 43. Spout and handle bottle depicting a deer being butchered and eaten.

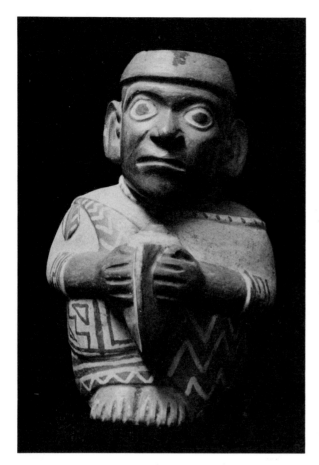
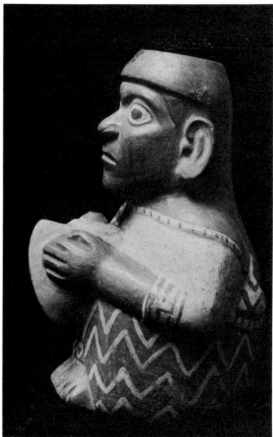

Figure 44. Figure holding a conch shell trumpet.

Certain types of fauna represented in the art are not native to the north coast of Peru. These include the monkey, toucan, iguana, and the conch shell *(Strombus galeatus).* All four of these are native to the coast of Ecuador in the north, and it is quite possible that they were all imported from that area. Representations of monkeys, shown frequently with collars, leashes, and earrings, suggest these animals may have been kept as pets or taught to aid in the harvest of some fruits. The toucan and

iguana may also have been imported live and maintained in cages. No remains of any of these creatures have yet been reported from Moche refuse. They were probably not used for food, and may have been quite rare.

The conch shell is frequently shown being blown or held like a trumpet (fig. 44). Conch shell trumpets have been found in Moche sites, and ceramic replicas were commonly made by Moche potters. An important supernatural creature in Moche art

Figure 45. The Strombus galeatus monster.

or provide valuable clues to the meaning of a specific scene.

Ceramic containers are frequently represented in the hands of individuals, or placed in the immediate vicinity of specific activities (figs. 47 and 48). It is apparent from these representations that elaborate ceramic vessels were not simply made to be used as grave offerings, but also commonly served as containers in a variety of activities. Excavation of Moche habitation refuse confirms this usage, since numerous ceramic fragments, including

is the *Strombus galeatus* monster (fig. 45), a combination of a conch shell, an eared serpent head, and a feline body with claws and feline spots. On the snout of the monster are the antennalike objects clearly derived from the land snail (fig. 46). There is a likely explanation for the combination of features on this figure. Since conch shells were imported from Ecuador, the Moche people probably never saw the creature living inside. They may, however, have made an analogy between a creature that they thought inhabited the conch shell and the land snail that is native to the north coast of Peru. The latter has a very delicate white shell, similar in form to the conch, which is less than two centimeters long and can be easily crushed between the thumb and forefinger. Moche people would have been quite familiar with the creature that inhabits the land snail shell. Imagine their surprise when first viewing enormous *Strombus galeatus* shells measuring more than ten inches long and weighing several pounds! It is likely they were aware that the conch shells came from the ocean because they invariably depicted the *Strombus galaetus* monster in ocean settings.

IMPLEMENTS

The implements shown in Moche art are numerous and highly varied. Often they reflect the status or activity of the individuals holding them,

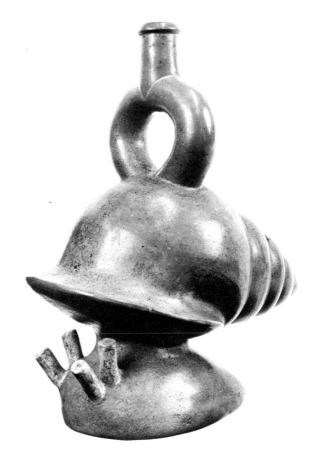

Figure 46. Stirrup spout bottle modeled in the form of a lomas snail.

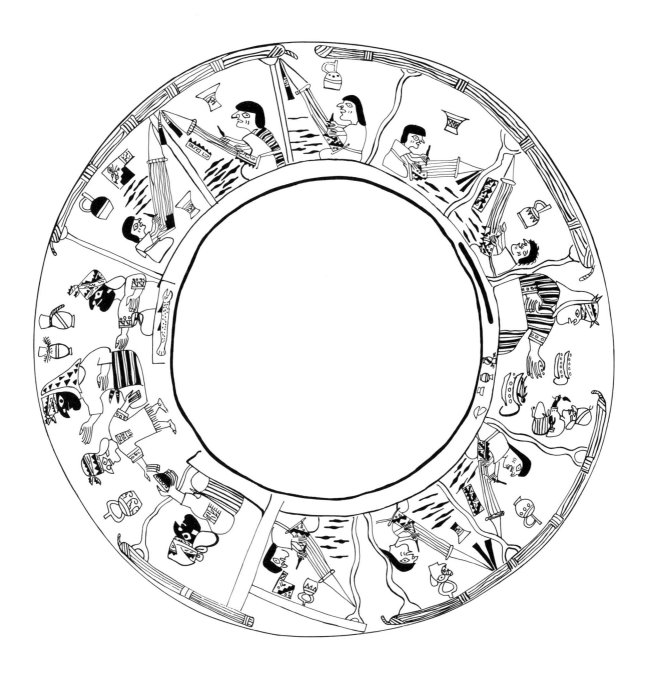

Figure 47. Flaring bowl with fineline drawing of weaving activity.

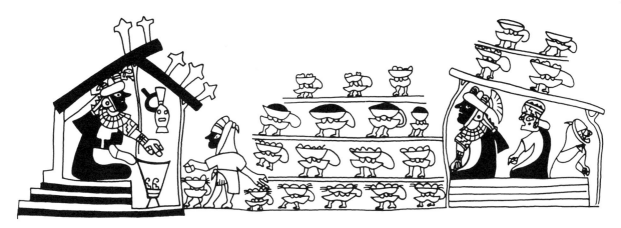

Figure 48. Ceremony involving the presentation of food.

pieces of the most elaborate vessels, are found along with fragments of plain cooking and storage pots.

If we compare the full inventory of vessel forms shown in the art with those found in excavation of Moche refuse, we find an almost perfect correlation. Perhaps the only significant discrepancy is that the art does not depict the full range of cooking pots. It is likely, however, that these are not represented only because scenes of food preparation are so rare.

One vessel form shown in the art has not yet been found archaeologically. This is a large vessel with high vertical walls and a tripod base. It is represented in only two scenes within our sample (on the left in fig. 1, and to the right and forward in color plate 5). These suggest that it had a special ceremonial function. The complete absence of this form in the archaeological record is surprising in view of the thousands of sherds that have been excavated including fragments of all other vessel forms shown in the art. It seems likely that we are dealing here with an extremely rare form, whose function was limited to a very specific aspect of Moche life.

The archaeological evidence indicates that most of the small cups, bowls, and plates shown in Moche art are made of gourd rather than pottery. An analysis of the gourd and ceramic forms excavated from Moche habitation refuse suggests that containers for personal use (cups, plates, and bowls) normally were made from gourds, while those that had communal functions (cooking and storage pots, and serving vessels) were normally ceramic. Various small ceramic bowls were made. Some of these may have been for individual use, but they are so rare that we assume most vessels for individual use were made from gourds.

Metal objects were relatively rare in Moche culture. Those that did exist were normally small and had an ornamental rather than utilitarian function. The two most notable exceptions to this are *tumi* knives and star-shaped mace heads. Tumi knives are frequently depicted in the art. They are almost invariably held by supernatural beings, and are consistently used for decapitation (fig. 49). Some examples have been found archaeologically. They are made of copper and are work-hardened along the cutting edge.

When the first star-shaped mace head was found

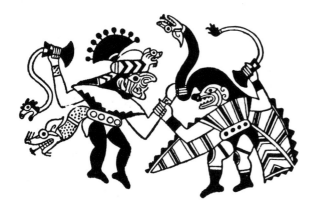

Figure 49. Supernatural combat.

in the grave of an adult male along with other metal and ceramic objects (fig. 52). The staff was lying along the left side of the body. The long pole was made of wood, portions of which were sheathed in sheet metal. Almost all of the wood had decomposed during the centuries since its burial, but it is clear that it originally had short crosspieces that went through holes near the end, just as in the artistic representations. The cross-

in Moche refuse, there was some doubt about its authenticity. Moche warriors were known to have carried another type of war club which is distinct from the star-shaped type. Analysis of the iconography, however, indicates that the star-shaped mace was used by the Moche people, although its distribution is clearly limited to a select group of warriors (fig. 22).

Many individuals are shown holding staffs (fig. 50), and these have a variety of forms. Similar staffs have been found in Moche graves. In a major tomb excavated in the Virú Valley, for example, three elaborate staffs were found. Each was intricately carved, and two were inlaid with shell and semi-precious stones (see figs. 78 and 79, below).

There is one unusual staff shown in the art, which has been the subject of considerable speculation (fig. 51). It consists of one long pole with short crosspieces attached near each end. The center portion has a pliable cordage wound around it many times. At one end of the cordage is a flowerlike object. From the artistic representations, it appears that when these staffs are tossed into the air, the cordage wrapped around them unwinds, thus giving a spiral rotation to the staff. During excavations at the Pyramids of Moche in 1972, an object resembling the staff was found

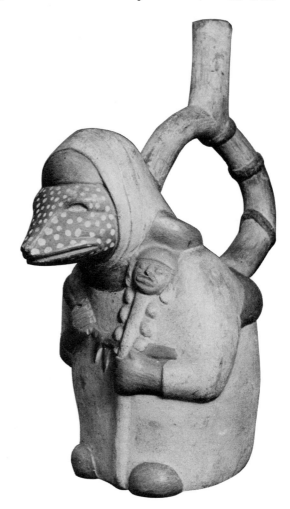

Figure 50. Supernatural figure holding a staff.

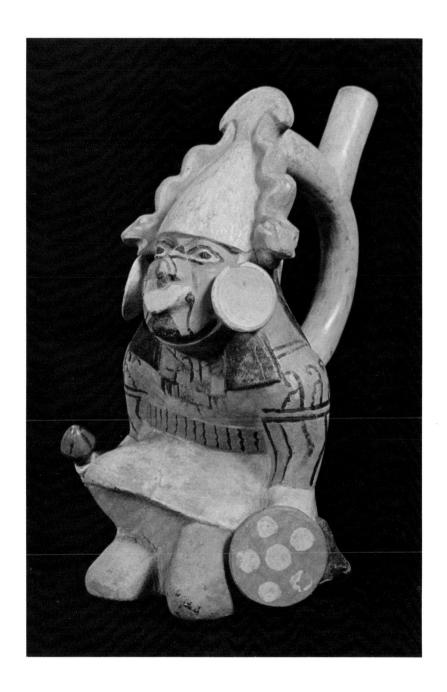

Plate 1. Kneeling warrior holding a club and shield.

Plate 2a. Ruins of Pañamarca, Nepeña Valley.

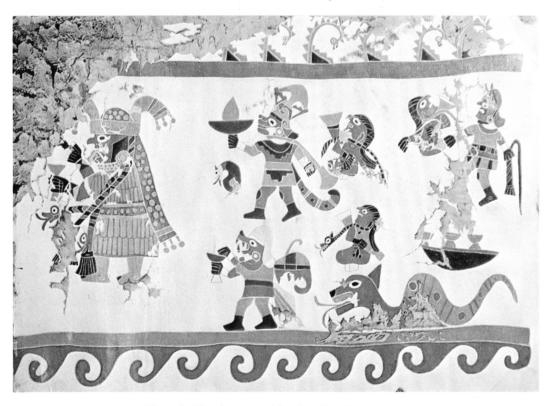

Plate 2b. Mural on a mud brick wall at Pañamarca.

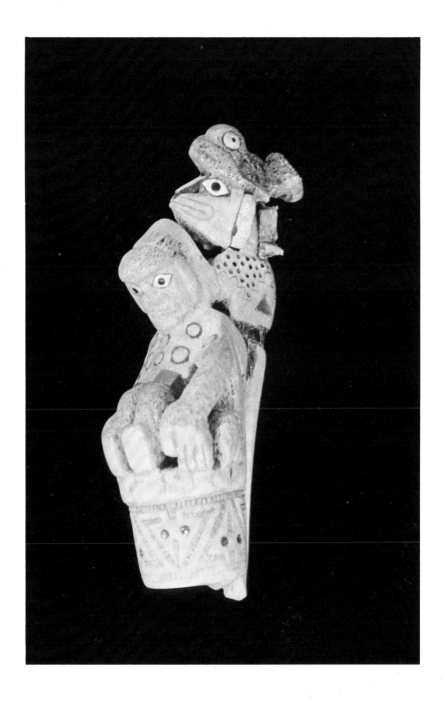

Plate 3. Carved bone depicting an anthropomorphized iguana and a human figure.

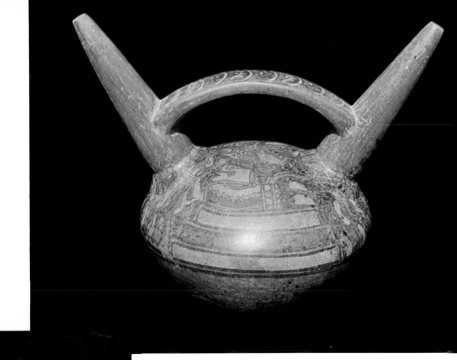

Plate 4a. Double spout and bridge bottle with design in polychrome slip paint that is unique to Phase V.

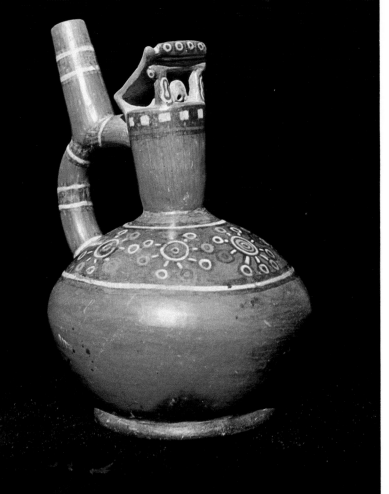

Plate 4b. Stirrup spout bottle with design in polychrome slip paint that is unique to Phase V.

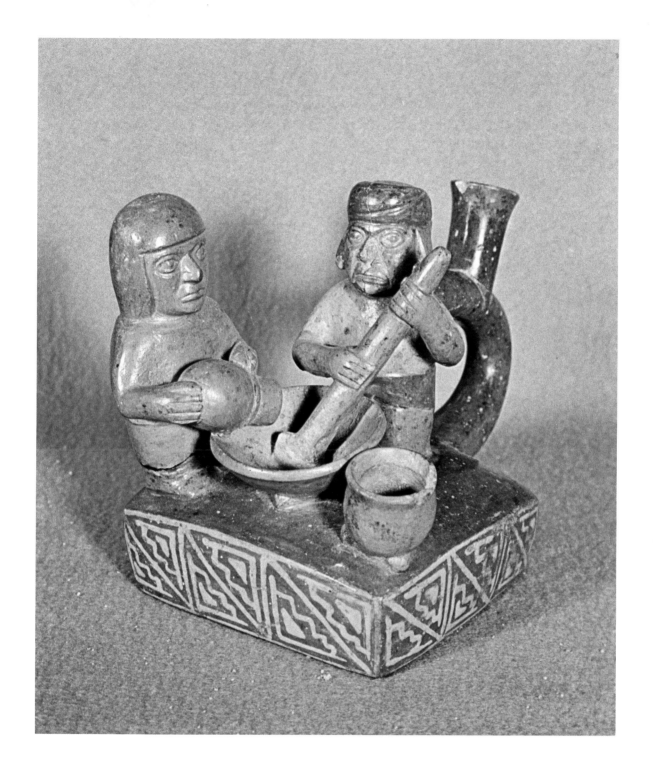

Plate 5. Two figures possibly preparing chicha (corn beer). The two
vessel forms resting on the ground are unusual in Moche art.

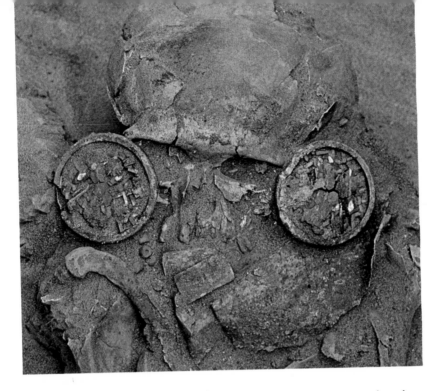

Plate 6a. Head of an individual who was buried wearing large earspools and a stone bead necklace (cf. plate 7a.)

Plate 6b. Detail of one of the large earspools shown in plate 6a. It has a mosaic representing a deer with two darts in his back jumping into a hunting net (cf. plate 7b).

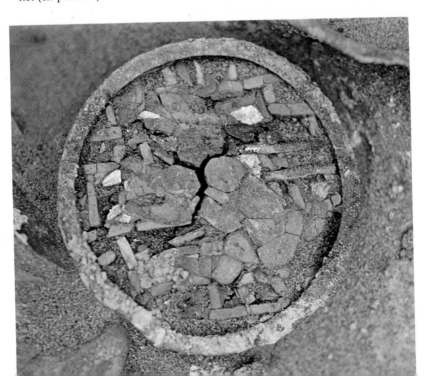

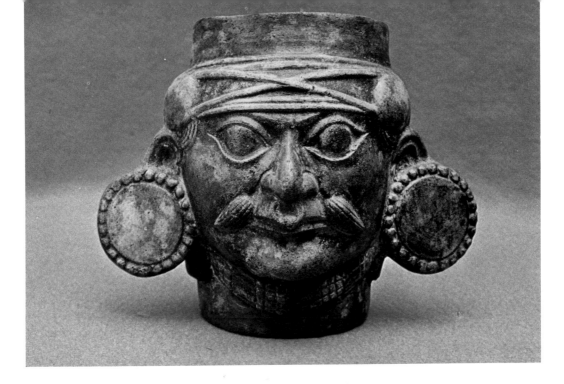

Plate 7a. Portrait head bowl depicting an individual wearing large earspools and a bead necklace.

Plate 7b. Deer being hunted with a hunting net, darts, and throwing stick.

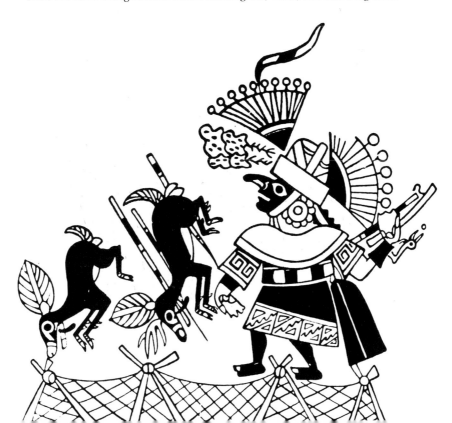

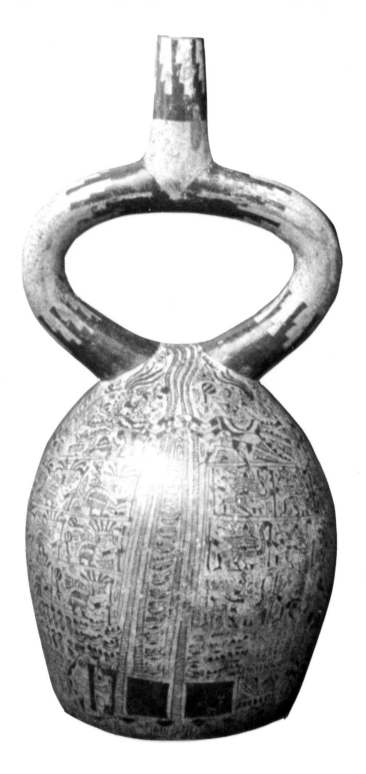

Plate 8. Stirrup spout bottle with fineline drawing of a burial ceremony (cf. figure 65).

Plate 9. Figure tied to a rack, with a piece of flesh on his back cut away, possibly to tempt carnivorous birds.

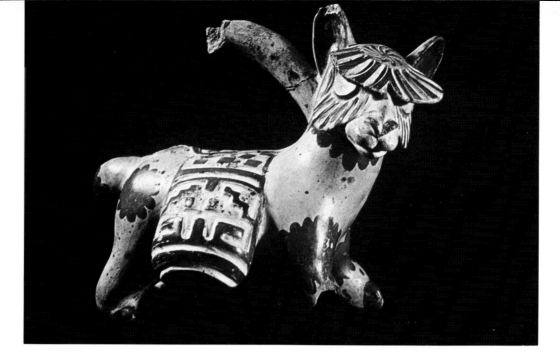

Plate 10a. Llama with woven pack bag.

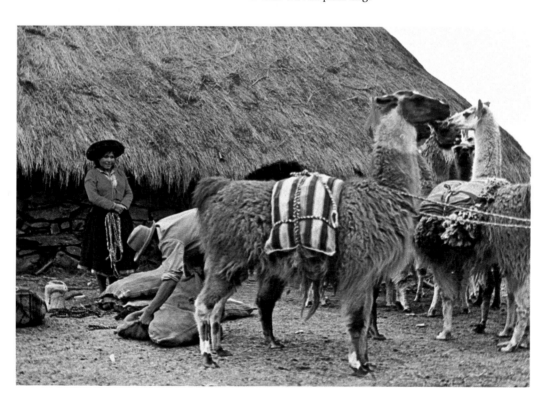

Plate 10b. Present-day llamas with woven pack bags.

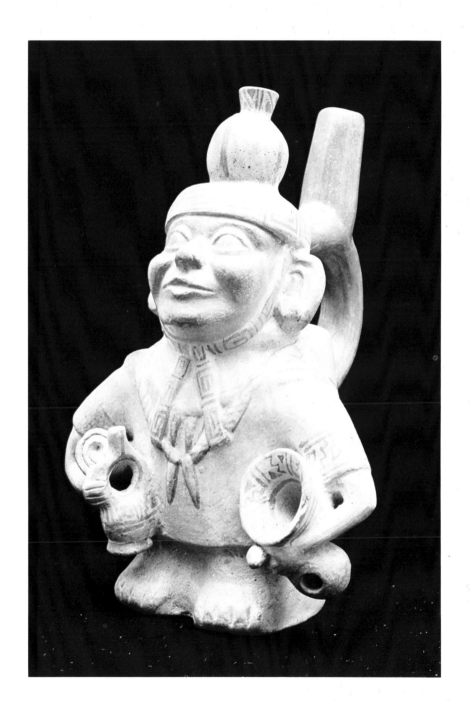

Plate 11. Individual carrying an assortment of ceramic vessels and a rolled mat.

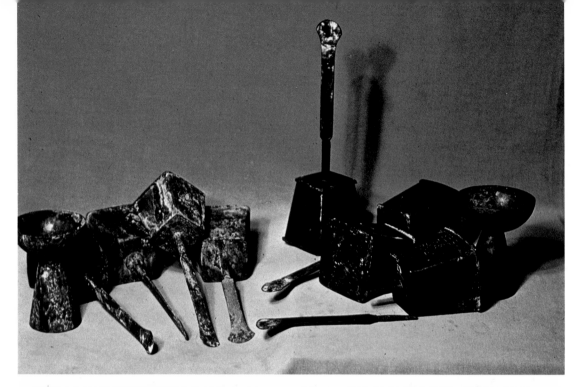

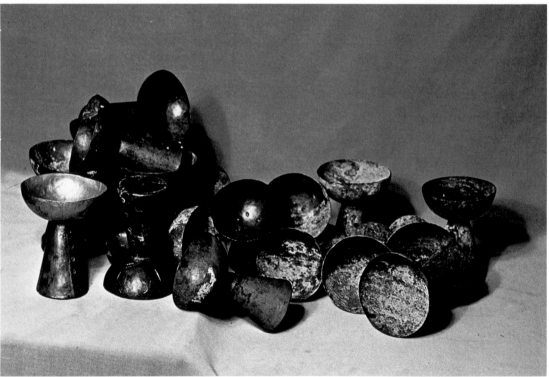

Plate 12. Group of copper goblets and rattles that pertain to the Presentation Theme.

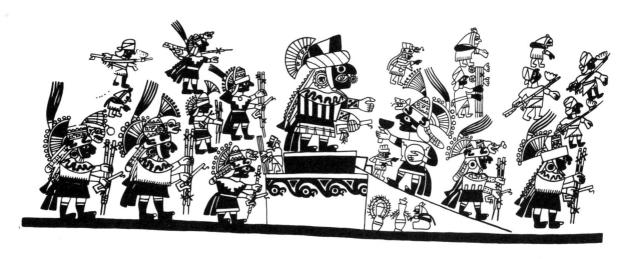

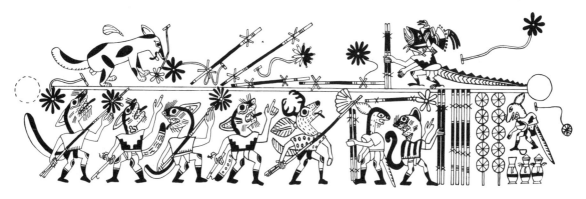

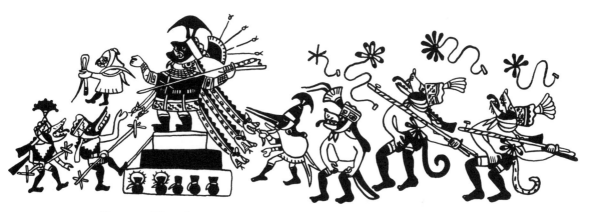

Figure 51. Three fineline drawings showing the use of staffs with crosspieces at each end.

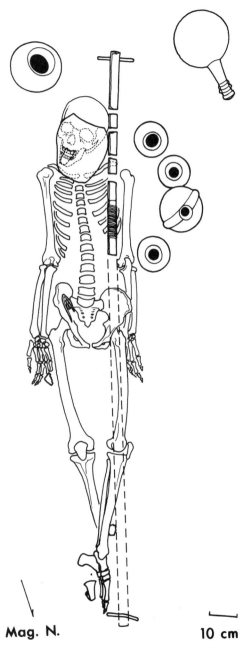

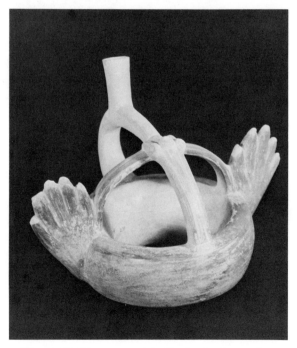

pieces were made of metal, and held in place with metal wedges. Corrosion of the metal sheeting near the central portion of the staff revealed that it had cordage wound around it when placed in the grave, but the cordage had long since decomposed. Here, then, we clearly have the counterpart of the staff shown in Moche art. We can reconstruct its original size and manufacture, and even suggest that it was the property of an adult male of high status. Nevertheless, its function and meaning continue to elude us, and at present must await additional evidence.

DRESS AND ORNAMENT

It would be almost impossible to reconstruct the nature of Moche dress and ornament from the archaeological record alone. Although textile, leather, and metal objects are found in the tombs and habitation refuse, they are almost never suf-

Figure 52. Moche burial containing a staff with crosspieces at each end.

Mag. N.

10 cm

Figure 53. Stirrup spout bottle in the form of a headdress.

70

Figure 54. Warrior's clothing and equipment.

ficiently complete to reconstruct the original garment. Thus the best source of information about Moche dress and ornament is the artistic representation itself. Here we find not only the garments being worn, but in some instances the representation of individual garments alone (figs. 53 and 54).

The precise correlation between the artistic representation and the archaeological evidence confirms the accuracy of the artistry, and also provides some insights concerning the materials and techniques used in the manufacture of wearing apparel. For example, excavations at the Pyramids of Moche in 1972 uncovered the burial of an adult male wearing large metal earspools and a necklace of stone beads (color plate 6a). Although the flesh

had decomposed on his face, red pigment adhering to the bones of his forehead and face indicated that these areas were painted at the time of burial. His earspools were made of gold-copper alloy, and were gilded to look like pure gold when new. Each was skillfully inlaid with turquoise, lapis lazuli, shell, and gold to depict a deer with two darts in his back, jumping into a hunting net (color plate 6b). This scene is commonly depicted in Moche fineline drawing (color plate 7b). One portrait head bowl in the sample illustrates a male wearing similar earspools and bead necklace (color plate 7a). Thus we know for certain that not only was jewelry of this size and form worn by men in Moche culture, but we can also reconstruct how and from what materials it was made.

ARCHITECTURE

It is interesting to compare the architecture depicted in Moche art with the remains of Moche architecture that have been excavated. Again we find a strong correlation between the iconography and the archaeological record, and the information derived from each provides a valuable complement to what can be learned from the other.

Representations of architecture are common in Moche art, and have considerable variation. Close examination of a large sample of these, however, reveals a surprisingly limited number of basic forms. Most representations show a structure on top of a solid platform. The platform often has a square or circular base and two or more stepped terraces. The summit, which is flat, is reached by a series of small steps or a ramp. These platforms are probably representations of the large pyramid constructions associated with major Moche sites. The pyramids are made of mud brick, and vary in size and form. One of the most spectacular of these is the Pyramid of the Sun at Moche, which is more than 40 meters high and covers more than five hectares at the base. It is assumed that these solid earth platforms were used in ceremonies, and had small structures built at their summits.

All of the structures shown in Moche art have a single story and a square or rectangular floor plan. Both single and multiple room structures are illustrated. When multiple room structures are shown, the floors of contiguous rooms are frequently on different levels.

Many of the structures illustrated are open on three sides and have roofs supported by Y-shaped beams. There are two forms of roof for these open structures: a simple sloping roof and a roof with an overlapping gable (fig. 48). The open structures with overlapping gabled roofs are usually more elaborate than the other form. They frequently have roof supports and/or roof beams in the form of serpents, and often have roof comb decorations

Figure 55. Structure with a crenulated decoration along the crest of the gabled roof.

Figure 56. Structure with a double step roof decoration along the crest of the gabled roof.

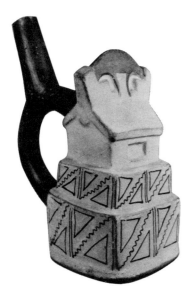

Figure 57. Structure with a double step and crescent design along the crest of the gabled roof (cf. figure 59).

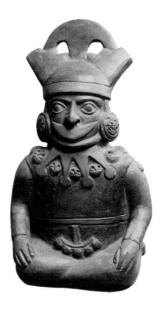

Figure 59. Seated figure wearing a headdress with a double step and crescent form (cf. figure 57).

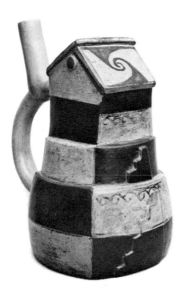

Figure 58. Structure with an overlapping gabled roof.

consisting of either war clubs or modeled felines. Furthermore, they are almost invariably built on top of a stepped platform, a feature that is much less common with the simple sloping roof. Although open structures are usually shown in fineline drawing, there are some modeled representations as well. The latter indicate that the back wall is generally solid, and may or may not be built as part of a stepped throne that occupies the back of the room. Elaborately dressed individuals are frequently seated on these thrones, where they appear to be eating or receiving tribute.

In contrast to the open structures shown in Moche art, there are three types of structures with solid walls. The most common has a single room and a simple gabled roof with a modeled design along its crest. On one specimen this is crenulated (fig. 55). In other instances it is in the form of a double step (fig. 56) or double step with crescent (fig. 57). These forms of roof decoration occur exclu-

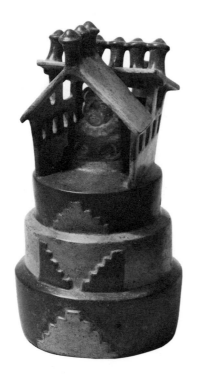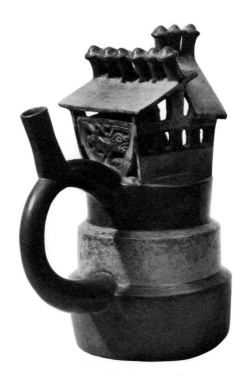

Figure 60. Structure combining both a sloping and a gabled roof. Note
the war club decoration along the roof tops.

sively on structures with solid walls, and other forms
of roof decoration do not occur on these struc-
tures. Furthermore, the double step and double step
with crescent are worn as headdress ornaments
by certain individuals shown in the art (fig. 59).

The second type of solid structure is similar to
the first, but has an overlapping gabled roof that
either has no modeled design along the crest (fig.
58), or is ornamented with a series of war clubs.

The third type of solid structure is a composite
form. It consists of a solid structure with a sloping
or gabled roof and a short structure with a gabled
roof (fig. 60). Composite structures almost invaria-
bly have some decoration on the crest of one or
both roofs, and this decoration is usually in the
form of war clubs.

Doorways in the solid structures are at floor level
and are usually located near the center of the
wall—invariably a wall beneath a sloping side of
the gabled roof. Sometimes a low wall is built up
at the doorsill, which would have to be stepped
over by people passing through the doorway.

The walls forming the sides of the solid structures frequently have openings near the top and sometimes also in the lower portion. These were probably left for light and ventilation, and they are often decorative. The exterior walls of the houses, and occasionally the roofs, appear to be plastered and painted with geometric designs.

Excavation of Moche architecture provides some details that cannot be learned from the artistic representations alone. The major building materials are rectangular, sun-dried mud bricks set in mud mortar. These bricks are sometimes laid on foundations of uncut fieldstone or rounded cobbles set in mud mortar. Some evidence of wattle and daub construction has been found in Moche sites, and it is assumed that buildings of this material were fairly common. Adobe walls built with openings for light and ventilation have been found. These openings were formed by leaving spaces between mud bricks as the wall was being constructed.

Generally only the lower portions of the ancient walls remain, but these confirm the consistent use of a square or rectangular floor plan, as well as the placement of the door near the center of a wall. In contrast to the artistic depictions, however, foundations of freestanding one- and two-room structures are very rarely found. Moche domestic architecture normally consists of clusters of contiguous rooms. Often more than 10 rooms are joined together in a single unit. This suggests that the architecture shown in Moche art is possibly a simplification of this norm into single- or double-room structures for purposes of illustration. Alternatively, what is shown in the art may have been a distinct type of structure—normally consisting of only one or two rooms—which was used for ceremony and commonly found at the summit of a pyramid or platform mound.

Since the upper portions of the ancient structures are no longer preserved, the archaeological record cannot confirm the consistent use of a gabled or sloping roof nor indicate details of the roof construction. Buildings on the north coast today almost invariably have flat roofs, however, because the scarcity of rainfall in the area does not require a sloping roof for runoff. The exclusive use of sloping roofs in Moche art, therefore, seems rather curious. Rainfall in the area during the Moche occupation was possibly somewhat greater than it is today, but there is no evidence that it was so much greater that sloping roofs would have been necessary. Possibly the Moche people came to the north coast from an area of greater rainfall, and maintained their custom of building this type of roof, even though it was not necessary. Or, what we are seeing in the art may be imaginary structures whose form was not actually being employed in Moche architecture. This seems quite unlikely, however, since almost everything else shown in the art has been demonstrated through archaeological excavation to be part of Moche culture, and the lower portions of excavated structures conform in most details to their counterparts in the art.

The objects shown along the crests of the roofs provide some evidence that sloping roofs did exist. As noted above, the roofs are frequently ornamented with such items as serpent heads, felines, or the upper portions of war clubs. These items were the subject of much speculation while we were compiling our sample of Moche art and beginning the analysis of the iconography. It seemed plausible that these were simply added by the artist to convey to the viewer some information about the nature of the structure—its function, meaning, or the status of those who used it—but that such features did not actually exist. In 1972, however, while excavating at the Pyramids of Moche, one area of Moche architecture yielded numerous ceramic fragments of an unusual and previously unrecognized form. They were similar to sherds of Moche cooking pots, being of coarse clay, and neither polished nor slip painted. But they showed no trace of having been used over a fire. After

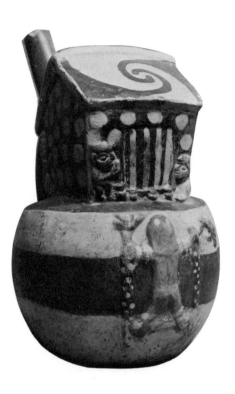

Figure 61. Structure with an individual tied to a rack in front of the door (cf. plate 9).

Figure 62. Structure with a rack in front of the door.

a large number of these fragments were found, it was apparent that their form was identical to that of the roof comb decorations that look like war clubs (figs. 15, 48, 60), and their size was in scale with the roof comb decorations represented in the art. Recently other such pieces in the shape of serpent heads—almost certainly the counterpart of these forms as represented in the art—have been identified. The existence of ceramic roof comb ornaments demonstrates that they are not merely an artistic device. Moreover, since roof comb ornaments are consistently shown on gabled and

sloping roofs, their existence supports the assumption that such roofs also existed, exactly as they are represented.

The function of the architecture represented in Moche art is difficult to define. For reasons which are explained in detail in chapter 9, it is likely that the structures carry symbolic meaning in their form and decoration and are not for secular use. Since they are almost invariably shown on top of an artificial platform, they may be the structures that were at the summit of the large, solid pyramid mounds. In fact, the fragments of roof comb deco-

rations found at the Pyramids of Moche were adjacent to a large adobe platform containing numerous burials of high status individuals. Similar roof comb decorations have not yet been reported from places where remains of ordinary domestic architecture are found.

In examining the artistic representations of architecture, we find that the people most frequently represented in the vicinity of the structures are prisoners who are in procession toward the structure, are being killed, or have been dismembered. Two specimens (e.g., fig. 61) show an individual tied to a rack near the house. In three other examples the rack is also shown, but it does not have a person tied to it (e.g., fig. 62). All this would suggest that these structures served, at least in part, for the arraignment and treatment of prisoners.

Other architectural depictions show the presentation of goods to an elaborately dressed individual seated within the structure (figs. 2b, 48). These goods consist of conch shells, food, and jars full of liquid. Several other houses have individuals inside or around the structures, but their activities are not clear. Only rarely are structures shown associated with supernatural figures.

In addition to the various types of structures shown in Moche art, there are numerous representations of small stepped platforms that look like thrones. These are usually built on top of a circular base, which has a ramp or steps leading to the top (fig. 63). The throne itself may consist of a single bench or a series of two to four steps on which an individual sits or stands (figs. 48 and 51).

One Moche structure reported from the Virú Valley is so similar to the artistic representations of thrones that it warrants a brief description. It is part of an isolated adobe pyramid located in the lower part of the valley near one of the largest Moche sites. The base of the pyramid is square, and measures about 20 meters on a side. The summit platform is about 7 meters square, and

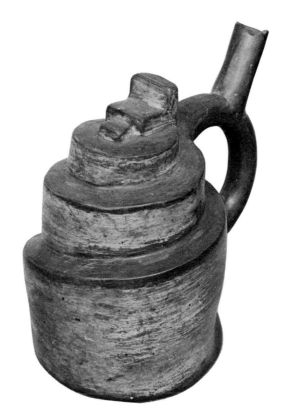

Figure 63. Throne at the top of a circular platform.

has a flat top about 3 meters above the surrounding ground surface. This flat top serves as the floor of a room containing a throne made of mud bricks and covered with white plaster (fig. 64). White plaster also covers the walls of the room. The throne itself has a rectangular base surmounted by a cylindrical pedestal. The latter is 72 centimeters high, 1.6 meters in basal diameter, and slopes slightly inward at the top. A flight of seven steps ascends the throne on the south side. On top of the cylindrical pedestal are the remains of a low seat, measuring almost 1 meter across and about 30 centimeters high (Willey 1953:215–218).

Although most thrones represented in the art

Figure 64. Moche throne on top of a circular platform.

are not shown inside rooms (figs. 99, 115 below), this remarkable find demonstrates that at least some were enclosed by walls and presumably a roof. They may well have been inside buildings like those described above. Depictions of thrones in fineline drawing show them either freestanding in the open (fig. 51) or inside open structures (fig. 48).

Such a wide range of activities and individuals is shown on or near the thrones that their function is difficult to define. Thrones are clearly related to nonsecular activities, however, and are normally occupied by people of obviously high status. Unoccupied thrones are frequently the subject of modeled representations, suggesting that thrones have a symbolic meaning in their own right—possibly standing for the status or activity of the people who normally used them.

One final architectural feature represented in the art is a platform that appears to be used as a bed (figs. 117 and 118 below). Platforms are shown only in erotic scenes and scenes that appear to show curing. They are either round or rectangular, and have a flat top large enough for a person to lie out fully extended. They are usually covered with a long textile, rolled up at one end to form a pillow. As with most representations of thrones, platforms are not shown enclosed with walls, but are likely to have been inside of solid or open structures.

It can be seen from the above that there is an extremely rich archaeological record that can be useful in understanding Moche iconography. It will be interesting to see the degree to which continued excavation will provide valuable information that can be correlated with the art.

VI. Historical Record

Since the native people of the Andean area had no writing system prior to the coming of Europeans, there are no pre-Columbian documents to aid in the interpretation of Moche iconography. There are, however, Spanish documents written in the sixteenth and seventeenth centuries which provide information about the native culture of the north coast of Peru. For the most part it has been assumed that these documents are only useful in reconstructing the native culture immediately prior to European contact, and as far back as the first half of the fourteenth century A.D. Since the Moche kingdom came to an end a full six centuries earlier, little attempt has been made to search through the historical accounts for information relating to this earlier time period. In the course of our research, however, it was felt that this might be a worthwhile avenue of investigation. The results surpassed even our most optimistic expectations.

There are various sources of historical information dealing with the native culture of the north coast of Peru. Some of the best sources are found in local archives, repositories of documents pertaining to colonial Spanish institutions. These often contain information concerning the native population. Records of legal suits over title of land (titulos), for example, frequently contain information on pre-Columbian land distribution, inheritance of property, and political divisions. Similarly, records from ecclesiastical archives contain valuable information about native religious practices. Because of the preoccupation of the Spanish clergy with the task of converting the native population to Christianity, detailed descriptions of native religious practices were written. These accounts provide the best descriptions of ceremonies, religious paraphernalia, and supernatural figures worshiped by the native people.

Other sources of useful historical information are the accounts by individuals interested specifically in recording aspects of native culture that were still extant in the early colonial period, what could be recalled by the native informants about the pre-Columbian customs, or, in a few instances, what was preserved as oral tradition that had been retold for generations prior to the coming of the Europeans. The latter include accounts of courts, royal lineages, kings, and even the specific events occurring within the reign of a single king.

It is known that oral histories were kept by the Inca at the time of the Spanish conquest. Mythology, legend, historical romance, and history were handed down from generation to generation in the form of long poems (ballads, sagas, and little epics), which were learned word for word and repeated at public gatherings until everyone was familiar at least with their content (Rowe 1946:321). We know that there was a similar practice among the native people of the north coast of Peru, and some scholars have even suggested that it was from the latter that the Inca obtained their interest in the preservation of oral traditions (ibid.:202). It is very unfortunate that so few of these oral traditions were recorded by the Spanish after the conquest, since those that were recorded provide many extremely important pieces of information.

There are basically two reasons that have caused scholars to assume that historical data are only pertinent to the cultures immediately prior to European contact. First, it is reasonable to assume that the native traditions maintained during the early colonial period would have been derived only from the period immediately preceding the Spanish arrival, since there was no evidence to suggest that they would have been relevant to a people living centuries earlier. Second, some of the accounts of specific events described in the oral histories can be placed rather precisely in the 250 years immediately prior to European contact (see chart). For

example, the account of the Inca conquest of the north coast, said to have occurred during the reign of a local king called Minchançaman, is known on the basis of other data to have occurred after A.D. 1460. Thus, the specific individuals who comprise the lineal ancestry of Minchançaman, as well as the events said to occur during the lifetime of each, could not pertain to periods prior to about A.D. 1300.

Within the existing body of historical data, however, there are tantalizing clues suggesting that folk tradition preserved information about an earlier cultural period. To understand the way this data can be used to interpret Moche iconography, it is useful to divide it into three types of information: (1) the historical data that clearly seem to be relating information about a time period many centuries prior to European contact—presumably the period of Moche occupation of the north coast, (2) the historical data assumed to be related to Chimu culture, but which have detailed and specific representation in Moche iconography, and (3) additional data of a general nature about Chimu culture which suggest certain interpretations of specific categories of Moche iconography.

The first type of information is very rare, but the few examples we do have are quite provocative. Bishop Bartolomé de Las Casas, writing around 1550, recorded one of the clearest accounts of a period many centuries prior to the arrival of Europeans.

This early period lasted about five or six hundred years. During this time the country was divided into a great number of chieftaincies, some larger than others but none of any great extent. [Presumably the Moche kingdom was one of these.] The moral tone of the chiefs was one of genial paternalism, each state having its peculiar institutions and its own economic life. Between the peoples of adjacent communities there was a primitive kind of commerce whereby products of one kind were bartered for those of another. There was, therefore, some slight trade between neighboring states, but none at all between widely separated localities. These idyllic conditions lasted for some time, but later on wars and discords gradually came into being, chiefly provoked by questions relative to land and water rights.

The people of the coast, during this early period, used javelins in their wars, whereas the contemporary highlanders used slings as their chief weapons of offense. The lords of the shore-country were wont to build their palaces upon the summits of hills or, if no suitable hill were available, they would cause their people to pile up vast amounts of earth so as to make an artificial eminence.

The chieftaincies did not pass by any rule of primogeniture; rather, the chiefs of the early coastland kingdoms chose their heirs from among their sons or from among their brothers, according as to where among their near kinsmen the most able man was to be found. The chosen successor was always made known to the people beforehand so that they might accept him as their future ruler, and thereafter he was carefully trained to fill worthily the high place to which he was destined (Las Casas 1892:102–111; quoted from Means 1931:65–66).

Another account, written by Fray Jerónimo de Román y Zamora very largely corroborates the account of Las Casas. These conditions, he tells us, occurred during the earlier of two distinct cultural periods in pre-Hispanic Peru. This early period is said to have lasted for many centuries, and terminated about 600 hundred years before his time or, in other words, at about the end or middle of the tenth century A.D. (Román y Zamora 1595: Vol. III, folios 162 to 163).

These two accounts suggest that the folk memory of the native cultures in the early colonial period did maintain a recollection of a period before the development of the Kingdom of Chimor. And the chronological placement of this period as before the tenth century A.D. is remarkably accurate when compared to the chronology accepted today. In fact, before the development of the radiocarbon dating technique, it was not possible for archaeologists to assign as accurate a chronological placement of the Moche and Chimu cultures.

Let us now examine instances in which the his-

torical accounts are assumed to refer to Chimu culture, but for which there are detailed and specific representations in Moche iconography. One of the most provocative of these has to do with the role of curers among the people of the north coast. Fray Antonio de la Calancha, in his *Crónica moralizada* written between 1630 and 1638, states that prior to the arrival of Europeans, curers *(Oquetlupuc)* were public officials of high privilege and were paid a regular wage by the state. Their curing was done largely with herbs. If a curer lost a patient through ignorance, however, he was put to death by beating and stoning. His body was tied to that of his dead patient by a rope, and the latter was buried. The curer, however, was left above ground to be eaten by birds (Calancha 1638:556). An event closely resembling this is depicted in fineline on several Moche bottles of Phase V (figs. 2a, b, 65, color plate 8). The drawing clearly illustrates the burial of an individual being lowered into his grave with ropes manipulated by two figures standing at the edge of the grave. The body is encased in a coffin, possibly of rigid basketry. Similar coffins have been found in Moche tombs, as have gourd and ceramic vessels filled with a variety of food and other materials, similar to those that are seemingly being placed in the grave above the coffin. The rather large quantity of grave goods, along with the strombus shells beneath the coffin, would suggest that we are witnessing the burial of an individual of high status. This assumption is supported by the apparent depth of the grave pit itself, since rich Moche graves are generally found deeper than others.

To one side of the figures lowering the coffin into the grave is a dead, nude male figure who is lying on the ground being consumed by birds pecking at his flesh. The details of the scene are so similar to the practice described by Calancha, that in the absence of any other plausible explanation, it seems fair to suggest that the two are related.

Another correlation between the historical rec-ord and Moche iconography can be found in Fray Calancha's list of various witches from different parts of northern Peru. Among these, mention is made of a witches' guild at Barranca which had a rite involving ceremonial cannibalism and sexual orgy (Calancha 1638:632). Several Moche bottles with low relief designs depict a similar event (fig. 1). The scene focuses on two individuals engaged in sexual intercourse under a gabled roof. The male is elaborately dressed and has a fanged mouth. Above the roof are dismembered human heads and legs. To the right are two females standing beneath another gabled roof. They appear to be eating while observing the sexual act. Although it is impossible to identify what is being eaten, it is painted white as are the dismembered heads and feet nearby. If this does represent cannibalism, it is clearly associated with sexual intercourse, and involves at least the passive participation of several individuals. Although we cannot automatically assume that this scene is a depiction of a witches' guild similar to that mentioned by Calancha, it seems fair to suggest that the two may be related.

In another portion of Calancha's account of witches, mention is made of a rather popular witch named Mollep (The Lousy). Mollep is said to have lived at Coslechec in Talambo (Pacasmayo Valley) and was extremely dirty. He told the people that as his lice multiplied so would they (Calancha 1638:606–607). Three stirrup spout bottles in the archive provide tantalizing evidence for the occurrence of a similar figure in Moche society. Two of these bottles are nearly identical, and possibly were produced from the same mold (one of these is shown in fig. 66). Their chambers are modeled in the form of a seated figure. The face of the figure, characterized by distinctly almond-shaped eyes and a fanged mouth, stares blankly forward. The upper part of the torso is bare, and a long strand of hair extends from the top of the head across the chest, where it is being held by the left hand. Also clearly shown on the individual's body are three insect forms resembling lice.

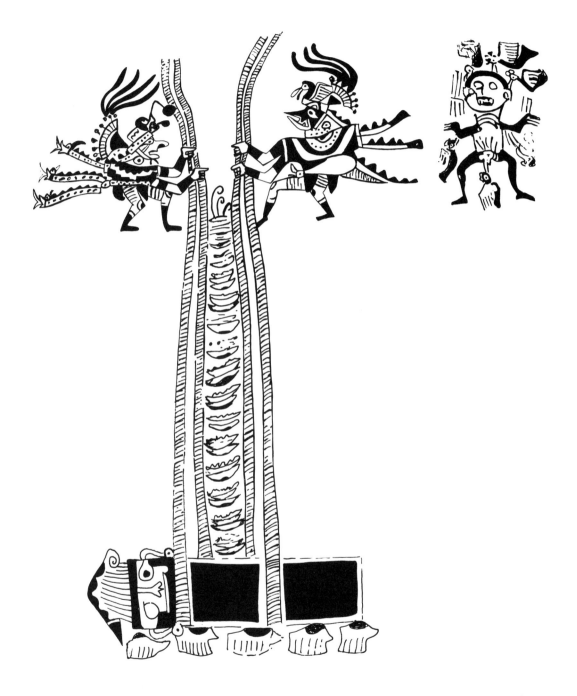

Figure 65. Fineline drawing of burial ceremony (cf. color plate 8).

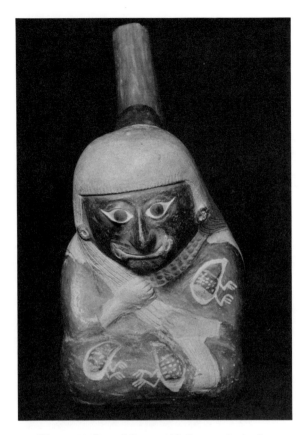

Figure 66. Seated figure with lice on the body.

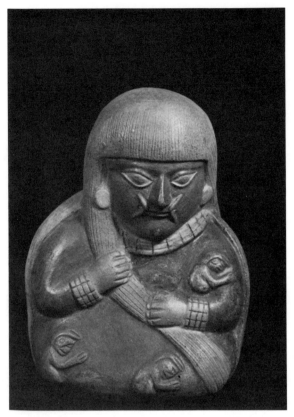

Figure 67. Seated figure with human forms on the body.

A third bottle has a chamber similar to the other two (fig. 67). The modeled figure is almost identical in facial features and body position. The only significant difference is in the three objects on its body. Although they are in the same location, and are approximately the same size as the insect forms on the other bottles, here they have distinctly human forms. The facial features and posture of this individual, as well as the placement of three objects on his body, are unique and distinctive within our sample of Moche art. Thus there is no question that we are seeing the same individual on all three bottles, and the substitution of lice and humans is unmistakable.

In the absence of Calancha's account of Mollep, it is likely that no interpretation could be given for this particular figure, or for the substitution of lice and humans. With this account, however, a very plausible interpretation is suggested. Naturally, there is insufficient evidence to conclude that the figure we are seeing in these three representations is Mollep, or that the figure lived at Coslechec. Yet it does seem reasonable that the figure depicted in Moche art is somehow related to the one described in the historical record.

These rather precise correlations between the historical record and Moche iconography strongly suggest that there was a continuing cultural tradi-

tion on the north coast of Peru which had its development at least as early as the second century A.D. and continued into the Spanish colonial period. Thus many of the customs, beliefs, and religious practices were maintained over more than 1300 years without significant change. This would imply that the Huari and Inca influences, rather than forming major breaks in the culture sequence of the north coast, had a relatively minor effect.

From the historical records we know that the Inca conquered the north coast by military means around 1470, and set about incorporating the population into their already existing empire. The historical documents make it clear, however, that although the Inca removed great quantities of precious metals from the Kingdom of Chimor, and kept the ruler in honored exile in Cuzco, the administration of the north coast was carried out primarily through the local institutions. The Kingdom of Chimor was superior in organization and culture to anything the Incas had ever seen at the time they conquered it, and they appear to have been inclined to incorporate it into their own empire rather than setting out systematically to destroy it. The Incas had a very liberal policy toward the religions of the people they conquered, allowing the people to continue worshiping their local deities while merely adding the Inca gods to the local pantheon. It is clear from the historical accounts that the Incas abhorred sodomy, which was widely practiced by the people on the north coast, and they made efforts to abolish it. This, however, is the only aspect of the local culture the Incas are known to have tried to abolish.

Less is known about the nature of Huari contact in this area, which occurred approximately A.D. 750–900. It is generally thought, however, to have been similar to the Inca conquest.

Recent archaeological work on the north coast has produced very little Inca or Huari material, and what has been found is limited to only small parts of a very few archaeological sites. No major

effect on art style, architectural pattern, technology, or economic relationships can be attributed to either Huari or Inca influence. Presumably there was also little or no effect on the lives of most of the inhabitants. If this was so, then the local cultural tradition, which was well established by the second century B.C., continued without major change until after the arrival of Europeans. This would account for similarities between the historic record and details of Moche iconography. Practices such as the killing of a physician at the death of his patient, ceremonies involving the combination of sexual orgy and human cannibalism, and religious figures such as Mollep can all be seen as parts of a cultural tradition maintained over many centuries by the local inhabitants. Since some information recorded by the Spanish chroniclers was derived from oral traditions that had survived from earlier times, it is also possible that portions of the information contained in these oral traditions had been carried on not just for the period beginning about 200 years before Spanish contact, but rather for more than 1000 years!

It should be pointed out that the sixteenth-century Spanish chronicler had little awareness of the long sequence of cultural development on the north coast of Peru, extending back thousands of years before his arrival. Indeed, it was not until the beginning of this century that an adequate picture of the chronology of cultures in the Andean area began to be assembled. Similarly, the native informant who related the oral tradition to the Spaniard was more than a generation removed from the events he was describing, and thus in many instances would have had little way of knowing exactly how far back in time a particular part of the story took place. Thus it is quite possible that some of the events recounted in the oral traditions took place much earlier than was thought by either the native informant or the Spanish chronicler.

Assuming that there was a continuing cultural tradition on the north coast from the time of the

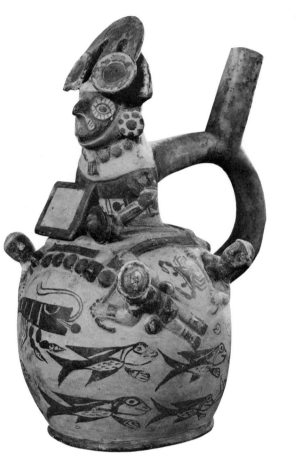

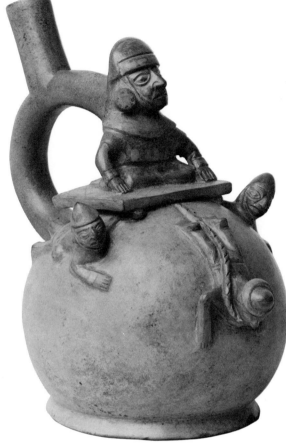

Figure 68. Anthropomorphized bird warrior seated on a raft that is pulled by swimmers.

Figure 69. Warrior seated on a raft that is pulled by swimmers.

Moche kingdom until the arrival of the Spanish, other historical information about the native culture in this area could suggest possible interpretations of other aspects of Moche iconography. For example, in our sample of Moche art, there are three depictions of a person seated on a raft pulled by individuals swimming alongside (figs. 68 and 69). The raft is distinct from the ocean-going tule craft that is so commonly represented in Moche art. Moreover, there are no rafts of this kind in

use in the area today, nor have they been reported from recent times. In the historical sources, however, a raft is said to have been used for crossing rivers in northern Peru. Their aboriginal use is attested by Diego de Trujillo in 1571 who, in his eyewitness account of the conquest of Peru, mentions that the members of Francisco Pizarro's invasion party who could not swim crossed the Río Saña on gourd rafts (Trujillo 1948:54).

Furthermore, Garcilaso de la Vega includes a

description of such a craft in telling of the various means used by the native people for crossing rivers.

They make other rafts of large whole gourds, enclosed in a net and tied strongly together. The raft measures a yard and a half square, more or less. . . . In front they put a leather sling, shaped like a saddle, into which the Indian raftsman puts his head and commences to swim. As he swims he pulls the raft with its cargo. . . . If necessary, one or two Indians help by swimming behind and pushing (Garcilaso de la Vega 1960: 107–108).

Another description of this type of craft comes from an anonymous traveler who visited Peru between 1605 and 1620. In the account of his travels he tells of crossing the Río Santa.

[The river] is crossed in some rafts made of gourds which they call *mates*. . . . These *mates* are as large as shields or bucklers and about a *palmo* [about 20 centimeters] high. They are round, flat on both sides, and slightly hollow in the center. These are netted together with cords in sufficient quantity to make the size of a bed, somewhat longer than wide. On top they put a few sticks of wood, and then load everything that is to be carried, including people as well as baggage (Edwards 1965:59–60)

Still other references to this type of craft were recorded by Acosta in 1590 (1894:247) and Cobo in 1653 (1956:266). Both of these accounts specifically state that these rafts were used at the Río Santa, a river that was clearly within the Moche kingdom (see map 1). Since the description of these rafts conforms so perfectly to the depictions in Moche art, it seems reasonable to assume that this is what is being illustrated.

Let us turn now to another depiction, this time of what appears to be an ancient smelter (fig. 3). This is a unique representation in our sample of Moche art. It shows four figures standing around a dome-shaped structure. Three of the figures hold long tubes to their mouths and the fourth appears to be manipulating one of the objects on the surface of the dome. The scene can only be understood by reference to the historical accounts of native

metalworking, such as the account of Inca metalworking provided by Garcilaso:

They did not have files or graving tools, nor did they reach the stage of bellows for smelting; they smelted by blowing with small copper tubes, more or less half a *braca* [about 90 centimeters] in length, depending on whether the furnace was large or small. The tubes were closed at one end leaving a small hole through which the air would leave with more force. As many as eight, ten or twelve of these were put together, according to the requirements of the furnace. They went around the fire blowing with tubes, and today they still use the same method, not being willing to change their customs (my translation, Garcilaso de la Vega 1944:126).

Similar accounts of native metalworking, utilizing blowtubes to create a forced draft of air, were written by Cieza de Leon in 1553 (Cieza de Leon 1864:404), Benzoni in 1565 (Benzoni 1967:62), Capoche in 1585 (Capoche 1959:109–110), and Raleigh in 1596 (Raleigh 1848:96).

Still another aspect of Moche iconography that might be interpreted through analogy to the historical record is the representation of individuals tied to posts while being consumed by birds. The legal system of the Chimu people involved a rather remarkable preoccupation with prohibitions against stealing, and the punishment of thieves was a religious as well as a civic matter—suggesting that property was a divine right. When a robbery was discovered, they set up a pole hung with ears of maize as a warning and to arouse the neighborhood. Sacrifices were made to the moon and to the constellation of Patá (our constellation Orion) to entreat their aid in finding the thief, and diviners were consulted. When the thief was found, he and his father and brothers were turned over to the injured man for execution. The dark of the moon was explained by saying that she (the moon) was in the other world punishing thieves. In the constellation of Patá (Orion), the row of three stars (Orion's Belt) was seen as a thief flanked by emissaries of the moon who were sent to feed him to the buzzards (Calancha 1638:553). The latter

were represented by the four stars immediately below. Various Moche specimens depict figures tied to posts with their faces flayed, or dead and being consumed by buzzards (e.g., Larco 1938–1939: fig. 215). Color plate 9 represents an individual tied to a rack. A flap of skin hangs down from the back of his right shoulder, possibly to tempt carnivorous birds. Quite possibly these Moche specimens represent the punishment of criminal acts committed by people within Moche society. Although there is no way of knowing what the specific crime may have been, theft should be considered a possibility.

We can get some idea of the social divisions of north coast society from an analysis of Muchic, the native language spoken on the north coast at the time of the Spanish conquest. Although our knowledge of this language is far from complete, a partial grammar was recorded by Father Fernando de la Carrera, which was published in Lima in 1644. In this grammar, Carrera lists two words for ruler: *alaec* and *cie quic.* The former was probably the title of the feudal lords of the various valleys, and the latter one of the titles of the king of Chimor. The other preserved words of social status are *fixllca*, gentleman; *paraeng*, vassal or subject; and *yana*, domestic servant (Carrera 1939:33, 63, 69). One might infer that the differences in social classes were great and immutable on the north coast, for the creation legends of these people relate that two stars gave rise to the kings and nobles, and two others to the common people (Calancha 1638:553–554). If the Moche people spoke Muchic, and shared the same creation legend with the later inhabitants of the north coast, it is reasonable to expect that they also shared these concepts of social status.

One final point should be made from an analysis of the existing historical record. This deals with the account of an early dynasty that is said to have ruled the Lambayeque Valley long before the dynasty that was in power during the Kingdom of Chimor. A detailed account of this dynasty is provided in *Miscelanea antartica* written by Miguel Cabello Balboa in 1586 (see chart 1). The story, in somewhat abbreviated fashion, is as follows:

The people of Lambayeque say that in times so very ancient that they do not know how to express them a man of much valor and quality came to that valley on a fleet of balsa rafts. His name was Naymlap. With him he brought many concubines, and a chief wife named Ceterni. He also brought many people who followed him as their captain and leader. Among these people were forty officials, including Pita Zofi, Blower of the Shell Trumpet; Ninacola, Master of the Litter and Throne; Ninagintue, Royal Cellarer (he was in charge of the drink of that lord); Finga Sigde, Preparer of the Way (he scattered sea-shell dust where his lord was about to walk); Occhocalo, Royal Cook; Xammuchec, Steward of the Face Paint; Ollopcopoc, Master of the Bath; and Llapchiluli, Purveyor of Feather-cloth Garments. With this retinue, and with an infinite number of other officials and men of importance, Naymlap established a settlement and built his palace at Chot [probably Huaca Chotuna].

Naymlap also brought with him a green stone idol named Yampallec. This idol represented him, was named for him, and gave its name to the valley of Lambayeque.

Naymlap and his people lived for many years, and had many children. Eventually he knew that the time of his death had arrived. In order that his vassals should not learn that death had jurisdiction over him, his immediate attendants buried him secretly in the same room where he had lived. They then proclaimed it throughout the land that he had taken wings and flown away.

The empire and power of Naymlap was left to his oldest son, Cium, who married a maiden named Zolzdoni. By her and other concubines he had twelve sons, each of whom was father of a large family. After ruling many years, Cium placed himself in a subterranean vault and allowed himself to die so that posterity might regard him as immortal and divine.

Subsequently there were nine rulers in succession, followed by Fempellec, that last and most unfortunate member of the dynasty. He decided to move the idol that Naymlap had placed at Chot. After several unsuccessful attempts to do this, the devil appeared to him

DATE	RELATIVE CHRONOLOGY	CUZCO	LAMBAYEQUE VALLEY	MOCHE VALLEY
1604				Don Antonio Chayguar
				—
				—
	Colonial Period			—Six christian caciques
				—(unnamed)
				—
		Atahuallpa		—
1528		Huascar		Caja-çimcim (Don Martin)
			Pecfunpisan	Ancocuyuch
	Late Horizon		Efquempisan	
	(Chimu Inca Style)	Huayna Capac	Fallenpisan	Guaman-chumo
			Cipromarca	
			Chullumpisan	Chimun-cuar
		Topa Inca	Llempisan	
1462–1470		Pachacuti	Oxa	Minchançaman
			Pallesmassa	—
	Late Intermediate		Pongmassa	—
	Period			—Seven rulers
	(Chimu Style)			—(unnamed)
				—
ca. 1370				Guarcri-cuar (Ñançen-pinco)
				Taycanamo
			Fempellec	
			Acunta	
			Lanipatcum	
			Llamecoll	
			Mulumuslan	
	Early Intermediate		Nofan Nech	
	Period (?)		Allascunti	
	(Moche Style ?)		Cuntipallec	
			Mascuy	
			Escuñain	
			Cium & Zolzodoñi	
			Ñamlap & Ceterni	

Chart 1. Early rulers of the north coast valleys. This is a suggested reconstruction based on historical records.

in the form of a beautiful woman. He slept with her and as soon as the union had been consummated the rains began to fall, a thing that had never been seen upon these plains. These floods lasted for thirty days, after which followed a year of much sterility and famine. Since the priests knew that their lord had committed this grave crime, they understood that it was punishment for his fault that his people were suffering with hunger, rain, and want. In order to take vengeance upon him, forgetful of the fidelity that is owed by vassals, they took him prisoner and, tying his feet and hands, threw him into the deep sea. With his death was ended the lineage of the native lords of the valley of Lambayeque and the country surrounding remained without patron or native lord during many days.

Then a certain powerful tyrant called Chimo Capac came with an invincible army and possessed himself of these valleys, placing garrisons in them. In Lambayeque he placed a lord called Pongmassa, a native of Chimor. He died a peace-loving lord, and left as his successor a son named Pallemassa. He in turn was succeeded by his son, Oxa, and it was in his time that the Incas were passing through Cajamarca. Thus Oxa was the first of his lineage to have news of the Inca lords. From this time forward the coast people began to live in constant dread of being conquered by the people from Cuzco.

Subsequently there were five successive rulers, followed by Pecfunpisan, in whose reign the Spaniards entered Peru (adapted from a translation of Means 1931:51–53).

The interesting chronological aspects of these dynasties of Lambayeque are worth a brief discussion at this point. The dynasty founded by Chimo Capac, with Pongmassa as the first ruler, was relatively late in the history of the valley. The third ruler of this dynasty, Oxa, must have reigned around A.D. 1470, since that was the time of the Inca conquest of the north coast. Pecfunpisan, the ninth ruler of that dynasty, was ruling when the Spanish entered Peru in 1528. It is almost certain, then, that Pecfunpisan's dynasty represents the ruling family of Lambayeque during the Late Intermediate Period, or essentially the time of Chimu domination of the north coast.

The earlier dynasty, that beginning with Naymlap, is more difficult to assign to a chronological period. This is largely because Cabello's narrative is not specific about the length of time between the two dynasties. Means (1931:54–56) suggests that this interregnum was contemporary with the time of Huari influence on the north coast, thus making the Naymlap dynasty contemporary with the Moche kingdom. Arbitrarily assigning an average reign of 25 years to each of the 12 rulers of the Naymlap dynasty, he suggests that the dynasty must have lasted about 300 years, and that this occurred during the first six centuries or so of our era.

When Bennett conducted a brief archaeological reconnaissance of the Lambayeque Valley in 1936, he found little evidence of Moche occupation, and suggested that the Naymlap dynasty occurred during the early part of the Chimu domination of the north coast, rather than during the Moche period (Bennett 1939:120). In the last ten years, however, there has been substantial evidence for a Moche occupation in the Lambayeque Valley (Donnan 1972; Day 1971). This evidence refutes Bennett's argument that the Naymlap dynasty occurred during Chimu times.

Rowe pointed out that neither Means's suggestion that the Naymlap dynasty was contemporary with Moche, nor Bennett's alternative placement during the Chimu domination seemed to fit the evidence satisfactorily (Rowe 1945:280). In a later article Rowe suggested that the interpretation of the ancient narrative be done following the principle that if the story explains the origin of a shrine or custom, or if the hero becomes a divinity or disappears instead of dying, then it belongs to the realm of legend and does not necessarily represent events that actually occurred (Rowe 1948:36). Rowe points out that there is a strong correlation between

places mentioned in the Naymlap narrative and places in the Lambayeque Valley, and close correlations between the names of certain characters in the narrative and the names of local shrines. He also suggests that Naymlap and Fempellec appear, according to his principle, to be legendary figures. Thus he concludes that the story as a whole is pure legend, and little more than an explanation of monuments and districts within the Lambayeque Valley.

I am rather reluctant to dismiss the Naymlap story as pure legend on this basis, although it seems equally unwise, in the face of available data, to assume that it represents strictly historical fact. Any judgment on the historicity of the narrative will have to await further evidence. Additional evidence is also required to determine whether the account refers to events of the Chimu period, or whether these events, be they historical or legendary (or a combination of history and legend), occurred during the Moche occupation of the north coast.

Given the nature of the continuing cultural tradition, it seems reasonable that the list of courtiers that Naymlap brought with him to Lambayeque is possibly a reflection of the official train maintained by the feudal lords in the Moche kingdom. It is possible to find representations in Moche art of people who may have held positions such as Blower of the Shell Trumpet (fig. 44), Master of the Litter and Throne, and Royal Cellarer.

We cannot automatically assume that these are the correct identifications of figures in Moche iconography. Nevertheless, the narrative does provide valuable insights into the nature of north coast culture, and many of these insights can be used to form working hypotheses, or even suggested explanations, of features of the iconography which would otherwise be completely unintelligible. The historical documents are clearly a valuable tool for working with Moche iconography. The deliberate search for correlations between the historical accounts and specific artistic depictions, of which this section represents only a beginning, should definitely be continued as more documents become available.

VII. Ethnographic Record

Since the native people living in the Andean area today still practice many aspects of culture that have their origin in the pre-Columbian past, ethnographic analogy can provide important clues for understanding Moche iconography. We are often rewarded by finding instances where objects and activities represented in Moche art have counterparts in native culture today.

One of the best correlations is between the tule boats represented in Moche art and those still used by native fishermen along the north coast of Peru. These water craft are made of a local species of reed *(totora)* bound in bundles to form the upturned, pointed prow and square stern (fig. 70). They are propelled by a paddle about eight feet long and three to four inches wide. Each paddle is simply a split piece of cane *(caña de Guayaquil)* that is held by both hands in the middle and used as a double-ended paddle.

In operation, a single fisherman either sits astride the craft with his legs dangling in the water on each side, or kneels on top with his legs doubled up under him. Occasionally fishermen venture out of sight of land, but more often fish within a mile or two of shore, beyond the zone of breakers and heavy swells. The craft are used today for three types of fishing: crabbing, line fishing, and net fishing. If used constantly, they become waterlogged or start to disintegrate. Thus totora craft are normally dragged out of the water and stood

Figure 70. Present-day fisherman with his tule boat and split cane paddle.

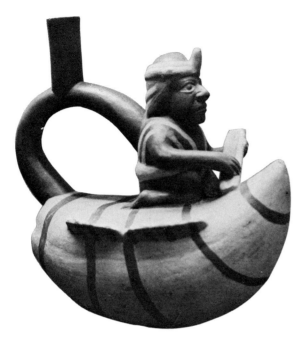

Figure 71. Moche figure on a tule boat, holding a split cane paddle.

up on their sterns when not being used. Many of the fishermen own more than one craft, so that they are able to use one while another is drying on the beach.

The modern totora craft and paddle are identical to many representations in Moche art (fig. 71). In the art, however, there are also representations of similar craft large enough to carry several passengers and even some cargo in the form of jars (fig. 72). On these larger craft the bow and stern are often elaborated with supernatural heads, and the craft are anthropomorphized by the addition of arms and legs. Although no large craft are in use today, they are reported in accounts written in the early part of the colonial period. Father Bernabé Cobo, writing in 1653, stated that two sizes of tule craft were built: small ones for fishing in the sea and large ones for crossing rivers and lagoons. He reported that the smaller craft were about six feet long with a maximum circumference as much as a man could encircle with his arms; they were able to carry only one or two occupants.

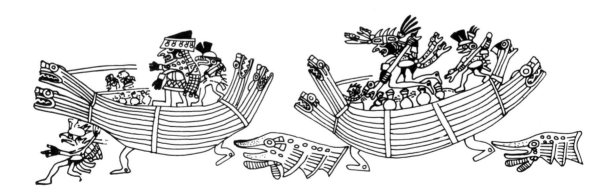

Figure 72. Tule boats with multiple passengers and cargo.

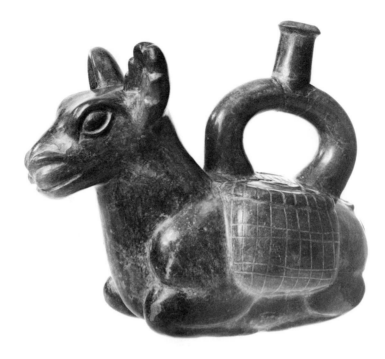

Figure 73. Llama with pack bag and one notched ear.

The larger boats were fifteen to twenty feet long and from ten to twelve feet wide and could transport a dozen people at one time (Cobo 1956:265–266). Manufacture of this large tule craft ceased along the coast sometime between the middle of the seventeenth century and early part of the nineteenth, although the large craft are still being made in the area of Lake Titicaca.

Another correlation between the ethnographic present and Moche iconography involves the use of llamas. The burden bags frequently shown on the backs of llamas represented in the art (color plate 10*a*) are almost identical to those used today by the people of the highlands (color plate 10*b*). They are made of coarse wool yarn that is fre-

quently woven with stripes of alternating colors. The present-day practice of earmarking llamas for identification (Tschopik 1946:521) is also found on several llama representations (fig. 73).

Individuals chewing coca frequently appear in Moche art. This was apparently done the same way as it is today—by chewing a handful of dry coca leaves until they form a quid. The quid is then kept in the cheek, and lime, which serves as a catalyst to free the cocaine from the leaves, is added as the chewing continues. The lime is kept in a small, narrow-necked gourd and is transferred to the mouth in small quantities by means of a stick. The lime gourds shown in Moche art are unusual in having a thick rim around the upper

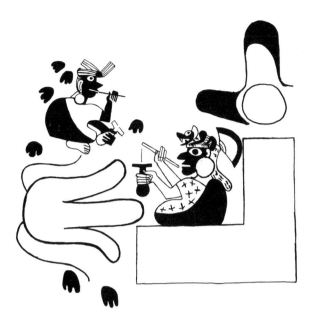

Figure 74. Individuals chewing coca.

part of the neck (figs. 17 and 74). These, however, are similar to the lime gourds reported ethnographically among the Cágaba of Colombia (Park 1946:884). After these people use the stick to put lime in the mouth, they rub the stick around the neck of the gourd, thereby depositing a small residue of lime. In time this builds up a hard concretion around the neck, thus forming the thick rim (fig. 75).

Curanderismo (folk healing) is still very prevalent on the north coast of Peru, and it clearly contains many elements of pre-Columbian ideology and practice. Although these elements are mixed with some Spanish culture traits, a study of present-day folk healing can provide many valuable clues to the interpretation of Moche iconography.

There have been various published accounts of folk healing in northern Peru (Gillen 1947; Cruz Sanchez 1948; Dobkin de Rios 1968; Chiappe 1968), but these have not attempted to relate the

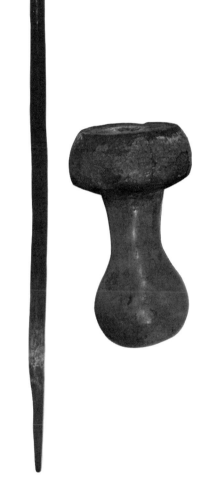

Figure 75. Lime gourd and spatula collected from present-day people of Colombia.

Figure 76. Overview of the mesa of a present-day folk healer in Peru.

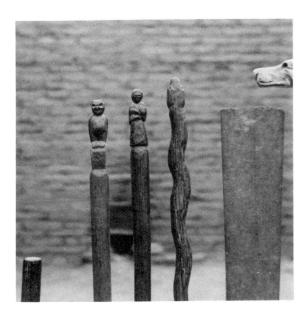

Figure 77. Detail of staffs at the head of the mesa shown in figure 76.

Figure 78. Detail of the wooden staffs from the tomb shown in figure 79.

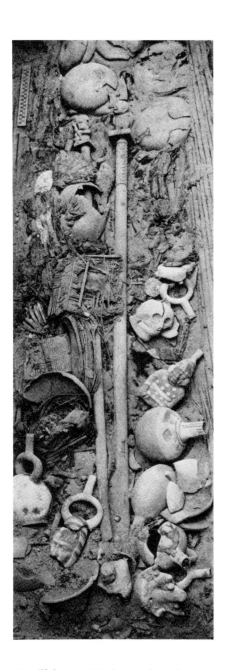

Figure 79. Elaborate Moche tomb with various objects placed on top of a wicker casket.

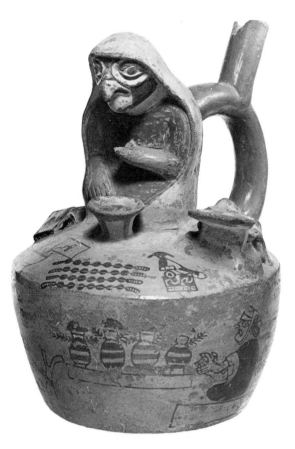

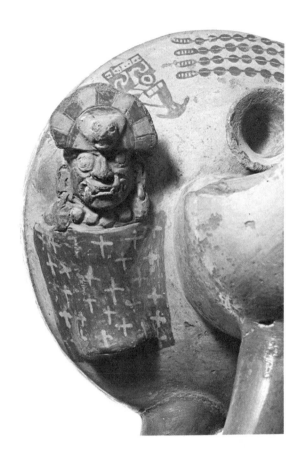

Figure 80a. Stirrup spout bottle illustrating various aspects of curing.

Figure 80b. Detail of the patient.

practices to pre-Columbian iconography. In 1970 Douglas Sharon began a study of Eduardo Calderon, a prominent *curandero* (shamanic folk healer) practicing in the Trujillo Valley. This study, involving participant observation in the form of apprenticeship to the curandero, continued on four subsequent field trips to Peru (Sharon 1972*b*, 1972*c*, 1973; Sharon and Donnan 1974). As Sharon's study proceeded, the Moche Archive was searched for representations that might correlate with the artifacts and ideology of present-day folk healing. Some materials from the Moche Archive were even

taken to Peru by Sharon, and shown to Eduardo to determine whether certain pre-Columbian themes still have meaning to modern folk traditions on the north coast.

Present-day folk healing practices consist of all-night curing sessions involving elaborate ritual, chants sung to the beat of a gourd rattle, ingestion of potions derived from a hallucinogenic cactus, and invocation of supernatural powers. Each shaman who conducts these rituals has a set of power objects known as a *mesa*. Placed on the ground in an altarlike arrangement, the mesa is the focal

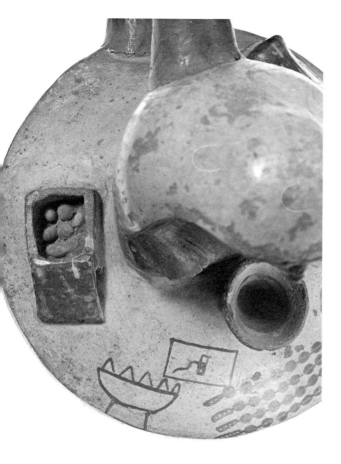

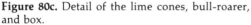

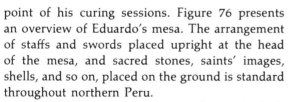

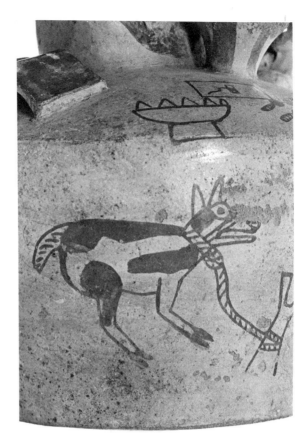

Figure 80c. Detail of the lime cones, bull-roarer, and box.

Figure 80d. Detail of the llama.

point of his curing sessions. Figure 76 presents an overview of Eduardo's mesa. The arrangement of staffs and swords placed upright at the head of the mesa, and sacred stones, saints' images, shells, and so on, placed on the ground is standard throughout northern Peru.

In Moche art there is nothing depicted which closely resembles Eduardo's mesa. Nevertheless, certain objects and individuals that are commonly represented correlate directly with items on the mesa. One of the most obvious correlates is the rattle (below the right hand corner of the crucifix

in figure 76). This instrument—used today in conjunction with whistling and songs to attract guardian spirits—activates all of the supernatural forces concentrated by the mesa. It also has a defensive function in warding off evil spirits, and is used by the shaman in a purification ritual that involves rubbing the bodies of all those present at the curing ceremony. Rattles are frequently depicted in Moche art (fig. 81), and various forms of Moche rattles have been found archaeologically.

Another item on the mesa, which suggests a survival from Moche times, is the Owl Staff (sec-

ond from the left in figures 76 and 77). North coast excavations by Strong and Evans in the 1940s uncovered a similar owl staff (fig. 78) in an elaborate tomb (fig. 79). The contents of this tomb suggest that the individual was of high status and had a religious role in Moche society (Strong and Evans 1947, 1952).

Eduardo's Owl Staff has ambivalent referents. For example, the owl is considered to be a symbol of wisdom and vision because of its capacity to see in the dark, and it is used to invoke the spirits of the ancients inhabiting *huacas* (pre-Columbian shrines) in order to cure witchcraft. But the owl also symbolizes corpses, cemeteries, and spirits of the dead—all representative of forces that must be activated in order to discover causes of witchcraft.

Adjacent to the Owl Staff is the Single Woman Staff (fig. 77). It is used to invoke sacred lagoons in the northern Andes of Peru for the cure of love spells. According to local folklore, these lagoons are places where the most powerful magical herbs used in folk healing are to be found. The spirit governing these lagoons is described by Eduardo as a female guardian wearing a shawl and carrying a bouquet of flowers symbolic of the curative herbs over which she has domain. She is also conceptualized as an ancient spinster, a sort of wise old lady whom Eduardo associates with the traditional herbal lore and wisdom of the pre-Columbian peoples.

The juxtaposition of the Owl Staff and the Single Woman Staff on Eduardo's mesa does not appear to be accidental. Rather, it is reminiscent of a series of curing scenes in Moche ceramics where the curer is represented as part woman and part owl, and always wears a shawl. Figure 80 shows various views of one of the most complex curing scenes in Moche art. Since many elements in this scene were reminiscent of Eduardo's ritual artifacts and practices, it was felt that his interpretation might be particularly valuable. Thus, detailed photographs of the piece were shown to Eduardo and

Figure 81. Individual holding a rattle.

his comments were solicited. He identified some of the elements immediately and with great confidence. He believed that the main figure wearing the shawl was the ancient Single Woman or pre-Columbian female herbalist and curer (fig. 80a). He saw her owl features as possibly symbolizing invocation of the spirits or transformation into an owl to effect the cure. The individual lying to the left side of the main figure was identified as the patient (fig. 80b). Eduardo felt that this patient is wearing the mask and headdress of a principal deity as a necessary part of the curing ceremony.

Figure 82. Individual holding strands of espingo seeds.

The patient's own headgear, a conical helmet, is represented in fineline drawing on the ground just above his head (fig. 80a).

Also in fineline drawing, immediately in front of the Single Woman (fig. 80a), are four strands of circular objects that Eduardo recognized immediately as *espingo*,[3] dried seeds brought in from the jungle beyond Chachapoyas (see map 1). These are traditionally strung on long strands of cotton twine and can still be purchased in local markets (Friedburg 1963:Plate VIII). On the Moche specimen, the four strands of espingo seeds are shown

with "handles" at each end. Today, similar handles are made by attaching loops of *margarita*, another medicinal plant. Such loops may have been used for holding the espingo strands as shown in figure 82. Although Eduardo uses espingo seeds to cure supernatural disorders, a sixteenth-century Spanish account tells of their use for stomachaches, hemorrhages, and other illnesses. The Indians also used them as offerings for their idols, shrines, and sacred objects (Arriaga 1968:44).

Just above the espingo seeds, enclosed within a rectangle, is an item that Eduardo recognized immediately as a bull-roarer used to attract or drive off spirits (fig. 80c). He uses a similar instrument—a rope belt from a monk's habit—which, when not being employed as a bull-roarer, can be draped over the crucifix (fig. 76) or worn around the neck for protection. Below the rectangle (fig. 80c) is an object that was perceived by Eduardo as a pedestal bowl containing five solid cones of lime. Lime is still sold in this form in local markets, and is used in a purification ritual at the end of the all-night curing sessions.

Eduardo was less certain about the identification of the remaining objects drawn in fineline. He suggested, however, that the individual on the lower part of the chamber (fig. 80a) could be the assistant to the Single Woman, that the jars in front of the assistant may contain magical herbs, and that the tethered llama (fig. 80d) is possibly being used for magical removal of sickness.

Eduardo was also unsure about the identification of the material inside the box located on the right-hand side of the curer (fig. 80c). He thought that the oval discs might be colored powders compacted into this shape and applied to skin irritations. It should be noted, however, that although colored powders are available for this use in the local markets, they are not currently sold in a compacted form.

Another aspect of the curing scene which deserves special attention is the material held in the

left hand of the main figure. Eduardo was aware that this material was modeled in a way that made it distinct from the objects in the box. He suggested that it may be a slice of *San Pedro,* the hallucinogenic cactus that is widely used in shamanistic ritual today. This tentative identification is strongly supported by similar curing scenes in which the main figure holds a more fully modeled representation of what is clearly San Pedro in her outstretched hand (cf. Sharon 1974:fig. 6).

Contemporary healers classify San Pedro as *the* magical plant *par excellence.* Thus its persistent association with the female herbalist, overseer of the

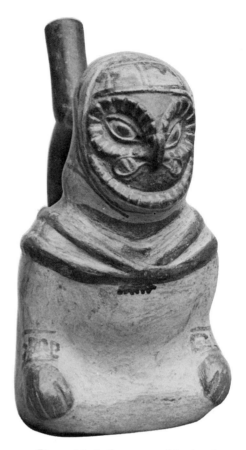

Figure 84. Anthropomorphized owl.

Figure 83. Anthropomorphized owl holding a human head and a tumi knife.

realm of the magical lagoons and plants, is very appropriate. It should be noted that the continuous utilization of this plant from circa 600 B.C. to the time of European contact is demonstrated by its consistent representation in pre-Columbian Peruvian art (see Sharon 1974:figs. 1–10). Its use is also mentioned in several of the historical accounts written in the early colonial period (Cobo 1956:91–105; Oliva 1857:124–125).

Before discussing the other artifacts on Eduardo's mesa which correlate with elements in Moche iconography, more should be said about

the owl motif. We have already noted the ambivalent (that is, wisdom vs. the macabre) nature of its valuation in Eduardo's system of symbols. In Moche iconography the owl also appears to have a variety of roles and connotations. In some representations it holds a knife and a decapitated human head (fig. 83), while other situations suggest a more pacific role (fig. 84). Thus, the predominance of the owl in contemporary folk healing may result from a conjunction of various themes from both the pre-Columbian and Spanish cultural heritages.

Another bird given supernatural significance by Eduardo is the hummingbird, which finds expression in a Hummingbird Staff (fourth from the right in fig. 76 and second from the right in fig. 86). Because of the sucking ability of the hummingbird, this artifact is associated with the removal of foreign objects inflicted by sorcerers. It is also associated with herb "gardens" under the aegis of the Single Woman Staff. Hummingbirds, both

Figure 86. Detail of staffs at the head of the mesa shown in figure 76.

Figure 85. Anthropomorphized hummingbird.

natural and anthropomorphic, find frequent expression in Moche art (p. 32 and fig. 85).

In view of the frequent depiction of ornithomorphic traits in Moche iconography, the Eagle Staff at the head of Eduardo's mesa (sixth from the right in fig. 76 and third from the right in fig. 86), deserves special attention. To Eduardo, it is a symbol of personal intelligence and vision, the latter related to the sharp eyesight of the eagle. This staff is used to boost the morale of patients who are suffering from ill fortune or personal tragedy. In his curing songs, Eduardo associates it with the highest mountain peaks in Peru which, for him, symbolize the soul's capacity to soar through the air. Such "magical flight" is performed by Eduardo during the ecstatic trance state induced by the hallucinogenic San Pedro. Calancha

Figure 87. Anthropomorphized eagle warrior.

(1638:632–633) cites Teruel who verifies this capacity for seventeenth-century coastal shamans when divining. It can be suggested that some of the anthropomorphized eagle warriors in Moche iconography (fig. 87) allude to ecstatic "magical flight." When engaged in "flight," Eduardo frequently has occasion to take up arms—one of the swords at the head of the mesa—to attack or defend against evil spirits.

In addition to the owl, hummingbird, and eagle, certain animals are clearly important in Moche iconography and have symbolic meaning in present-day shamanism. The deer is commonly depicted in Moche art. It is represented on Eduardo's mesa by the right front foot of a deer (third artifact in line with the base of the first "staff" on the left in fig. 76). Symbolizing swiftness and elusiveness, the deer is used by Eduardo to detect attacking spirits, as well as to exorcise spirits in cases of possession. In many Moche representations, deer are shown in association with a tree (fig. 88) which has recently been identified by Furst (1972:65) as *Anadenanthera colubrina* (previously known as *Piptandenia colubrina*). Seeds from this tree were mixed with *chicha* and drunk by Inca sorcerers to discover lost or stolen objects or to divine what was occurring in distant places (Polo

1916:30). It does not seem likely that the association of deer with this hallucinogenic plant is an accident. Furst (1972:65) provides the following information regarding contemporary ethnographic usage:

> The seeds are widely made into a potent psychotomimetic snuff, called Willka (or *Vilca)* in the Andes; they are also ingested in an alcoholic drink and, in some highland villages, play an important role in the making of *llampu,* a sacred substance used in cattle increase and other rituals.

Another significant animal in Moche art is the sea lion. It is frequently represented on the mesas of contemporary folk healers by sea lion stones (Gillin 1947:124, nos. 15 and 18). These are common beach pebbles that are swallowed by sea lions. They are obtained when sea lions are hunted on the offshore islands of Peru, and are considered to have extremely powerful medicinal properties. Powdered portions of these stones are used to cure heart

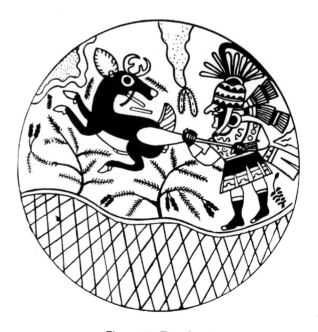

Figure 88. Deer hunt.

troubles. Although Eduardo does not have such stones on his mesa, he is fully aware of their use by other curers. He claims that the intestinal juices from the sea lion's stomach provide the stones with their curative properties, and that they are useful in curing epilepsy and heart disorders.

As noted above (chap. 3), in Moche art sea lions are generally depicted with a rounded object in or immediately in front of their mouths. In illustrations of sea lion hunts, these objects are almost always shown (fig. 14). Eduardo explained that when sea lions are hunted today they frequently cough up the stones. It seems almost certain that Moche artists were representing the sea lion stones in their depictions, and it is likely that the present-day beliefs about the curative powers of these stones represent a survival from Moche culture.

Felines are frequently depicted in Moche art. They are represented in natural and anthropomorphized form (p. 30 and fig. 89), and feline attributes

Figure 90. Anthropomorphized fox warrior.

Figure 89. Feline.

such as fangs, claws, and pelage markings are commonly seen in Moche dress and ornament (figs. 53 and 92). Felines are important in the ideology of present-day folk healing. Eduardo has a cat fetish on his mesa. It is called the Cat, and is placed on top of a quartz crystal mirror. Although the Cat is not shown in our photograph of his mesa, the mirror is the last artifact in line with the base of the Serpent Staff (fourth from the left in fig. 76). The Cat is composed of the eyes and right paw of an alley cat that Eduardo hunted especially for the mesa. After killing it, he sucked the blood from its neck three times to absorb the power and aggressiveness of the feline. This artifact sits on the crystal mirror where it can best visualize attacks by malevolent spirits reflected in the mirror. Like the owl and eagle, the cat is valued because of its sharp eyesight, symbolic of visionary insight.

Figure 91. Foxlike creature with possible lunar symbolism.

Like the deer, it is important because of its swiftness and agility, which are used to chase off supernatural dangers. Finally, the force and valor of the cat are considered indispensable to Eduardo's success as a shaman; like the attributes of the eagle, they help him attack and defend against evil spirits.

The fox is another important animal. It is symbolized on the mesa by the Fox Ceramic, a pre-Columbian pottery fragment modeled in the form of a fox head (fourth in line from the base of the Owl Staff in fig. 76). To Eduardo the fox symbolizes misfortune and danger caused by guile and deception. At the same time, it represents the ability to overcome setbacks and obstacles with the astuteness of the fox. Eduardo also associates it with the moon. The fox, in either natural or anthropomorphic form, is the most frequently depicted animal in Moche art (fig. 90), including scenes with possible lunar symbolism (fig. 91).[4]

Another animal referent on Eduardo's mesa is the Dog Staff (fourth from the right in fig. 86 and fifth from the right in fig. 76). Like the deer and cat, the dog is valued because of its swiftness and speed. But its greatest value lies in its sense of smell and ability to track down lost or stolen objects and runaway people, such as spouses who have abandoned their families. In addition to the ability to smell the human shadow or soul, the dog's tracking capacity includes the ability to smell out evil spirits who wish to do harm to Eduardo's patients. In contemporary northern Peruvian folklore, dogs are credited with the ability to see spirits. When dogs in a neighborhood bark in unison, it is interpreted either as being caused by the presence of disembodied spirits or as an omen of impending disaster. When relating the supernatural qualities of the dog, Eduardo refers to it as *alcosunca* (a spotted, short-haired dog) or *alcocala* (a hairless dog).[5] He contends that by placing either of these dogs in the bed of a person suffering from a fever, it is possible to alleviate the condition, since the dog will take on the heat and "humors" of the fever. Also, when tracking evil, this dog drinks at an "evil" stream flowing out of one of the sacred lagoons in the Andes. In Moche iconography, the dog (identified by Eduardo as alcosunca) is frequently found in ritual scenes, where it is positioned adjacent to the most important figures (p. 30 and fig. 104). In addition, Calancha (1638:628) informs us that coastal shamans were capable of transforming themselves into dogs.

Eduardo's Serpent Staff (fourth from the left in figs. 76 and 77) embodies the concept of balance which governs the mesa. He sees the serpent as the mediator of opposing forces—for example, good and evil, light and dark, death and rebirth—which are activated by the mesa. It also unites the sun and ocean. Perhaps "mediated dualism" was part of the message conveyed by serpents in Moche iconography. In this respect note that fanged beings (who may be transformed shamans) often wear serpent ear ornaments and/or serpent belts (fig. 92). This correlation of feline and serpentine traits persists today on Eduardo's mesa. The line of artifacts at the base of the Serpent Staff terminates with the cat amulet discussed previously. This row, beginning with the Serpent Staff and terminating with the cat is the focal point in Eduardo's supernatural "power" and "vision." By mediating and

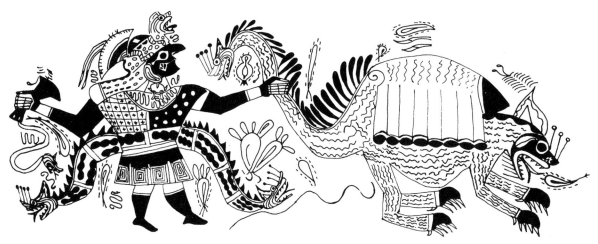

Figure 92. Combat between a fanged individual wearing a serpent belt and a *Strombus galeatus* monster.

concentrating the dualistic forces of the mesa, it makes supernatural therapy possible. Perhaps the serpent/feline associations in Moche art were meant to portray shamans with this same capacity.

The lizard is yet another creature that is frequently represented in Moche art and is important in folk healing. Lizards are native to northern Peru and live in the scrub forests along the margins of the river valleys. They subsist exclusively on the seeds of the algarroba tree, which may be a close relative to the hallucinogenic *Anadenanthera colubrina* shown in figure 88. Algarroba seeds are believed to have powerful medicinal properties, but they have a bitter taste. Thus the local people consume the lizards, which are considered a delicacy, with the assumption that they will thereby derive the benefits of algarroba (Holmberg 1957). When lizards are represented in Moche art, they frequently are shown in association with algarroba pods, suggesting that this association was prevalent in the minds of the Moche people as well (p. 34). Eduardo does not have a lizard referent on his mesa, but they have been noted on the mesa of at least one north coast shaman (Gillin 1947:127).

Before leaving this analysis of Eduardo's mesa artifacts, a word seems in order regarding the function of the staffs and swords at the head of the mesa. These artifacts play key roles in curandero therapy. At a given time during the ritual, one of the staffs becomes the focal point in the patient's ailment and must have its powers activated by the curandero's chants. In serious cases of witchcraft, the swords can be used in ferocious battles, during which the curandero exorcises malevolent spirits responsible for the patient's malady. Perhaps the precedent for such "spirit battles" can be found in some of the war scenes on Moche pots. Although it is likely that actual combat did take place between different populations on the north coast during Moche times, it appears that warfare had ritualistic and magico-religious overtones. Moreover, much of what appears to be combat is probably the portrayal of shamanistic encounters with supernatural demons and evil spirits. Thus war clubs, which are so frequently represented in Moche art in both natural and anthropomorphized form (figs. 87, 96, and 102), may well be seen as the pre-Columbian counterparts of the staffs and swords used by present-day curanderos. In a shamanic clash the artifacts of

Figure 93. An individual holding corn and manioc plants, standing at the base of three mountain peaks (two views).

daily life take on their supernatural aspects, just as Eduardo's weapons can be turned to "spirit battles."

Up to this point, we have been discussing fairly graphic examples of present-day curing practices that correspond to Moche artistic representations. Let us now move to a more conceptual level of analysis for which there is less direct ethnographic evidence, but which is nevertheless worthy of consideration. This line of investigation attempts to trace parallels between certain key concepts of present-day shamanism and two categories of modeled Moche ceramics: mountain scenes and hand signals.

Mountain scenes are fairly common in Moche art. They are vessels modeled in the form of mountain peaks, with the highest peak in the center and smaller peaks receding evenly to left and right (figs. 93, 94, and 95; see also lower right corner of fig. 79). Most of the mountain scenes have five peaks, although a few have three, four, six, or seven. A variety of activities that seem to have ritual or symbolic significance occur in the mountain scenes. Some of these are quite simple, with one or two figures at the base of the mountains or among the peaks (figs. 93 and 94). The more complex mountain scenes, such as that shown in figure 95, often have a figure draped over the central peak (with the hair falling forward), smaller figures seated between the peaks, a larger fanged figure positioned to one side, and other figures represented at the base of the peaks.

The number and variety of mountain scenes in Moche art suggest that the mountains played an

important role in the ideology of the Moche people. Mountains still play a major role in the world view of present-day folk healers. Mountains are very important in Eduardo's folk healing. Besides nurturing the magical herbs used in therapy, mountains are believed to be inhabited by guardian spirits *(auquis)*. During a night healing session, certain powerful mountains are invoked in Eduardo's songs so that the guardian spirits will assist in his therapy.

Both the mountains and highland lagoons are places where novice curanderos are initiated as shamans. These power spots embody the dualistic ideology underlying curanderismo, for there are "good" and "evil" mountains and lagoons just as there are "good" and "evil" archaeological religious shrines (huacas) inhabited by the dead and the spirits of the ancients. Mountains, lagoons, and huacas are significant to Eduardo's practices. During ecstatic "magical flight" induced by the ingestion of San Pedro, he journeys in spirit to these supernatural sites—often entering the labyrinthine passageways of the mountains and huacas. In light of the above, it is entirely possible that some of the figures shown in Moche mountain scenes are the pre-Columbian counterparts of the guardian spirits (auquis) invoked by Eduardo.

It is also interesting to speculate about the figure lying on its stomach over the central peak in many mountain scenes (fig. 95). This individual almost always has its head down, with the hair flowing down the central mountain. We know that hair

Figure 94. Two seated individuals and an animal in the setting of five mountain peaks (two views).

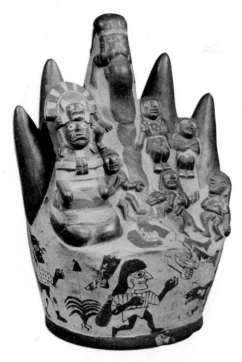

Figure 95. Various individuals apparently engaged in human sacrifice in the setting of five mountain peaks (two views).

was symbolically important in native Peruvian culture prior to European contact. Morua (1922–1925:110) says that when the Inca washed his hair there was great festivity and exchanging of gifts. During the church's efforts to eliminate idolatry in the early colonial period, Licentiate Rodrigo Hernandez reported the following:

In the house of the parents of a leading Indian they had hidden the hair of a great-grandfather, an Indian idolater. These locks of hair were displayed, respected, and worshiped in his memory (Arriaga 1968:86).

It was also noted that one of the most effective ways to shame a native magico-religious practitioner was to cut his hair "as the queue is regarded as an important ornament" (Arriaga 1968:116). This is reminiscent of combat scenes from Moche art—

which, as noted previously, seem to have magico-religious overtones—where the victorious warrior grasps the foreknot of his conquered opponent (fig. 96). Also, prisoners are frequently shown with their hair relatively short and in disarray as though it had just been cut (fig. 15).

Hair is still important today in Eduardo's shamanism. He keeps hairs from the crown of his head in a jar along with perfumes, saints' medals, magical herbs, and the like. This jar, which Eduardo considers to be his *alter ego*, is used to divine the cause of a patient's malady during night curing sessions. One of the most common ailments so divined is witchcraft performed with hair from the head of the victim. Sharon (1972*a*:133–134) relates his observations of Eduardo's therapy dur-

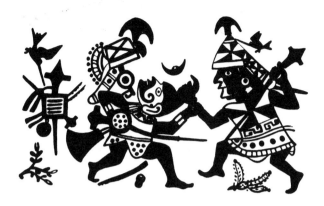

Figure 96. Combat scene depicting the pulling of hair by the victor.

ing which participants claimed to see a monster pulling the patient's hair from behind. It seems that today—as in the past—hair is believed to have a vital link with the life force.

Related to the mountain scenes in Moche art is a group of representations that involve a hand signal. This hand signal, which is referred to hereafter as the "half fist," is formed in a fashion similar to that for a full fist, except that the thumb remains erect at the side and four fingers are only half clenched, so that the fingernails are still visible. In addition, the knuckle of the middle finger is

Figure 97. Modeled forearm with hand in the half fist position.

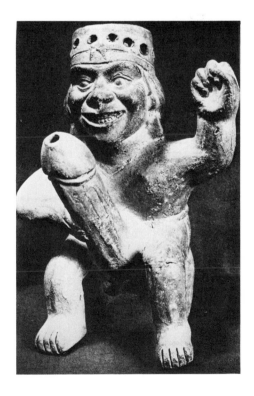

Figure 98. Erotic male figure with hand raised in the half fist position.

111

held higher than the others to protrude above the remaining three fingers and thumb (fig. 97). In the Moche Archive, there are nine depictions of the half fist. Six of the nine pieces simply depict hands or arms displaying half fists. Two more pieces are erotic (figs. 98 and 99), and the remaining piece depicts a creature with a fanged human head and human arms on the body of a manioc plant (fig. 100).

The relationship between mountain scenes and the half fist is demonstrated by certain specimens,

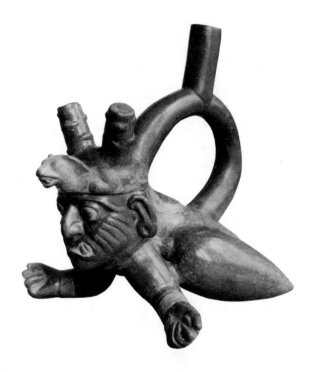

Figure 100. Anthropomorphized manioc deity with both hands in the half fist position.

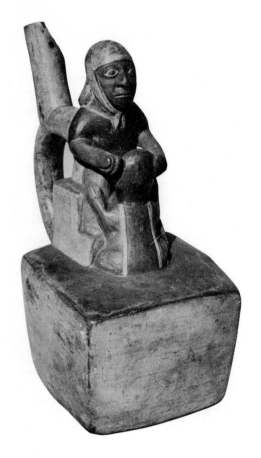

Figure 99. Erotic representation with the male's hand in the half fist position.

such as figure 101, in which the back of the fist is modeled in the form of five peaks, while the front clearly shows the half fist posture of the hand. Like the mountain scenes, the half fist emphasizes a central point with symmetrically arranged protrusions to each side.

Although it is difficult to understand fully the symbolic meaning of the half fist, its relationship to shamanism is demonstrated by a beautiful Moche bone specimen in the British Museum (fig. 102). This specimen, carved in the form of a half fist, has an incised design that incorporates many shamanic elements—ornithomorphic beings, clubs and shields, anthropomorphized clubs and shields (one holding a goblet), a serpent, felines in association with cacti (San Pedro?), and geometric designs. A detailed study of similar scenes in

Moche iconography suggests that this is a representation of a ceremony involving blood-letting and consumption of a ritual beverage (see chap. 8). It seems quite possible that the half fist is a symbolic gesture referring to the essential qualities of the mountains in shamanic ideology, as well as the rituals that take place in the context of mountains and highland lagoons.

One final aspect of Moche iconography that can be related to shamanism is the depiction of individuals holding an assortment of ceramic vessels (color plate 11). These individuals are generally considered to be pot vendors, possibly on their way to market to sell their wares. In the more complex representations, they hold a stirrup spout bottle, a flaring bowl, a dipper, a jar, and a reed

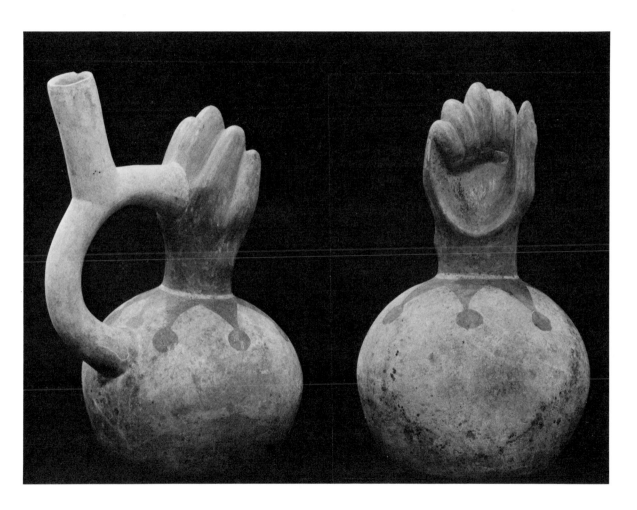

Figure 101. Modeled hand in the half fist position (two views). Back of the hand is modeled in the form of five mountain peaks (cf. figures 94 and 95).

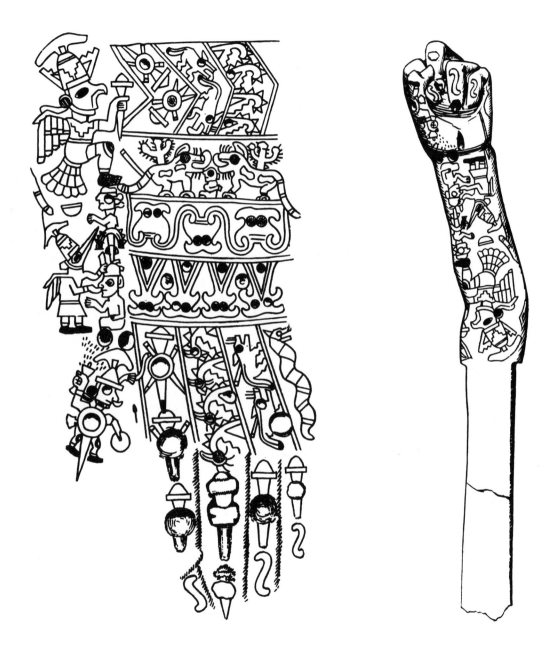

Figure 102. Bone spatula carved in the form of a hand in the half fist position, and detail of incised design.

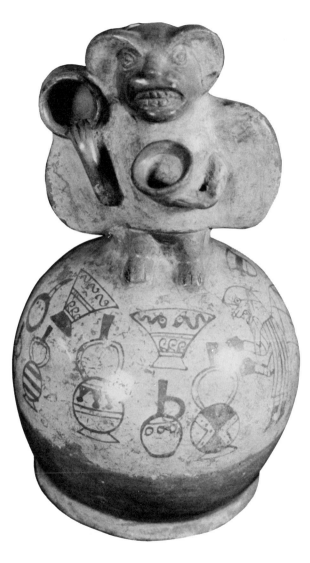

Figure 103. Anthropomorphized bat holding a flaring bowl and a jar.

mat, while balancing a jar on the head. It is important to note, however, that a similar inventory of vessels, plus the reed mat, is sometimes held by anthropomorphized bat figures (fig. 103).

On the basis of present-day folk healing, it seems plausible that these individuals, whether fully human or part human and part bat, are related to shamanism—the mat, possibly a pre-Columbian mesa, and vessels being part of the curing paraphernalia (note the numerous bowls and containers on Eduardo's mesa, fig. 76). In support of this interpretation, very often these figures are shown whistling. As noted above, whistling occurs at various times during the curing ritual to invoke guardian spirits. Eduardo has a bat fetish on his mesa (second in line from the base of the Owl Staff in fig. 76). It is a fragment of pre-Columbian ceramic modeled in the form of a bat. Eduardo feels that the bat has the power to enter ancient huacas or shrines to invoke malicious spirits of the dead who dwell therein. In so doing, the bat is able to detect the cause of witchcraft.

All this is not to say that the human figure holding ceramic vessels had nothing to do with pottery manufacture. Although probably not "pot vendors" in the strictly commercial sense, the ancient shamans may have been involved in the manufacture of art objects. The complex iconography of Moche art must have been produced by individuals versed in the esoteric "code" that it communicates. In this regard, note that Eduardo is a gifted artist, competent in ceramics, woodworking, and stone sculpture. It is well-documented that in many non-Western cultures the shaman is a person with a particularly acute aesthetic sense. He often is a master of the artistic skills deemed most valuable by his society, and is frequently reported to have highly developed musical, poetic, and dramatic talents. Quite possibly, Moche shamans, through the medium of their artistic creativity, were the transmitters of traditional lore just as Eduardo is today.

It should be stated that these relationships between Moche iconography and present-day native culture do not represent a definitive interpretation. Rather, they are presented as tentative correlations that may represent survivals from the pre-Columbian past. Although the native culture is still very much intact, in adapting to a changing cultural milieu, it has evolved into a functional syncretism of Indian and European traits that tend to lose their significance if artificially separated. The demonstrated parallels between native culture and Moche artistic depictions suggest that much can be learned from detailed observations of present practices when combined with a careful study of a large sample of Moche art.

VIII. The Thematic Approach to Moche Art: The Presentation Theme

Although Moche art gives the impression of having an almost infinite variety of subject matter, analysis of a large sample of it indicates that it is limited to the representation of a very small number of basic themes. In this section we demonstrate the nature of these basic themes, and the advantages of working with Moche art in terms of them.

To illustrate what is meant by a basic theme, it is perhaps best to make an analogy to Christian art. If we were to examine a large sample of Christian art, certain basic themes would become apparent because of the frequency with which they are depicted. Among these basic themes would be the birth of Christ, the last supper, and the crucifixion. By carefully studying numerous representations of one of these basic themes, it would be possible to identify a specific set of symbolic elements that are characteristic of it. With the birth of Christ, for example, the symbolic elements include certain individuals (the infant, the virgin, Joseph, wise men, innkeeper, etc.) and objects (manager, inn, barnyard animals, star, etc.). There are also certain activities that are traditional for each of the characters. Since most of these activities relate to the birth of the Christ child, we might refer to the various depictions of this event as examples of the Nativity Theme.

Although the symbolic elements that characterize the Nativity Theme are standard, there is considerable variation in the way they are combined in different representations. In some of the representations only one of the symbolic elements is shown—perhaps only the Christ child, or the star, or the manger. More often, artists choose a combination of elements. Thus there are numerous representations of the virgin and child, or the virgin, child, and Joseph. Others combine the child, manger, and star in a single representation, or wise men, star, and child. The possible combinations are almost infinite. It should be noted, however, that the complete inventory of symbolic elements is rarely found together in a single representation.

In the course of our research, it became apparent that Moche art is very similar to Christian art in consisting of a limited number of basic themes. One of the basic themes of Moche art involves the presentation of a goblet to a major figure, and thus we refer to it as the Presentation Theme. The contents of the goblet are not known, but there is reason to suspect that they may, at least in part, be human blood that is taken from prisoners who are normally shown in the same scene. To understand the nature of this theme, let us begin by examining a depiction of it which includes a large number of its symbolic elements. An excellent example is the famous fineline drawing shown in figure 104. To facilitate identification of the symbolic elements of this representation when comparing them with others, we identify each with a letter.

A. A rayed figure, who can be recognized by the rays emanating from his head and shoulders; his size is large relative to the other figures in the scene; and he is being presented with a goblet by a figure holding a disc. He also consistently wears a conical helmet with a crescent-shaped ornament at its peak, a backflap, and a short shirt and skirt.

B. This figure holds a disc in one hand and a goblet in the other. He normally is shown presenting a goblet to figure A. He is always part bird and part human, and wears either

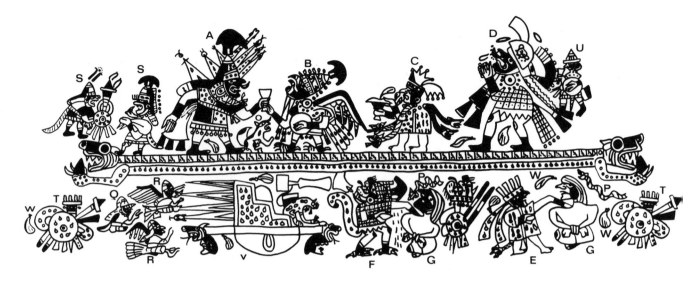

Figure 104a. A fineline representation of the Presentation Theme.

a conical helmet as shown in this representation, or a headdress similar to that worn by figure D in this scene.

C. This figure holds a goblet in one hand and appears to be covering the goblet with a gourd plate (upside down), which is held in the other hand. He has a diagnostic set of clothing which makes him recognizable wherever he is depicted. This includes the long shirt, and headdress with tassel ornaments hanging in front and behind (in this instance, for lack of space, the artist has drawn the forward tassel on top of the headdress rather than in front of it—see fig. 104c). From the shoulders of this figure hang long sashlike objects that terminate in serpent heads. In some representations this figure holds the disc in one hand while presenting a goblet with the other.

D. This figure is recognizable because of certain details of his clothing—primarily the scarflike objects hanging from his shoulders, which have serrated upper edges, and the

other sashlike objects with a series of discs at the border. The figure also wears an elaborate nose ornament and a very characteristic headdress. The front of the headdress has a half circle of sheet metal with an animal face, possibly a feline, embossed near its center. This half circle is flanked by two curved objects that are possibly also of sheet metal. At the back of the headdress is a tuft of feathers (for a three-dimensional representation of this headdress, see fig. 112 below).

E. A human figure in the process of drawing blood from a bound, nude prisoner.

F. An anthropomorphized feline figure in the process of drawing blood from a bound, nude prisoner. Sometimes this figure is fully feline, with no noticeable human attributes.

G. A bound, nude prisoner from whom blood is being drawn.

These, then, are most of the major figures involved in the Presentation Theme. Other major figures not shown in this representation are added

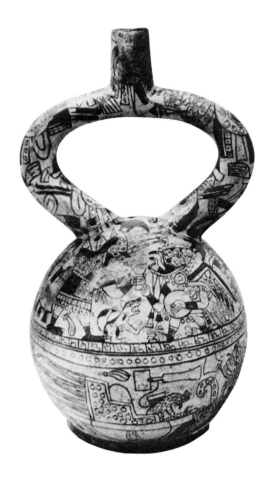

Figure 104b. Stirrup spout bottle from which the fineline drawing of the Presentation Theme in figure 104a is derived.

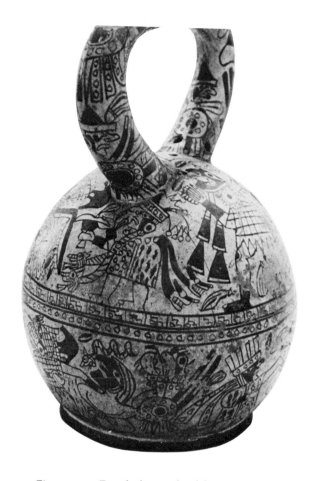

Figure 104c. Detail of one side of the stirrup spout bottle shown in figure 104b.

from other depictions discussed below. In addition to the major figures, the following minor figures and objects are customarily included:

O. A dog near the rayed figure (A).
P. A serpent.
Q. An anthropomorphized fox warrior.
R. An anthropomorphized bird warrior.
S. An anthropomorphized feline warrior.
T. A club and shield.

U. An anthropomorphized club and shield, frequently shown holding a goblet.
V. A litter. In some representations a throne is represented instead of a litter.
W. An ullucu fruit.

Another example of the Presentation Theme is a low relief design from the chamber of a dipper (fig. 105a, 105b). In this case, the limited area available for the design may well have been a factor

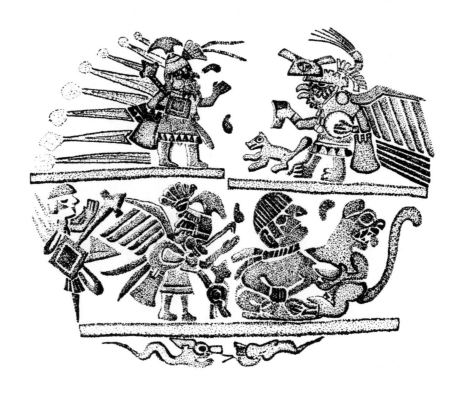

Figure 105a. A low relief representation of the Presentation Theme.

in the artist's decision to simplify the Presentation Theme by using fewer figures. He has nevertheless included the primary figure (A) in the upper left-hand corner, complete with the rays emanating from his head and shoulders. Facing him, holding the disc, and presenting him with a goblet, is the anthropomorphized bird figure (B) who in this instance is wearing the headdress typically worn by figure D. Immediately below the figure with the disc is the bound, nude prisoner (G) being held by a feline (F). In this instance the feline has no obvious human attributes. To the left is the anthropomorphized bird warrior (R) seen here as a rather significant figure in contrast to the way he was shown in the scene discussed above. The artist has also included two serpents (P) and a club and shield (T) next to the prisoner, and an anthropomorphized club and shield (U) on the far left of the scene.

Still another example of the Presentation Theme is seen in a fineline drawing from the chamber of a stirrup spout bottle (fig. 106). Here again we

Figure 105b. Dipper from which the low relief representation of the Presentation Theme in figure 105a is derived.

Figure 106. Stirrup spout bottle with a modeled figure blowing a conch shell trumpet (above). On the chamber is a fineline representation of the Presentation Theme (below).

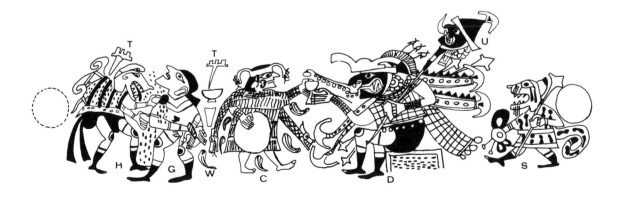

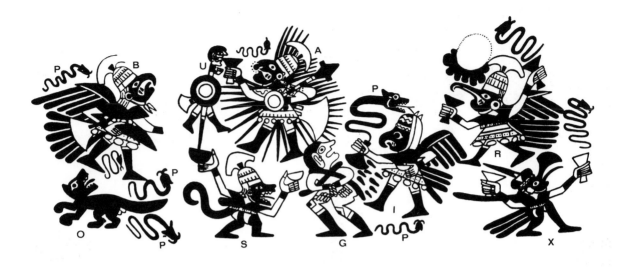

Figure 107. Fineline representation of the Presentation Theme.

have a slightly different arrangement of the symbolic elements, but the theme itself is clearly recognizable. On the left can be seen the bound prisoner (G) who is having his blood taken by the captor. In this instance the captor is neither a human figure nor a feline, but rather an anthropomorphized bat, clearly identifiable because of the form of the ear and the large curved thumbnail on the upper part of the wing. Other examples of the Presentation Theme include similar bat figures, and these suggest that he is an individual whose function and overall importance are equal to that of the feline and the human figures who are in charge of the prisoners. He can thus be added to our inventory of major figures and given the letter designation H. The primary individuals in figure 106 are the two in the center. The one on the left (C) is clearly the same individual as C in figure 104. He has the same headdress and clothing, but in this instance he carries the disc and presents the goblet, a role usually played by the anthropomorphized bird figure (B). Moreover,

in this representation the goblet is presented to a seated individual (D) who is identical to D in figure 104. Thus, although the role played by these two is distinct from the previous examples, they are easily identifiable because of their clothing, and are appropriate to the basic inventory of major figures that characterize the Presentation Theme.

On the right in figure 106 is an anthropomorphized feline (S), the counterpart of S in figure 104. The clubs (T) are the counterpart to the usual club and shield, and the anthropomorphized club (U) in the hands of the seated individual may well be the counterpart to the anthropomorphized club and shield that are regularly a part of the Presentation Theme.

Figure 107 provides still another version of the Presentation Theme. The placement of the figures is somewhat distinct from the other versions, although the basic activities of taking blood from a bound prisoner and presentation of a goblet are clearly recognizable. The characters are also easily identified by analogy with the other versions. The

same letter designations have been added to facilitate comparison. The only new figures in this version of the Presentation Theme are the anthropomorphized Muscovy duck (X) who should perhaps be added to our list of minor figures, and the captor (I) who in this drawing has neither bat nor feline attributes, but rather is an anthropomorphized bird.

With this basic inventory of characters and an awareness of the activities that are inherent in the Presentation Theme, let us now turn our attention to the famous Moche mural from the site of Pañamarca (color pl. 2b, figs. 108, 109). This is the most remarkable of all Moche murals because of its complexity and excellent state of preservation. Nevertheless, it is obviously only a part of what originally must have been a much larger mural. The activity shown in this mural has generally been interpreted as a procession, with the figure at the left having the major role and importance (Bonavia 1959). It is now possible to identify this mural as a representation of the Presentation Theme. Each of the figures shown on the preserved section is clearly identifiable on the basis of the other representations described above. The anthropomorphized bat (H) and feline (F) appear to have already taken blood from the bound prisoners (G) behind them, and are in procession toward the central activity of the mural. A human captor (E) still stands beside one of the prisoners. Beneath the prisoners and in front of the anthropomorphized feline are serpents (P), and on the far right is the standard club and shield design (T). One additional feature not previously noted in examples of the Presentation Theme is the large thick-rimmed open bowl with what appear to be three goblets inside (Z).

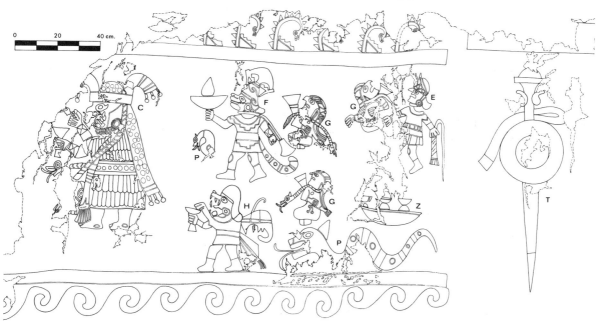

Figure 108. Drawing of a mural at Pañamarca which depicts the Presentation Theme (cf. color plate 2b).

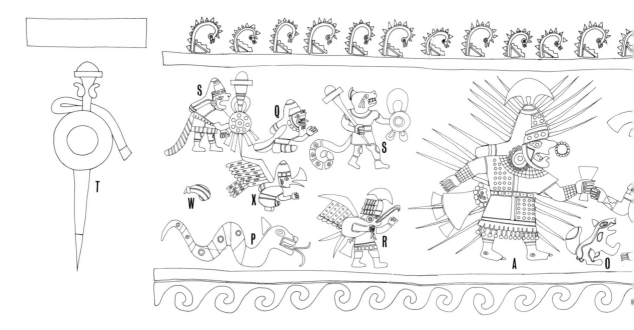

Figure 109. Reconstruction of the mural at Pañamarca depicting the Presentation Theme.

By comparing what remains of the Pañamarca mural with the examples of the Presentation Theme described above, it is possible to reconstruct what the complete mural may have been, since the basic symbolic elements are somewhat predictable. The large figure on the left of the preserved section is identifiable as figure C on the basis of his costume. He holds a goblet in one hand, but is clearly not holding a disc in the other. Instead, he was probably holding a cover in that hand, just as in figure 104. Since the presentation of a goblet to the major figure is normally done by someone holding a disc, this large figure in the preserved section was probably not one of the primary figures on the mural, but rather was standing to one side of the primary figures. On the basis of figure 104, it seems likely that in front of figure C (fig. 109) there was an anthropomorphized bird figure (B) presenting a goblet to the

rayed figure (A). In reconstructing the original form of this mural we have chosen to represent this bird figure wearing the headdress usually worn by figure D. He could, alternatively, wear a conical helmet with a crescent-shaped ornament. A dog (O) would have been appropriately placed between the two major figures. Further to the left any number of figures and objects may have been depicted, since these secondary features are numerous, and various combinations can occur. The set shown in this reconstruction is quite plausible. It consists of anthropomorphized feline warriors (S), an anthropomorphized fox warrior (Q), an anthropomorphized Muscovy duck (X), a bird warrior (R), an ullucu fruit (W), and another serpent (P). Based on the tendency toward bilateral symmetry that is found in Moche art, it also seems plausible that there was an enlarged club and shield design on the far left of the mural (T) to

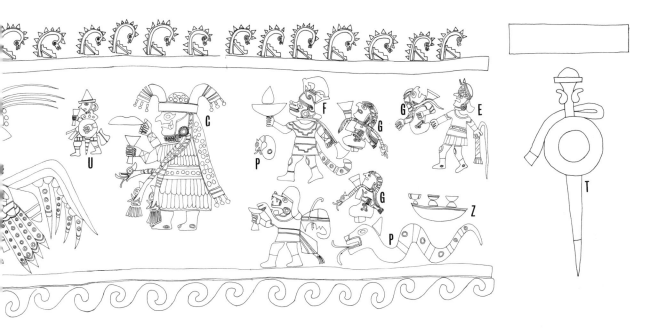

balance the one we know existed on the far right. One final element that was quite possibly shown on the mural was the anthropomorphized club and shield (U). We have chosen to place it to the right of the large bird figure holding the disc. Of course, this suggested reconstruction of the original mural is hypothetical, but it does seem reasonable on the basis of the other examples of the Presentation Theme in our sample.

It can be seen, therefore, that the identification of a major theme of Moche art, and thorough analysis of the symbolic elements of that theme, provide a certain potential for prediction in working with the art. As a result, it becomes possible in some instances to reconstruct the missing portions of a fragmentary depiction. Of even greater importance, however, is that it allows for the identification of some representations of figures which would otherwise be impossible to interpret accu-

rately. For example, modeled representations of bound prisoners held by felines (fig. 110) can be identified as one of the elements of the Presentation Theme, where they are often shown in identical form (see fig. 105). Similarly, the single figure of an anthropomorphized bird (fig. 111) takes on a special meaning when, because of his characteristic clothing and his holding a disc, it is possible to identify him as a figure in the Presentation Theme. The same is true of the figurine holding a disc and goblet who, on the basis of these objects, his headdress, and clothing, is clearly identifiable as figure C (fig. 112).

In 1961 a large cache of Moche copper objects was acquired by the American Museum of Natural History, including several large goblets that are identical to those used in the Presentation Theme, and several rattles with long narrow handles (color plates 12a and 12b). The form of the rattles is

Figure 110. Prisoner with feline captor (two views).

similar to that of the object above the front part of the litter (V) in figure 104. The chamber portion of one of these rattles has a design incised on each of the four sides and on the top (fig. 113). Each design is distinct, but taken as a group they clearly relate to the Presentation Theme. Figure A appears on the top of the rattle wearing his typical head-dress (a conical helmet with a crescent-shaped ornament), short skirt with kilt, backflap, and rays emanating from his head and shoulders.

On one side of the rattle (fig. 113) is a human figure with a tumi knife, apparently the counterpart to figure E, who generally is shown holding or drawing blood from a bound, nude prisoner. A second side of the rattle depicts a bound prisoner. He is somewhat unusual in this representation because he is tied to a rack, and human heads are associated with the rack itself. Yet similar human heads can be seen hanging from the litter in figure 104. The representation of the prisoner is not sufficiently detailed to determine whether or not the figure is nude, although other repre-sentations of figures in this position (color plate 9) suggest that he is. The third side of the rattle

Figure 111. Anthropomorphized bird holding a disc.

Figure 112. Individual holding a disc and a goblet.

has a figure holding a goblet in one hand and apparently a gourd lid in the other. It is likely that this is a representation of figure B, although the headdress is unusual in not having a clearly defined half circle in front similar to that in figure 109. All other aspects of the figure are appropriate, however, including the three featherlike objects on the back which can be seen as counterparts of the wings on figure B. The fourth side of the rattle shows the anthropomorphized bird warrior—a clear counterpart to figure R in the Presentation Theme.

The form of this rattle and its incised designs, as well as the form of the goblets found in the same cache of copper objects, thus can be directly associated with the Presentation Theme. It seems likely that these objects are related to the ceremony in which the various figures in the Presentation Theme are actively engaged.

Still another example of Moche art which can be related to the Presentation Theme is a stirrup spout bottle with modeled figures engaged in preparing some sort of concoction (color plate 5). The two figures are plainly dressed—neither has elabo-

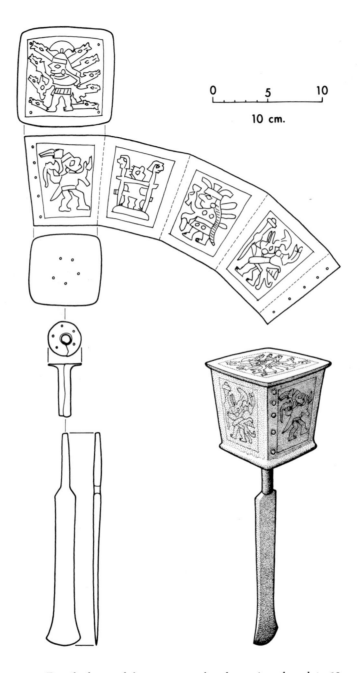

Figure 113. Detail of one of the copper rattles shown in color plate 12.

128

Figure 114. An anthropomorphized club and shield design from a mural in the Lambayeque Valley.

rate jewelry or headdress. One stands before a large open bowl, stirring the contents of that bowl with a long paddle, while the other appears to be pouring something into the large open bowl from a jar. In the entire sample of Moche art contained in the archive, there are only two representations of a bowl with this form: this modeled representation and the one drawn on the Pañamarca mural (fig. 109, Z), where it is shown with what appear to be three goblets. Fragments of these bowls have been found while excavating Moche

sites, but they are quite rare (Donnan 1973*b*:74, figs. 89–94). It is possible that these vessels are used in preparing the beverage presented to the rayed figure (A) and consumed on this occasion.

Finally it should be pointed out that another set of Moche murals, located in the Lambayeque Valley, can be seen as a variation of the Presentation Theme (fig. 114). When these murals were first reported (Donnan 1972) their relationship with the Pañamarca mural was noted but not well understood. Now, by isolating various examples of the Presentation Theme, it is possible to recognize the winged running figures as examples of the anthropomorphized club and shield designs like the one shown in figure 104, U.

It can be seen, therefore, that identification of the Presentation Theme allows us to better understand a great many examples of Moche art which would otherwise have little meaning beyond their obvious features. It also demonstrates the way Moche artists chose to represent a given theme by illustrating one of its symbolic elements alone or illustrating two or more of them together in various combinations. Realizing that the artist could and frequently did represent a complex theme by showing only one of its symbolic elements, present-day researchers working with Moche iconography should be encouraged to go beyond a simple explanation of a given piece, and to search for a basic theme to which it belongs.

IX. The Nonsecular Nature of Moche Art

By using archaeological excavation, historical documents, and ethnographic data, we have been able to suggest interpretations of specific aspects of Moche iconography. We have also demonstrated that Moche art expresses a very limited number of basic themes, and that many of these themes are interrelated. Let us now turn to the question of what is being communicated in Moche iconography. It has often been suggested that Moche iconography shows all aspects of Moche life, and as such offers the opportunity to conduct an ethnographic study of these ancient people. In the course of our research, it became increasingly apparent that the iconography expresses only the nonsecular aspects of Moche culture. In this section we document the nonsecular nature of the art and demonstrate the way certain depictions, although appearing to illustrate secular or daily occurrences, may in fact be pieces of a symbolic system that expresses only the supernatural and ceremonial aspects of this ancient culture.

First we must define exactly what we mean by the terms secular and nonsecular. This dichotomy, which is so apparent in the world view of persons of Western culture, is clearly not a dichotomy in the minds of many nonliterate people who have been studied by ethnographers in the last three centuries, and there is little reason to assume that it was a firm dichotomy to the ancient people of Peru. Quite the contrary, these people probably viewed the world around them as a unified whole without a strict demarcation between what we classify as natural and supernatural qualities or secular and nonsecular activities. A farmer planting his crop would not have distinguished between the activities of irrigation and cultivation on the one hand, and prayer and ritual on the other. These activities would have been seen as intricately interwoven into a whole, all of which was oriented toward bringing forth a bountiful harvest. Similarly, we separate the "natural" or "secular" aspects of childbirth, that is, the medical aspects, from the "nonsecular" or "supernatural" aspects that are handled by the church and/or a combination of superstitious beliefs. To the ancient Peruvian, the secular and nonsecular aspects may have been so interwoven that they could not have been separated into one or the other category. Clearly then, the secular versus nonsecular dichotomy that we are imposing upon an analysis of Moche iconography may have been foreign to the world view of the people who created the art. Nonetheless, this dichotomy is worthwhile for our purposes, since it provides us with insight into the essential quality or basic message of the iconography.

Traditionally, it has been suggested that Moche art shows all aspects of daily life. Considering the wide range of Moche artistic expression, it is remarkable that many common objects and activities are *not* represented. For example, there are no representations of agricultural activities, pastoralism, or mining. Nor are there representations of cooking, laundering, yarn spinning, pottery manufacturing, stone carving, or the manufacture of gourd containers. There are numerous depictions of architectural structures but none of the construction process. All of these would have been important daily activities, and one wonders why they would have been omitted from the inventory of artistic representations. In fact, there are very few representations of manufacturing in Moche art. Two of the most interesting of these are a weaving scene and a smelting scene both of which might at first be considered secular activities. To

demonstrate the nonsecular nature of Moche art, we should begin by considering these representations.

The weaving scene is on the inner panel of a flaring bowl in the British Museum (fig. 47). This has often been viewed simply as women engaged in the activity of weaving textiles. Their backstrap looms are supported by house posts, and around them are placed various ceramic vessels, including stirrup spout bottles, spout and handle bottles, flaring bowls, and jars. While the women sit on the ground weaving, elaborately dressed individuals stand nearby. It is often thought that the latter are involved in buying and selling the textiles woven by these women, and that one or more of the figures has authority over the weavers. Careful examination of the weavers, however, reveals that above and to one side of each of the looms is a small, elaborately decorated textile, which appears to be a model for the textile being created on the loom. These textiles are not simply random pieces of fabric, but in many instances are identifiable as portions of elaborate headdresses. They are the scarf portion that wraps about the head, under the chin, and tucks into the upper part of the headdress itself. Thus, we are viewing a set of weavers engaged in manufacturing headdresses. This is of particular interest since the unique bowl in figure 4 seems to illustrate the manufacturing of metal headdress components (Donnan 1973a:294–297). Since the weaving and metallurgy scenes both show the manufacturing of headdress elements, this suggests that the *essence* of these scenes is not simply manufacturing but specifically the production of headdresses. It is clear from our analysis of Moche iconography that headdresses are an extremely important aspect of ceremonial attire, and play a vital role in indicating status and activity of specific individuals. Quite possibly the *manufacture* of the headdress also had special meaning to these people. A similar situation obtains in the manufacturing of religious paraphernalia in certain religious groups of our own culture. For example, the manufacture of robes worn by the Pope on ceremonial occasions is carried out with great ritual.

Also, in the weaving scene, models that the weavers are copying which are not identifiable as headdress elements are garments—specifically half sections of shirts. Historical sources tell us that clothing was sometimes woven to be used as religious offerings (Arriaga 1968:168). If this is so for the clothing being manufactured in the Moche representation of weaving, then clearly this is not a scene of everyday secular activity.

Another Moche representation that seems to depict secular activity is a unique stirrup spout bottle with two modeled human figures who appear to be preparing food or drink (color plate 5). The figures are plainly dressed—neither has elaborate jewelry or headdress. One figure stands before a large open bowl, stirring the contents with a long paddle. The other appears to be pouring something into the large open bowl from a smaller jar. Nearby is a vessel with a tripod base. This scene has been interpreted as a depiction of *chicha* making. Since chicha (corn beer) is now produced by Peruvians for ordinary daily consumption, one might assume that this vessel illustrates a secular event. As noted in chapter 8, however, the vessel with a tripod base and the large open bowl are very unusual forms of Moche pottery. The only other depictions of the tripod vessel show it being used in a highly ceremonial context (fig. 1). The same is true of the large open bowl (see pp. 127–129). Chicha is known to have been made for consumption on ceremonial occasions by pre-Columbian people. That the vessel forms being used are rare, and are shown only in ceremonial context within the sample of Moche iconography, suggests that if this is the manufacture of chicha, it is chicha destined to be consumed on a ceremonial occasion. Thus the vessels showing weaving, smelting, and chicha brewing demonstrate that the manufacturing proc-

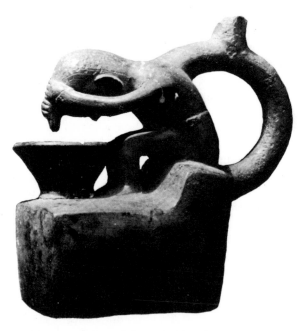

Figure 115. Seated figure holding his hair over a flaring bowl.

and drinking. Afterward the child's oldest uncle cut its hair and fingernails, both of which were preserved with great care (Cobo 1890–1895:b. 14, chap. 4). The hair would be offered to a *huaca* or kept as a sacred object (Arriaga 1968:54). Gillen (1947:110) reported a similar hair-cutting ceremony in the Moche community in 1945. We also know that the Incas practiced a ceremony at the event of a girl's first menstruation. The ceremony lasted several days. On the fourth day, the girl's mother washed her hair and subsequently combed and braided it. The girl then put on fine new clothes and white woolen sandals and emerged from a ceremonial hut to wait on her relatives who had assembled for a feast (Cobo 1890–1895:b. 14, chap. 6).

ess itself may become a ritual and nonsecular event.

Other scenes may also be interpreted as ceremonial in nature. The stirrup spout bottle in figure 115 seemingly illustrates a person washing his or her hair over a flaring bowl. Seen through our own cultural perspective, what could be more secular than the activity of washing one's hair? Yet if we consider the significance of human hair in the ancient Peruvian cultures, the interpretation of this piece is altogether different. We have already discussed some historical references to hair in a ceremonial context in chapter 7, but there are many more. Among the Incas, a child was not named until he was fully weaned, probably a year or two after birth. The name giving was part of an elaborate ceremony, the name of which in Quechua translates "hair cutting." Relatives and friends assembled for a feast that was followed by dancing

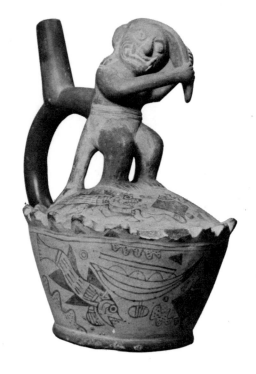

Figure 116. Standing deity figure holding his hair.

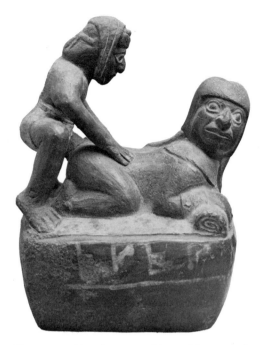

Figure 117. Couple engaged in anal intercourse.

is generally thought that the erotic art includes a great variety of sexual practices. In fact, it is limited to a very specific number of activities and postures. None of the art shows any practice that would lead to insemination and subsequent childbirth. In all instances where details are sufficiently clear, it is apparent that only anal intercourse is being shown (fig. 117). Fellatio (fig. 118), masturbation (fig. 119), the fondling of breasts, and kissing are the only other activities shown.

The lack of any activity that would lead to childbirth argues against the interpretation of Moche erotic art as fertility oriented, and demonstrates that Moche artists were not depicting the full spectrum of sexual behavior. Possibly they

Moche iconography repeatedly points out the special significance of human hair in Moche culture. Some supernatural figures with fanged mouths are shown pulling their own hair to one side (fig. 116). Combat scenes frequently illustrate individuals holding the opponent by the hair (fig. 96). In the confrontation between supernatural figures, one figure often grabs the other by the hair (fig. 49). In present-day curing ceremonies on the north coast of Peru, participants are thought to be attacked by demons who grab them by their hair and pull them backwards in such a way that they lose their balance (see chap. 7). Thus it is apparent that hair had mystical connotations. In view of this, scenes explicity depicting the washing of one's hair would almost certainly express a ritual or symbolic meaning.

Moche erotic art has gained a certain notoriety among art historians and archaeologists, and has been subject to a wide range of interpretation. It

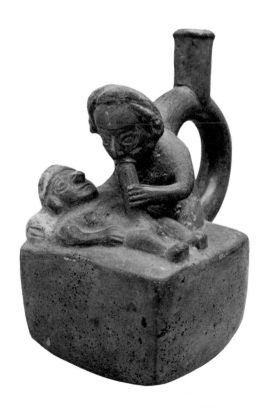

Figure 118. Couple engaged in fellatio.

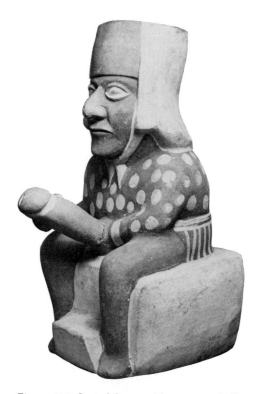

Figure 119. Seated figure with an erect phallus.

a representation of food. Stirrup spout bottles of this form have been illustrated in works dealing with Moche art before, but invariably are simply labeled as representations of plates filled with food (Benson 1972:figs. 4–8). Careful examination of a large sample of Moche art, however, indicates that a common feature of ceremony is the presentation of food. For example, figure 65 shows the placement of food in graves, and figure 48 depicts the presentation of food to an elaborately dressed person. In figure 48, the food containers walk on human legs. Food in these contexts is almost invariably contained in two gourd plates that are tied together. The depiction in figure 120, then,

were showing ritual practices that occurred in ceremonial contexts. Historical data indicates that the native people on the north coast of Peru at the time of European contact frequently practiced sodomy, and that some of their ceremonies included sexual orgies. It is likely that the erotic activity shown in Moche art is simply one aspect of ceremonial practice, quite distinct from the sexual practice of everyday life.

The vessel shown in figure 120 provides another example of what appears to be a secular object, but which in fact has a nonsecular connotation. The chamber is modeled in the form of two stacked gourds, each containing food. A line of dark paint suggests a cord tying the two gourds together. On first impression this pot would seem to be merely

Figure 120. Stirrup spout bottle in the form of two gourds tied together and filled with food.

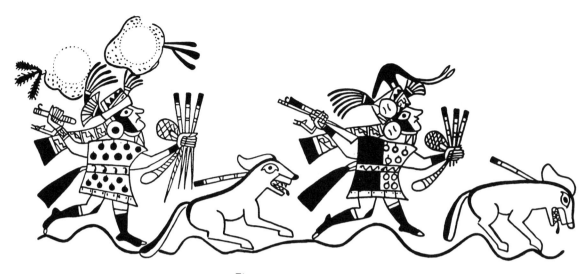

Figure 121. Fox hunting.

is probably not secular, but rather a representation of food to be presented in ceremonial context. It is likely that a Moche person viewing this particular stirrup spout bottle would not have seen it as a secular representation of food, but would have immediately recognized its symbolic meaning. Similarly, a Moche individual viewing a stirrup spout bottle whose chamber is modeled in the form of a simple bird, plant, or animal, would immediately understand the symbolism that these represent and associate them with the nonsecular context in which they belong.

The world of the shaman can be related to many secular-appearing vessels by using ethnographic analogy to the folk healers who still practice in small communities on the north coast of Peru today. Many of these vessels were discussed earlier in chapter 7, including a modeled figure of the so-called "pot vendor" (color plate 11) and a vessel with a fineline drawing of a sea lion hunt (fig. 14). The modeled figure is carrying several different types of pottery and a rolled-up mat, and he is usually shown whistling. It is not difficult to see the nonsecular nature of this vessel if the pottery

and rolled-up mat are interpreted as a shaman's mesa, and the whistling is viewed as a shaman's way of attracting guardian spirits. Moche artists frequently replaced this human figure with an anthropomorphized bat carrying the pottery and the mat (fig. 103), which strongly supports a supernatural relationship and completely refutes the idea that the human figure is a simple pot vendor.

The vessel with a fineline drawing of a seal hunt is even more clearly associated with shamanism. As discussed in chapter 7, small beach pebbles that are swallowed by sea lions are believed by present-day folk healers to have strong curative properties. These stones are taken from sea lions when they are killed by sea lion hunters.[6] When Moche artists represent sea lions, they almost always show them with a fish or a small round object either in or immediately in front of their mouths (p. 30, and fig. 14). In all scenes of sea lion hunts, at least a few and sometimes all of the sea lions are depicted with this round object. It is almost certain to be the counterpart of the sea lion stones currently used by folk healers who are still practicing much of the pre-Columbian curing ritual, and

representations of sea lion hunting in Moche art are most likely to be the depictions of a ritual activity— the quest for the magical sea lion stones.

What about the other hunting scenes represented in Moche art? Many show humans in pursuit of deer (color plate 7*b* and fig 88). It is important, however, that people engaged in this activity are very elaborately dressed. Their costumes, including face paint, elaborate ear ornaments, enormous and elaborate headdresses, beautifully woven tunics, necklaces and bracelets, seem rather strange attire for the stalking and killing of deer. If these are accurate depictions of deer hunts, the hunts could hardly be secular, everyday activities. It seems much more likely that we are viewing ceremonial, possibly ritual hunts by elite individuals on carefully specified occasions.

Depictions of fox and feline hunts are much less common in Moche art (fig. 121) despite the frequency with which the fox is depicted in the art. The hunter's attire suggests that fox and feline hunts, like deer hunts, are ritual events. Moreover, the dress utilized in hunting deer, foxes, and felines is strikingly similar to the dress used in human combat. Might we not be viewing a ceremony that is on the same order of ritual in Moche culture as the human combat so commonly represented in their art?

In almost all instances where there are sufficient data from the archaeological record, historical record, or ethnographic record to help interpret a specific representation, it becomes clear that what may on first viewing appear to be a secular scene of daily activity is in fact directly related to the supernatural realm, ritual, or shamanism of these ancient people. For the most part the more complex the scene or the more elaborate the individual being shown, the easier it is to demonstrate that the scene is related to a supernatural or nonsecular realm. For depictions of single figures or objects, the task becomes much more difficult. Unelaborated human figures who are simply seated and holding an object in their hands or seated with hands on their knees are very difficult to interpret, as are single animal or bird representations. It is our contention, however, that even these simple forms are symbols that carried nonsecular meaning in Moche culture.

Clearly Moche artists did not depict the full range of objects and activities in the world around them. Yet they left an amazingly complete picture—one that offers a unique opportunity to reconstruct this ancient culture, and to learn not only of the world in which its people lived, but the unique and wonderful way in which they perceived that world.

Our research represents only a beginning, but it is a beginning of a systematic study based on a large, well-organized sample of Moche art. The results thus far have been encouraging, but the frequency with which new insights are occurring indicates that we are only beginning to learn all that Moche art can tell us. We anticipate that in the next few years, by continuing to expand the Moche Archive and by systematically exploring specific facets of the iconography, major new advances in our understanding of these ancient people will be achieved.

Notes

[1]In the early 1960s, a major find of Moche material was made far to the north of the Lambayeque Valley, outside of what had previously been considered the area of Moche domination. Discovered in the Piura Valley (see map 1), this material consists of elaborate gold, copper, and silver metalwork, as well as Moche ceramics. Since the ceramics closely resemble those of the earliest Moche phases, the Piura finds have generated speculation about the possibility of Moche culture originating to the north of its subsequent area of domination. Unfortunately, nearly all of the Piura material was looted by grave robbers, and its original context and associations are unknown. Thus it is difficult to interpret these finds, and much more evidence must be made available before their real significance can be understood.

Since 1960, other objects of Moche style have been found outside of the primary area of Moche domination—this time far to the south in the Huarmey Valley (see map 1). Again, the material had been looted by grave robbers, and its original context is unknown. It consists of elaborate textiles that combine Moche stylistic features with features of the Huari style, and thus they are believed to pertain to the end of the Moche sequence.

[2]Ceramic in this context refers to fired clay. In a few instances, however, unfired clay objects identical to the fired ones have been found in Moche graves, suggesting that there were some clay objects that were left unfired. Owing to the perishable nature of unfired clay, however, very few such objects have survived.

[3]Espingo seems to be used very loosely both as a specific and/or generic term, applied by contemporary curanderos and herb vendors to several types of dried seeds that have a characteristically pungent odor. All of these are native to the jungle area beyond Chachapoyas, and are used as medicinal plants for curing supernatural disorders such as *aire* (evil winds) and *susto* (fright sickness or soul loss). Some of the plants occasionally referred to by this term also have individual names familiar to the more knowledgeable plant specialists—*tufion, ashango (asango), amala,* and *pucho.* Recently Wassén (1972) has identified espingo as a *Quararibea* sp. of the Family *Bombacaceae.*

[4]Garcilaso states that the native Peruvians had a fable to account for the spots on the moon. It tells of a fox that fell in love with the moon because of her beauty, and went up to the sky to steal her. When he tried to lay hands on her, she squeezed him against her, thus producing the spots (Garcilaso de la Vega 1966:118).

[5]Both types of dogs are represented in the pre-Columbian art of the north coast of Peru, although they are represented separately in distinct styles. The spotted, short-haired dog is depicted in Moche art, while the hairless dog (without spots) is depicted in the Chimu style.

[6]There are historical references (Arriaga 1968:166) to other magic objects similar to seal stones which were derived from animals. They were called *ylla,* the hair balls of animals, which the natives considered sacred.

Sources of Illustrations

FIGURES

1a Courtesy of The British Museum, London (drawing by D. McClelland)

1b Courtesy of Museo Nacional de Historia Natural, Santiago (drawing by A. Collins)

1c Ganoza collection, Trujillo, Peru (drawing by D. McClelland)

2a Courtesy of Rhode Island School of Design

2b Drawing by P. Perlman

3 Private collection, Lima

4 Private collection, New York (photo by T. Brown)

5 Private collection, Lima (photo by S. Einstein)

6 Courtesy of Museo Amano, Lima

7 Valerie B. Franklin collection (photo by S. Einstein)

8 Courtesy of the Department of Anthropology, Smithsonian Institution, Washington, D.C. (drawing by P. Finnerty)

9 Courtesy of The Art Institute of Chicago

10 Drawing by P. Finnerty

11 Drawing from Kutscher 1954a:28

12 Drawing by P. Finnerty

13 Drawing from Kutscher 1954a:11

14 Private collection, Buenos Aires (drawing by D. McClelland)

15 Drawing from Kutscher 1950b:fig. 4

16 Ganoza collection, Trujillo, Peru

17 Courtesy of the Lowie Museum of Anthropology, University of California, Berkeley

18 Courtesy of The British Museum, London

19 Private collection, Frankfurt

20 Courtesy of The British Museum, London

21 Private collection, Buenos Aires (drawing by P. Finnerty and D. McClelland)

22 Courtesy of Museum für Volkerkunde, Berlin (drawing from Kutscher 1954a:21)

23 Private collection, Washington, D.C. (drawing by D. McClelland)

24 Courtesy of Museum für Volkerkunde, Munich

25 Drawing by P. Finnerty

26 Drawing from Klein 1967:79

27 Drawing from Klein 1967:79

28a Drawing from Klein 1967:88

28b Drawing from Klein 1967:89

29a Drawing from Klein 1967:94

29b Drawing from Klein 1967:95

30a Drawing from Klein 1967:98

30b Drawing from Klein 1967:99

31 Drawing by P. Finnerty

32 Drawing by P. Finnerty

33 Courtesy of The British Museum, London

34 Courtesy of Museo de Arqueología, Universidad de Trujillo

35 Courtesy of Museo de Arqueología, Universidad de Trujillo

36 Courtesy of the Lowie Museum of Anthropology, University of California, Berkeley (drawing by D. McClelland)

37 Courtesy of the Lowie Museum of Anthropology, University of California, Berkeley (drawing by D. McClelland)

38 Courtesy of the Lowie Museum of Anthropology, University of California, Berkeley (drawing by D. McClelland)

39 Drawings by P. Finnerty

40 Courtesy of the Lowie Museum of Anthropology, University of California, Berkeley

41 Courtesy of the Lowie Museum of Anthropology, University of California, Berkeley

42 Courtesy of Museo Nacional de Antropología y Argueología, Lima

43 Courtesy of Milwaukee Public Museum

44 Courtesy of The British Museum, London

45 After Kutscher 1954a:fig. 3B

46 McClelland collection, San Marino, California (photo by S. Einstein)

47 Drawing by D. McClelland

48 After Larco 1938–1939:Lamina XXXI

49 After Kutscher 1954a:fig. 54B

50 Courtesy of Museum für Volkerkunde, Berlin

51a After Kutscher 1958:fig. 2

51b Private collection, Buenos Aires (drawing by M. Fang)

51c After Kutscher 1950a:fig. 4

52 Drawing by P. Finnerty

53 Courtesy of Museo Nacional de Antropología y Arqueología, Lima

54 After Montell 1929:fig. 3

55 Courtesy of Museum für Volkerkunde, Berlin

56 Courtesy of American Museum of Natural History, New York

57 Courtesy of Museum für Volkerkunde, Berlin

58 Ganoza collection, Trujillo

59 Salazar collection, Miami

60 Landman collection, New York

61 Salazar collection, Miami

62 Courtesy of Museum für Volkerkunde, Berlin

63 Ganoza collection, Trujillo

64 After Willey 1953:pl. 29
65 Drawing by C. Donnan
66 Courtesy of The Art Institute of Chicago
67 Courtesy of Linden-Museum, Stuttgart
68 Courtesy of the University Museum, University of Pennsylvania, Philadelphia
69 Private collection, New York
70 Photo by C. Meighan
71 Courtesy of Field Museum of Natural History, Chicago
72 Courtesy of The Art Institute of Chicago (drawing by A. Collins)
73 Burgess collection, San Marino, California (photo by S. Einstein)
74 Courtesy of The British Museum, London (drawing by D. McClelland)
75 Courtesy of American Museum of Natural History, New York
76 Photo by D. Sharon
77 Photo by D. Sharon
78 After Strong and Evans 1947:481
79 After Strong and Evans 1947:479
80 Courtesy of the Peabody Museum, Harvard University (photos by S. Einstein)
81 Courtesy of American Museum of Natural History, New York
82 Courtesy of Museo Nacional de Antropología y Arqueología, Lima
83 After Gonzalo de Reparaz 1960:fig. 25
84 Ganoza collection, Trujillo
85 After Kutscher 1954a:fig. 67A
86 Photo by D. Sharon
87 After Kutscher 1954a:fig. 36A
88 After Muelle 1936a:12
89 Courtesy of Hamburgisches Museum für Volkerkunde
90 Courtesy of Musée de l'Homme, Paris
91 Drawing by D. McClelland
92 Drawing by D. McClelland
93 Ganoza collection, Trujillo
94 Courtesy of Museo de América, Madrid
95 Courtesy of Museum für Volkerkunde, Berlin
96 After Larco 1946:169
97 Courtesy of Museo de Arqueología, Universidad de Trujillo
98 After Larco 1965:37
99 Courtesy of The British Museum, London
100 Neiman collection, Aachen
101 Courtesy of Rautenstrauch-Joest-Museum für Volkerkunde der Stadt, Cologne
102 After Joyce 1908:17, 18

103 Courtesy of Museo Nacional de Antropología y Arqueología, Lima
104 Courtesy of Museum für Volkerkunde, Munich (drawing after Kutscher 1955:24–25)
105 Landman collection, New York (drawing by D. McClelland)
106 Courtesy of Museo Nacional de Antropología y Arqueología, Lima (drawing by D. McClelland)
107 After Kutscher 1954b:fig. 2
108 Reprinted from ARCHAEOLOGY, Volume 25, No. 2, Copyright 1972, Archaeological Institute of America
109 Drawing by D. McClelland; painted by Cordy
110 Courtesy of the Peabody Museum, Harvard University (photos by S. Einstein)
111 Courtesy of The Art Institute of Chicago
112 After Wassermann-San Blas 1938:fig. 521
113 Drawing by P. Finnerty
114 After Donnan 1972:cover
115 After von Hagen 1964:fig. 21
116 Courtesy of Museum für Volkerkunde, Berlin
117 Miranda collection, Trujillo
118 Miranda collection, Trujillo
119 Courtesy of Museum für Volkerkunde, Berlin
120 Courtesy of The Art Institute of Chicago
121 After Kutscher 1954a:fig. 3B

COLOR PLATES

1 Courtesy of Linden-Museum, Stuttgart
2a Photo by C. Donnan
2b Photo by C. Donnan
3 Private collection, Germany
4a Courtesy of Museo Nacional de Antropología y Arqueología, Lima
4b Private collection, San Marino, California
5 Courtesy of Museo Arqueológico Bruning, Lambayeque
6a Photo by C. Donnan
6b Courtesy of Museo Nacional de Antropología y Arqueología, Lima
7a Miranda collection, Trujillo
7b After Kutscher 1954a:fig. 14C
8 Ganoza collection, Trujillo (photo by D. Sharon)
9 Ganoza collection, Trujillo
10a Courtesy of the Lowie Museum of Anthropology, University of California, Berkeley (photo by L. Dawson)
10b Photo by Carol J. Mackey
11 Miranda collection, Trujillo
12 Courtesy of American Museum of Natural History, New York (photo by J. Bird)

Bibliography

ACOSTA, JOSÉ DE
1894 *Historia natural y moral de las Indias . . .*
 I. Madrid.

ARRIAGA, PABLO JOSÉ DE
1968 *The extirpation of idolatry in Peru.* University of Kentucky Press, Lexington.

BAESSLER, ARTHUR
1902–1903 *Ancient Peruvian art* I–III. Berlin.

BENNETT, WENDELL C.
1939 *Archaeology of the north coast of Peru.* Anthropological Papers 37. American Museum of Natural History, New York.

BENSON, ELIZABETH
1972 *The Mochica, a culture of Peru.* Praeger, New York.

BENZONI, M. JERONIMO DE
1967 *La historia del mundo nuevo.* Translated by Carlos Radicati di Primedio. University of San Marcos, Lima.

BONAVIA, DUCCIO
1959 *Una pintura mural de Pañamarca, Valle de Nepeña.* Arqueológicas 5. Museo Nacional de Antropología y Arqueología, Lima.

CABELLO DE BALBOA, MIGUEL
1586 *Miscelánea antártica.* MS in New York Public Library.

CALANCHA, ANTONIO DE LA
1638 *Cronica moralizada del orden de San Augustin en el Peru, con sucesos egemplares an esta monarquia.* Barcelona.

CALKIN, CARLETON I.
1953 Moche figure painted pottery: the history of an ancient Peruvian art style. Ph.D. dissertation, Department of Art, University of California, Berkeley.

CAPOCHE, LUIS
1959 *Relación general de la villa imperial de Potosí.* Biblioteca de Autores Españoles, Madrid.

CARRERA, FERNANDO DE LA
1939 *Arte de la lengua Yunga* (1644). Publicaciones Especiales del Instituto de Antropología de la Universidad Nacional de Tucumán, Argentina.

CASAS, BARTOLOMÉ DE LAS
1892 *De la antiguas gentes del Perú.* Edited by Don Marcos Jimenez de la Espada. Madrid.

CHIAPPE, MARIO
1968 *Psiquiatría folklórica, Peruana: el curanderismo en la costa norte del Perú.* Anales del servicio de psiquiatría, vol. 2, nos. 1–2. Lima.

CIEZA DE LEON, PEDRO DE
1864 *The travels of Pedro de Cieza de León, A.D. 1532–1550.* Hakluyt Society, London.

COBO, BERNABÉ
1890–1895 *Historia del nuevo mundo, I–IV.* Edited by Don Marcos Jimenez de la Espada. Sociedad de Bibliofilos Andalucos, Seville.
1956 *Historia del nuevo mundo.* Biblioteca de Autores Españoles, Madrid.

CRUZ SANCHEZ, GUILLERMO
1948 Informe sobre las aplicaciones populares de la cimona en el Norte Perú. *Revista de Farmacología y Medicina Experimental* 1:253–259. Lima.

DAY, KENT
1971 *Royal Ontario Museum Lambayeque Valley (Peru) expedition.* Quarterly report. Xeroxed.

DOBKIN DE RIOS, MARLENE
1968 Trichocereus pachanoi: a mescaline cactus used in folk healing in Peru. *Economic Botany,* 22(2):191–194.

DONNAN, CHRISTOPHER
1965 Moche ceramic technology. *Nawpa Pacha* 3:115–138. Berkeley.
1972 Moche-Huari murals from northern Peru. *Archaeology* 25(2):85–95.
1973a A precolumbian smelter from northern Peru. *Archaeology* 26(4):289–297.
1973b *Moche occupation of the Santa Valley, Peru.* University of California Publications in Anthropology 8. University of California Press, Berkeley, Los Angeles, London.

DONNAN, CHRISTOPHER B., AND CAROL J. MACKEY
MS *Ancient burial patterns of the Moche Valley, Peru.* Department of Anthropology, University of California, Los Angeles.

EDWARDS, CLINTON R.
1965 *Aboriginal watercraft of the Pacific coast of South America.* Ibero-Americana 47. University of California Press, Berkeley.

FRIEDBURG, CLAUDINE
1963 *Mission au Perou, Mai 1961 - Mars 1962.* Journal d'agriculture tropicale et de botanique appliqué, vol. 10, nos. 1–4. Paris.

FURST, PETER, ed.
1972 *Flesh of the gods: the ritual use of hallucino-gens.* Praeger, New York.

GARCILASO DE LA VEGA
1944 *Comentarios reales de los Incas.* Emece editores. S.A., Buenos Aires.
1960 *Obras completas del Inca Garcilaso de la Vega II.* Biblioteca de Autores Españoles. Madrid.
1966 *Royal commentaries of the Incas.* University of Texas Press, Austin.

GILLIN, JOHN
1947 *Moche: a Peruvian coastal community.* Smithsonian Institution, Institute of Social Anthropology, Publication 3. Washington, D.C.

HOLMBERG, ALLAN R.
1957 Lizard hunts on the north coast of Peru. *Fieldiana Anthropology* 36:203–220. Field Museum of Natural History, Chicago.

IMBELLONI, JOSÉ
1942 Escritura Mochica y escrituras Americanas. *Revista Geográfica Americana,* Año IX, no. 109:212–226. Buenos Aires.

JIMÉNEZ BORJA, ARTURO
1950–1951 *Instrumentos musicales Peruanos.* Revista del Museo Nacional, Tomos XIX y XX. Museo Nacional de Antropología y Arquelogía, Lima.

JOYCE, T.
1908 The southern limit of inlaid and incrusted work in ancient Peru. *American Anthropologist* n.s. 19:16–23.

KLEIN, OTTO
1967 *La Cerámica Mochica, caracteres estilísticos y conceptos.* Publicación oficial de la Universidad Técnica Federico Santa María, Valparaiso.

KROEBER, ALFRED L.
1930 *Archaeological explorations in Peru. Part II: The northern coast.* Anthropological Memoirs. Field Museum of Natural History, Chicago.

KUTSCHER, GERDT
1950a *Chimu, eine altindianische Hochkultur.* Gebr. Mann. Berlin.
1950b Iconographic studies as an aid in the reconstruction of Early Chimu civilization. *Transactions of the New York Academy of Sciences,* series 2, 12(6):194–203.
1954a *Nordperuanische keramik.* Casa Editora, Gebr. Mann. Berlin. ·

1954b Sacrifices at Prières dans l'ancienne civilization de Moche (Perou du nord). *International Congress of Americanists, Proceedings,* Editoria Anhemi, São Paulo.
1955 *Arte antiguo de la costa norte del Perú.* Gebr. Mann. Berlin.
1958 Ceremonial "badminton" in the ancient culture of Moche (North Peru). *32nd International Congress of Americanists, Proceedings.* Munks Gaard. Copenhagen.

LARCO HOYLE, RAFAEL
1938–1939 *Los Mochicas.* Tomo I-II. Lima.
1942 La escritura Mochica sobre pallares. *Revista Geográfica Americana, Año IX,* no. 107:90–103. Buenos Aires.
1943 La escritura Mochica sobre pallares. *Revista Geográfica Americana,* Año XI, no. 122:277–292, 345–354. Buenos Aires.
1946 A culture sequence for the north coast of Peru. In *Handbook of South American Indians,* vol. 2: *The Andean Civilizations.* Edited by Julian Steward. Bureau of American Ethnology, Bulletin 143:149–176. Washington, D.C.
1948 *Cronología arqueología del norte del Perú.* Sociedad Geográfica Americana, Buenos Aires.
1965 *Cheecan.* Nagel, Geneva, Switzerland.

LAVALLÉE, DANIÈLE
1970 *Les representations animales dans la céramique Mochica.* Mémoires de l'Institut d'Ethnologie IV. Musée de l'Homme, Paris.

MEANS, PHILLIP
1931 *Ancient civilizations of the Andes.* Charles Scribner's Sons, New York.

MONTELL, GOSTA
1929 *Dress and ornaments in ancient Peru.* Archaeological and Historical Studies. Oxford University Press, London.

MORÚA, MARTÍN DE
1922–1925 *Historia del origen y genealogía real de los reyes Incas del Perú, de sus hechos, costumbres, trajes y manera de gobierno.* Edited by Horacio H. Urteaga and Carlos A. Romero. Colección de libros y documentos referentes a la historia del Perú, Lima.

MUELLE, JORGE
1936a *Muestras de Arte Antiguo del Perú.* Publicaciones del Museo Nacional, Lima.
1936b Chalchalcha. In *Revista del Museo Nacional* 5(1):65–88, Lima.

OLIVA, JUAN ANELLO
1857 *Histoire du Pérou.* Translated by M. H. Fernaux-Compans. Paris.

PARK, WILLARD Z.
1946 Tribes of the Sierra Nevada de Santa Marta, Colombia. In *Handbook of South American Indians,* vol. 2: *The Andean Civilizations.* Edited by Julian Steward. Bureau of American Ethnology, Bulletin 143:865–886. Washington, D.C.

POLO DE ONDEGARDO, JUAN
1916 *Los errores y supersticiones de los indios, sacadas del tratado y averiguación que hizo el licenciado Polo.* Edited by Horacio H. Urteaga and Carlos A. Romero. Colección de libros y documentos referentes a la historia del Perú, vol. 3. Lima.

RALEIGH, SIR WALTER
1848 *The discovery of . . . Guiana.* Edited by R. H. Schomburgk from the edition of 1596. Hakluyt Society, London.

REPARAZ, GONZALO DE
1960 *Peru.* Ediciones de Arte Rep, Lima.

ROMAN Y ZAMORA
1595 *Repúblicas del mundo . . .* Juan Fernandez. Salamanca.

ROWE, JOHN H.
1945 Absolute chronology in the Andean area. *American Antiquity* 10(3):265–284.
1946 Inca culture at the time of the Spanish conquest. In *Handbook of South American Indians,* vol. 2: *The Andean Civilizations.* Edited by Julian Steward. Bureau of American Ethnology, Bulletin 143:183–330. Washington, D.C.
1948 The Kingdom of Chimor. *Acta Americana* 6(1–2)26–59.

SAWYER, ALAN
1966 *Ancient Peruvian ceramics: The Nathan Cummings Collection.* New York Graphic Society, New York.

SCHAEDEL, RICHARD P.
1951 Mochica murals at Pañamarca. *Archaeology* 4(3):145–154.

SHARON, DOUGLAS
1972a The San Pedro cactus in Peruvian folk healing. In *Flesh of the Gods: the ritual use of hallucinogens.* Edited by Peter Furst. Praeger, New York.
1972b Eduardo the healer. *Natural History* 81(9):32–47.
1972c Curandero phenomology: the symbol system of a north Peruvian folk healer. M.A. thesis. Department of Anthropology, University of California, Los Angeles.
1973 A Peruvian curandero's seance: power and balance. *9th International Congress of Anthropological and Ethnological Sciences,* Chicago (in press).
1974 The symbol system of a north Peruvian shaman. Ph.D. dissertation, Department of Anthropology, University of California, Los Angeles.

SHARON, DOUGLAS, AND CHRISTOPHER B. DONNAN
1974 Shamanism in Moche iconography. In *Ethnoarchaeology.* Edited by Christopher Donnan and C. William Clewlow, Jr. Institute of Archaeology, Monograph IV. University of California, Los Angeles.

STRONG, WILLIAM DUNCAN, AND CLIFFORD EVANS, JR.
1947 Finding the tomb of the warrior god. *National Geographic Magazine* 91(4, April):453–482. Washington, D.C.
1952 *Cultural stratigraphy in the Viru Valley, northern Peru.* Columbia Studies in Archaeology and Ethnology, IV. New York.

TRUJILLO, DIEGO DE
1948 *Relación de descubrimento del reyno del Perú.* Edición, prólogo y notas by Raul Porras Barrenechea. Seville.

TSCHOPIK, HARRY
1946 The Aymara. In *Handbook of South American Indians,* vol. 2: *The Andean Civilizations.* Edited by Julian Steward. Bureau of American Ethnology, Bulletin 143:149–176. Washington, D.C.

UBBELOHDE-DOERING, HEINRICH
1967 *On the royal highways of the Inca.* Praeger, New York.

VON HAGEN, VICTOR W.
1964 *The desert kingdoms of Peru.* New York Geographic Society, Publishers, Ltd. Greenwich, Connecticut.

WASSÉN, S. HENRY
1972 *A medicine-man's implements and plants in a Tiahuanacoid tomb in highland Bolivia.* Ethnologiska Studier 32. Goteborg.

WASSERMAN-SAN BLAS, B. J.
1938 *Cerámicas del Antiguo Peru.* Casa Jacobo Peuser, Ltd., Buenos Aires.

WILLEY, GORDON R.
1953 *Prehistoric settlement patterns in the Viru Valley, Peru.* Bureau of American Ethnology, Bulletin 155. Washington, D.C.

Index